Chinese Bronzes
A General Introduction

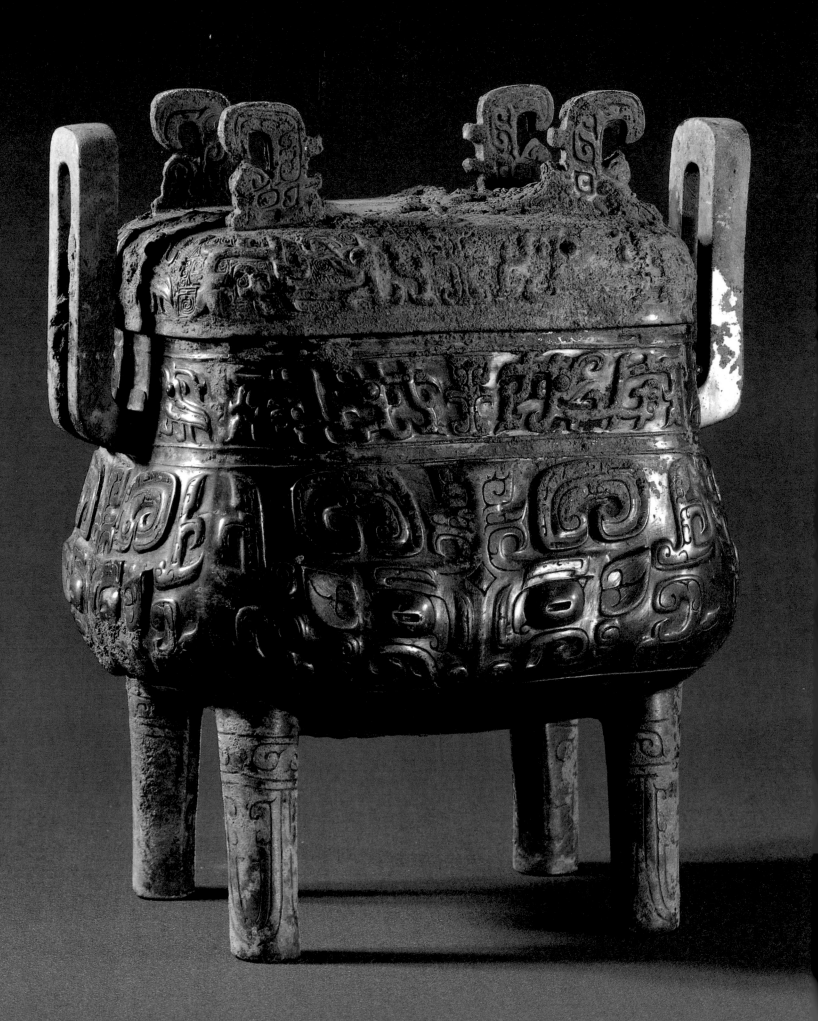

Chinese Bronzes
A General Introduction

Editor: Cheng Qinhua
Design: Cai Rong

#36257074-6

First Edition 1995

ISBN 7-119-01387-4

© Foreign Languages Press, Beijing, China, 1995
Published by Foreign Languages Press
24 Baiwanzhuang Road, Beijing 100037, China

Printed by Jingmei Colour Printing Co., Ltd.
11 Debao Xinyuan, Xiwai Dajie St, Beijing 100044, China

Distributed by China International Book Trading Corporation
35 Chegongzhuang Xilu, Beijing 100044, China
P.O. Box 399 Beijing, China

Printed in the People's Republic of China

Contents

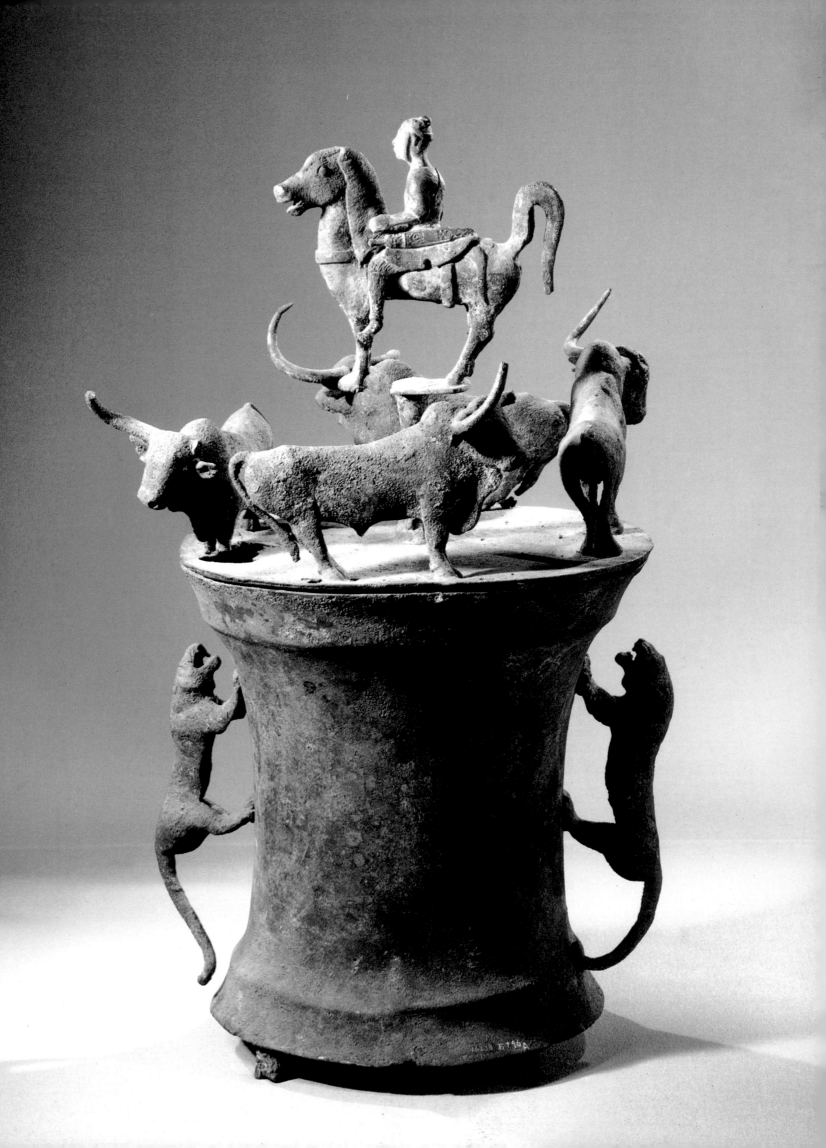

Preface

CHINA'S splendid ancient culture has created large numbers of matchlessly exquisite cultural relics; bronze ware is one of the important ones. China's ancient bronze ware, with a long history and diversified variety, is recognized by experts as precious fine art articles with high academic value. The collection and study of Chinese ancient bronze ware may be traced to the Western Han Dynasty (206 B.C.-A.D. 24). Books dealing specially with bronze ware began to appear as far back as the Northern Song Dynasty (960-1127); bronze works of art were treasured in the imperial court and by scholar-officials. Up to the 1950s, tens of thousands of bronzes of various kinds had been found, but the overwhelming majority was not from archaeological excavations. Therefore, the study of bronzes was rather limited.

Since the 1950s, especially in the last twenty years, along with the development of field archaeological work, precious bronzes, unprecedented both in quality and quantity, have been discovered in different parts of China. The accumulation of a tremendous amount of data from diggings has accelerated research in this field to a new level. Now in-depth investigation and systematic analysis can be made along scientific lines and in combination with technological, fine art and cultural history, so that the wonder of Chinese bronzes may be finally revealed.

To study ancient bronzes along scientific lines means to use the archaeologically excavated bronzes as main materials and to study them by applying archaeological theories and methods. This is quite different from methods used in epigraphy. I have always held that the study of bronzes should be conducted within the context of their cultural background. As for a particular bronze piece, it should be observed and studied comprehensively, from five aspects: its shape, decoration, inscription, function and technology. In this way, the study of bronze ware can reach a higher level.

The origin and evolution of China's bronzes need historical analysis and exposition. Generally speaking, there are two peaks of development for ancient bronze ware: the later years of the Shang Dynasty (c. 16th-11th centuries B.C.) and the Warring States Period (475-221

B.C.). By the Han Dynasty (206 B.C.-A.D. 220), bronze ware had declined gradually except for bronze mirrors. Also, ancient bronzes should be studied according to where they were produced, especially the Central Plain and the remote border areas, since their characteristics differ greatly. As for other relevant matters, we should make further investigations.

It is not easy to compile a comparatively complete and popular outline of China's bronze ware. Quite a number of scholars at home and abroad have made fine contributions to this field. To write such a book geared to the needs of readers today requires comprehensive knowledge, including archaeology, history, linguistics, philology, history of fine arts, science and technology. In 1979, commissioned by Beijing's Foreign Languages Press, I wrote the book, *The Wonder of Chinese Bronzes*, which was published the following year. Fortunately, publication was at the same time as exhibitions of ancient Chinese bronzes in various cities of the United States, and the book enjoyed a good sale. Professor Zhang Guangdao of Harvard University, U.S.A., recommends, in the fifth volume of *Early China*, that *The Wonder of Chinese Bronzes* is of benefit to scholars who are engaged in the study of bronzes, as well as lay readers who are interested in bronzes, and I would like to express my gratitude to him for his comment concerning my book. In 1987, Hong Kong's Commercial Press published the Chinese edition of this book.

In recent years China has made rapid progress in its archaeological work; hence, my book, *The Wonder of Chinese Bronzes*, needs much amending and revising. As a result, the Foreign Languages Press asked me to write a book to outline Chinese bronzes on the basis of my previous one. Supported and helped by the Press, I have compiled more illustrations and covered new archaeological research achievements. I hope my present book will provide readers with basic knowledge for the study of Chinese bronzes.

February, 1994
Li Xueqin
Institute of History,
Chinese Academy of Social Sciences

The Origin of Chinese Bronzes

OUR planet underwent aeons of geological evolution before it finally began to show, around 4000-3000 B.C., its first signs of civilization. Historical development in different parts of the world varied greatly: the more remote the age, the more limited the distribution of the first civilized regions. These were in the main concentrated along large rivers.

China is one of the few countries with an ancient civilization, which spread outward far and wide from the Huanghe (Yellow River) Basin, leaving behind a rich store of cultural relics. In the midst of these exists a huge range of bronzes of fine workmanship which gleam like a brilliant pearl among China's treasures.

These are the product of the skill and wisdom of the Chinese craftsmen of former ages. Their unfamiliar inscriptions are the forgotten records of experience of our ancestors. Ancient Chinese bronze is not only a widely-acclaimed work of art but is of important value to the understanding of the history, archaeology and development of science and technology of the world. The study of Chinese bronze usually spans an extensive period of time up to the end of the Han Dynasty, and is essential to the appreciation of China's ancient society and culture.

What is bronze?

One of the metals earliest known to and used by man was copper, which exists in the free metallic state in nature. It was probably this native copper that primitive man came across in his search for material to make implements, finding it different from other minerals in that it was more malleable and could be hammered into the shape of whatever tools he needed. He discovered, too, that copper could also be melted under high temperature and cast into articles of various forms. Later, ancient man invented the method of smelting copper from its ores, thus enriching the source of copper. This was the earliest metallurgy. But the metal then used was, except for a few impurities, pure copper—light red in colour, supple and rather difficult to handle. It is not yet the bronze that we are concerned with here.

With his long experience in smelting copper, man gradually learned that its melting point could be reduced and its hardness raised by adding to it a fixed proportion of tin, thereby yielding better results in casting. This alloy of copper and tin is, in modern terms, called tin-bronze —the substance which researchers of ancient Chinese bronze ware refer to as bronze. This alloy was an important invention of the ancients. Some have said that primitive man could cast bronze directly from copper ores without going through the stage of using copper. Such a claim does not conform to the law of technological history and, therefore, cannot stand.

The appearance of bronze was an epoch-making event in the ancient history of China and other countries. In extensive areas it replaced stone implements which had been the principal tools of production of earliest man. This substitution raised the productive forces, thus accelerating the formation and development of human civilization. China and a few other countries with an ancient civilization all underwent a protracted period when bronze was chiefly used to make tools and utensils. In archaeology, this is called the Bronze Age, an important historical age between the Stone and Iron ages.

Many ancient countries and nations have distinct recollections of their own Bronze Age as recorded in their historical annals or epics. China, too, has a considerable number of books recording the making of implements out of bronze in remote antiquity.

One of China's ancient books, *Yue Jue Shu* (*Lost History of the State of Yue*), contains an article entitled "Precious Swords," which tells us about the Prince of Chu of the 5th century B.C. making iron swords of the greatest value. His minister, Feng Huzi, recounted to him the history of the development of weapons and implements since ancient times. He explained that in the time of the legendary emperors Xuan Yuan, Shen Nong and He Xu, stone was used to cut down trees and construct palaces and houses; under the rule of Emperor Huang Di (or the Yellow Emperor), jade (considered to be fine stone) was utilized to cut wood, build houses and dig earth; in the reign of Yu of the Xia Dynasty, bronze was used to dredge and harness rivers and develop irrigation; finally, around the 5th century B.C., armies were overawed by weapons made of iron. The description of the changes from stone to bronze and then to iron complies with the historical process of development of implements fashioned from these materials. This concept of three

continuous stages as described by Feng Huzi in *Yue Jue Shu* emerged more than two thousand years earlier than that of European archaeology.

Feng Huzi's account reveals that bronze ware may have appeared in fairly large quantities in the Xia Dynasty. Other instances of making articles with bronze before the Xia are mentioned in a few ancient Chinese books such as *Shi Ben* (*Family Origins of Celebrities*), a work of the late Warring States Period, and a Han Dynasty book of annotations to Confucian classics, which describe Chi You, minister to Emperor Shen Nong, making five kinds of bronze weapons with which the reign spread its power and influence; and *Shi Ji* (*Records of the Historian*), in which the Chapter on Imperial Sacrifices to Heaven gives a rendering of how Tai Di (Tai Hao) made a divine cauldron, or *ding*,[1] and how Huang Di, too, had collected copper from Shoushan Mountain to make a number of *ding* at the foot of Jingshan Mountain in Hubei Province. However, these are only stories that were spread by necromancers and cannot be relied upon for historical research.

Some credence may be given to the legends about the making of the nine bronze *ding* of the Xia Dynasty. It was said that these came into the possession of the Shang royal house after the fall of the Xia. At the end of the Shang 600 years later, they were taken over by the Zhou royal house. The "nine *ding*" were a symbol of central authority of ancient China. Whoever possessed them would have supreme power over the nation. According to *Zuo Zhuan* (*Annals of Zuo Qiuming*), in the Spring and Autumn Period Prince Zhuang of the then very powerful State of Chu harboured the ambitious design to seize power from the Zhou king. Once, on approaching Zhou territory during a northern military expedition against the Lu Hun tribe, he purposely inquired of the Zhou people about the weight of the "nine *ding*." In reply, a Zhou official by the name of Wangsun Man related their origin as outlined above.

The chapter entitled "The Hereditary Princely House of Chu" in *Records of the Historian* describes the *ding* as possibly consisting of three hollow-legged round ones and six square ones. As to when they were made, some books state that it was in the reign of Yu of the Xia Dynasty. However, in *The Book of Mo Zi*, we are told that King Qi of the Xia ordered Fei Lian to procure copper ore from the mountains and rivers and make nine *ding* at Kunwu (now Puyang, Henan Province). Qi was the son of Yu, the second king of the Xia. Whether it was Yu or Qi, it is said that the nine *ding* were made in the early years of the Xia, that is, around the 21st century B.C.

In Chinese archaeology, the earliest material evidence

of copper articles should be attributed to a sword discovered in 1975 at Dongxianglinjia, Gansu Province. This sword, cast in a mould, was verified as being made of bronze. It was found at a site of Majiayao type, whose stratum was determined by C_{14} tests to be dating back to three millennia B.C.

In 1973, a semicircular piece of copper was found in the ruins of a house at a site of the Yangshao Culture at Jiangzhai in Lintong, Shaanxi Province. C_{14} tests revealed that the house dated back to 6,700 years ago and the piece was brass, or zinc-containing acid bronze alloy. Again at the same site in 1974, a tubular object rolled out of pieces of brass was found. It is possible that brass existed in the Yangshao Culture period, for experiments conducted by certain scholars in recent years have proved that brass could be obtained directly from the copper-zinc ore by primitive smelting methods. The piece of copper found in Jiangzhai was cast in a single mould, although specialists still cannot tell for what purpose it was used.[2] Copper articles of the Neolithic Culture, which was predated by Majiayao type, had also been discovered. Two copper pendants (Fig. 1), for example, were discovered in 1955 at Dachengshan in Tangshan City, Hebei Province, at a site of the Longshan Culture. The two are much alike —plain, without decorative design. They each have a hole near the top probably for threading a string through, so that they could be worn as ornaments. Both were unearthed close to the opening of a pit pertaining to the stratum of the Longshan Culture of 4,000 years ago. After their discovery, some scholars raised doubts about their dating, in the belief that they might have belonged to the stratum of a later culture, but had been accidentally mixed into the pit of the Longshan Culture. However, we now know that the stratum covering the pit at Dachengshan belonged to the Xiajiadian Culture, and that the articles of this culture, as found in various places, could only be bronze. After scientific examination, the two pendants were proved to be of copper; they could not possibly have come from the stratum above the pit. So we can safely say that these copper pendants belonged to the Longshan Culture. In recent years, traces of copper smelting have been found in certain sites of the Longshan Culture in Henan Province.

The book *Xi Qing Gu Jian* (*Xi Qing Collection of Ancient Bronzes*), compiled during the reign of Emperor Qianlong of the Qing Dynasty, has mention of a copper *gui*[3] (wine container), whose shape closely resembled Longshan earthenware *gui*. Similar earthenware *gui* existed in the Dawenkou Culture, which was still earlier than the Longshan Culture. From this, we can assume that fairly large copper articles were made during the Longshan

Fig. 1 Copper pendants discovered in 1955 at Dachengshan, Tangshan, Hebei Province.

Culture. Unfortunately, the whereabouts of the copper *gui* described in *Xi Qing Gu Jian* which was originally concealed in the Qing imperial palace is no longer known, so that it is impossible to conduct further research on it.

Corresponding roughly to the Longshan Culture both in time and structure is the Qijia Culture which was scattered over Gansu Province. Relatively small metal articles were found in its tombs. Most of them were tools —knife, awl and drill—which the person buried had used during his life, and ornaments, such as rings (Fig. 2). Tests show that Qijia objects were not all copper; the tin content of some articles exceeded the proportion of natural impurities. It must have been bronze that was used. Technologically, some were forged, while others were cast in moulds.

It is worth noting that the handle of the Qijia knife, though only a fragment of it is left, shows that its shape was rather novel. On it is a strip of triangular patterns.

Similar designs were often seen on later bronzes. With the discovery of the above objects, the Qijia Culture can be regarded as a transitional stage from copper to bronze.

The unearthing of the articles and vessels of the Longshan and Qijia cultures tells us one important fact, namely, that Chinese bronze had its own origin and development.

When bronze metallurgy appeared in China, other ancient nations of the world also began producing bronzes. For a long time, some scholars were of the opinion that China's bronze technology had come from ancient civilized nations of West Asia. Others over the past few years have suggested that China's bronze culture originated from Siberia. Recently, a site of a comparatively early bronze culture was discovered in Thailand, giving rise to the surmise that China's bronze technology was imported from South Asia. None of these arguments is convincing. According to Chinese archaeological facts, the areas where bronze made its first appearance were centred in the Huanghe Basin. There had not yet been found any way of spreading bronze manufacturing technology between these areas and the remote regions of other ancient civilizations. Moreover, Chinese bronzes possess certain characteristics distinct from those of other ancient nations, which only prove that they emerged and developed independently.[4]

Positive results have been obtained by Chinese scholars in the last few years in the exploration of Xia Dynasty bronzes. In all probability, we shall not have to wait long before we have the answer to the origin of China's bronze technology.

As mentioned above, China's ancient literature contains references to the making of large bronze objects

Fig. 2 Small tools unearthed from the tombs of the Qijia Culture, Gansu Province.

during the Xia Dynasty. The forefathers of the Chinese, being thus led to believe in the existence of such bronzes, attempted to trace them. Books of the Song Dynasty on the subject of bronzes mention "articles of the Xia" which were believed to allude to Xia bronze ware. But the belt clasps and dagger-axes recorded in *Bronze Inscriptions of Different Dynasties* by Xue Shanggong were in fact items of the Warring States Period. Luo Zhenyu's compilation *An Anthology of the Bronze Inscriptions of the Three Dynasties*, contrary to its title, actually covers only two dynasties, the Shang and the Zhou, but not the Xia. So it remained a problem as to whether any bronzes could be found belonging to the Xia. The discovery of the bronzes of the Erlitou Culture supplied valuable material in solving this puzzle.

The Erlitou Culture is an archaeological culture whose existence was ascertained in the 1950s. It was distributed mainly along both banks of the middle reaches of the Huanghe and also in western Henan and southern Shanxi provinces, all of which were regions inhabited by the Xia people according to ancient records. A typical site of this culture was excavated at Erlitou, in Yanshi County, Henan—hence its name. It was a development of the Longshan Culture in Henan, and a number of bronzes had been unearthed there. Its radiocarbon dating corresponds to the interval between the Xia and early Shang. At the Dongxiafeng site of Xiaxian County in Shanxi, a number of bronzes and stone moulds were also discovered. According to ancient books, the location of the Erlitou site corresponds to the ruins of Di Ku and also Xibo, capital of the Shang established by Tang, the dynasty's first king, while the Dongxiafeng site is near Mingtiaogang, to which Jie, last king of the Xia, fled when he was defeated. The discovery of bronzes in these two places was, therefore, of great significance.

The Erlitou bronzes range widely from knives, awls, chisels, arrow-heads, fish-hooks, bells and other small articles to containers and weapons. The most common type of container encountered was the bronze *jue*[5] (a wine goblet). Four of these were found around Erlitou:

(i) (Fig. 3, (1)) unearthed in 1973; flat bottom with short legs, no pattern, height 12 cm.

(ii) unearthed in 1974; flat bottom with long legs, a pair of short capped pillars on the rim, no pattern.

(iii) unearthed in 1975; flat bottom with long legs, openwork on the handle, no pattern, height 13.3 cm.

(iv) (Pl. 1) unearthed in 1975; flat bottom with long legs, a pair of pillars, lip especially long and narrow, openwork on the handle, nipple design on the belly, height 22.5 cm.

All four *jue* have thin walls, but each is different in shape and design.

In the Tianjin Museum there is a *jue* similar to those of Erlitou (Fig. 3, (3) and Pl. 1). With a height of 19.7 cm, it has a flat base, from the rim of which extends a wall in the shape of an inverted bowl with openwork on it, supported by three short legs. The front part of the spout is like a fistula, while the rest is an open groove. Apart from the openwork handle, it has no decorative design. It is said to have been brought over from Shangqiu, the capital of the early Shang, in Henan.

On display in the Shanghai Museum is a bronze *jiao*[6] (wine goblet) (Fig. 3, (2) and Pl. 2), not quite intact, also with a flat base joined onto an openwork wall in the shape of an inverted bowl. A spout with two hooklike knurls protrudes from the belly, which is decorated with two rings of a nipple design. The height of the *jiao* as it stands is 20.6 cm. It closely resembles an earthenware one found at Erlitou and should belong to the same era.

The bronze weapons discovered at Erlitou include a *qi*,[7] or battle-axe, with a screen (Fig. 4, (2)) and a *ge*,[8] or dagger-axe, without one. A *ge* could either have a curved tang decorated with a whirligig (Fig. 4, (1)), or a straight tang with a pattern of horizontal lines like the teeth of a comb, made in imitation of a jade dagger-axe (Fig. 4, (3)). A bronze disc inlaid with turquoise was also found at Erlitou (Fig. 5).

An analysis of this group of bronzes draws some interesting inferences:

First, bronzes were widely used at the time of the Erlitou Culture. Tools for production and wine vessels, such as the *jue* and *jiao*, were made. Weapons, too, were made, and the appearance of arrow-heads in particular shows that the production of bronzes had reached a certain quantity, since arrow-heads could not be easily recovered once they were shot out.

Secondly, casting technique had improved greatly. The *jue* and *jiao* mentioned above are not large but their shapes are complicated; to make them with moulds required a relatively advanced technique. The bronze dagger-axe with its cloud design is of fine workmanship. The perforated inverted bowl around the lower part of the *jue* and *jiao* was an ingenious idea. It was designed to absorb heat more easily so that, apart from being used as goblets to drink wine out of, the *jue* and *jiao* could also be used to warm wine.

Thirdly, bronzes had become a work of art. The nipple and cloud designs, along with other complicated patterns, appeared. The technique of inlaying with turquoise appeared at the same time, which later became the traditional method of inlay on bronzes. The ancient Chinese were aware that the colour of turquoise brought

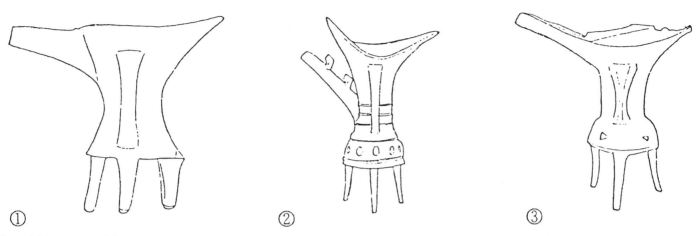

① ② ③

Fig. 3 (1) Bronze *jue* of the Erlitou Culture (unearthed in 1973).
(2) Bronze *jiao* in the Shanghai Museum.
(3) Bronze *jue* in the Tianjin Museum.

Fig. 5 Bronze disc inlaid with cross designs found at Erlitou.

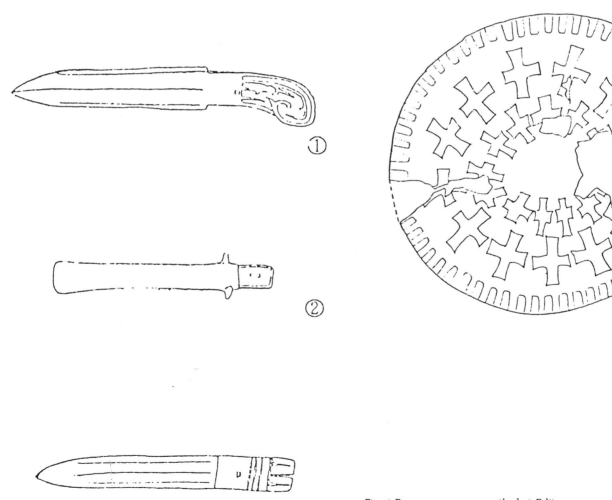

①

②

③

Fig. 4 Bronze weapons unearthed at Erlitou:
(1) *ge* dagger-axe with a curved tang
(2) *qi* battle-axe with a screen
(3) *ge* dagger-axe with a straight tang

2.
Su *jiao* (incomplete), wine goblet, Erlitou Culture, height
(from mouth to bottom) 20.6 cm.

out the brilliance of bronze. A fine example of this is the
disc with its cruciform design found at Erlitou—a true
masterpiece of ancient Chinese artistry.

To sum up, the Erlitou bronzes, as against the Qijia
bronzes with their rudimentary nature, show remarkable
progress in technique. We may expect more discoveries
traceable to the people of the Erlitou Culture to be made
of bronzes much larger and more complicated than the
jue and *jiao*.

Some museums in China and in other countries house
a number of bronzes of a very simple shape, such as the
plain bronze cup mentioned by the American professor,
Max Loehr.[9] Do articles of this kind belong to the same
time as those of Erlitou? Were there any of an even earlier
age? With the steady progress of archaeological work, we
believe that this question will be answered before long.
At present, we can at least say that, since the bronze age
of the Erlitou Culture corresponds to the Xia period, there
is good reason to believe that bronzes did indeed exist
during the Xia.

1.
Openwork *jue* with nipple design, wine goblet, Erlitou Culture, said to
have been unearthed at Shangqiu, Henan, height 19.7 cm.

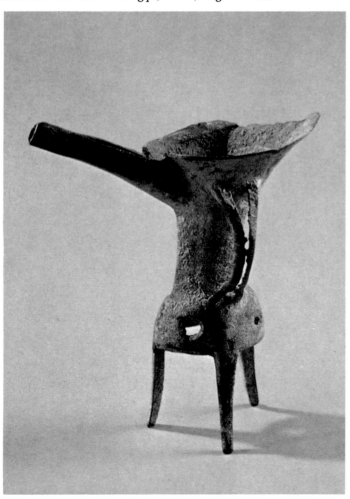

[1] 鼎

[2] For further information, c.f. Banpo Museum, Shaanxi Provincial
Institute of Archaeology and Lintong County Museum, *Jiangzhai*,
Cultural Relics Publishing House, 1988, pp. 544-548.

[3] 鬶

[4] For further information, c.f. Noel Barnard, *Radiocarbon Dates and
Their Significance in the Chinese Archaeological Scene*, 1979.

[5] 爵 [6] 角 [7] 戚 [8] 戈

[9] Max Loehr: *Ritual Vessels of Bronze Age China*, 1968, Pl. 1.

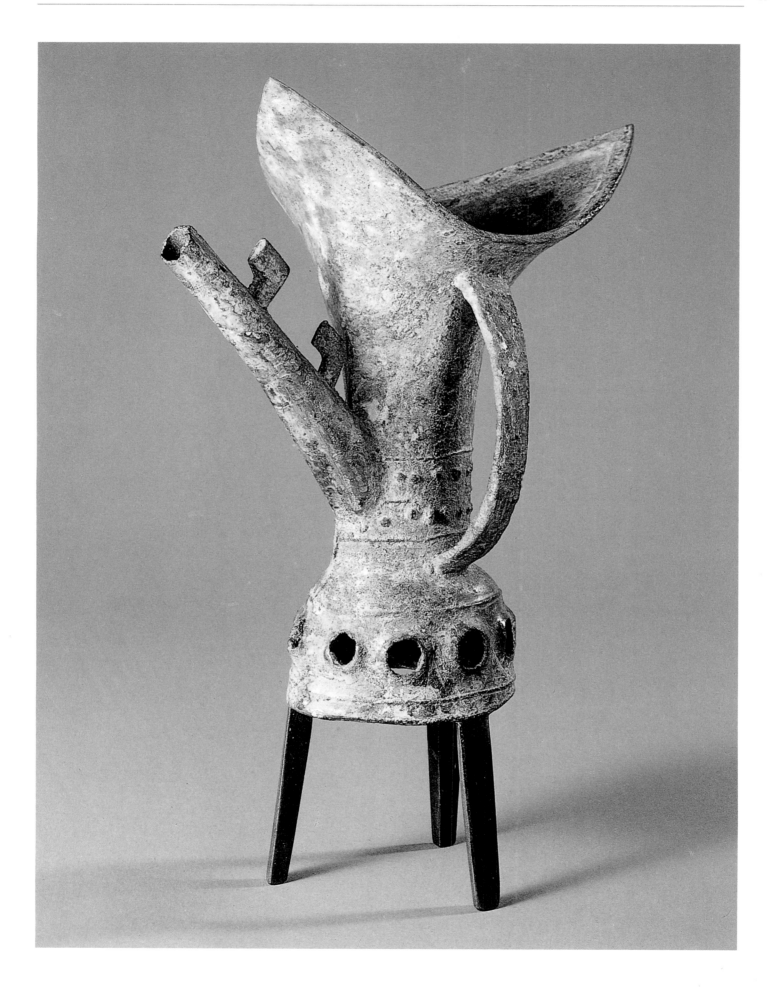

Classification of Bronzes

IF we take the period from the Xia Dynasty to the early Shang as the dawning of China's Bronze Age, then we can consider the middle and late Shang to be its peak. Not only did bronze metallurgy emerge at a remote date, but it also prevailed for a protracted length of time. Even during the Warring States Period and the Qin and Han dynasties, when iron articles were widely used, bronzes were still popular and their technique continued to develop.

Innumerable discoveries of ancient bronzes have been made. The inscribed bronzes dealt with in *The Xiao Jiao Jing Ge Rubbings of Bronze Inscriptions*[1] compiled by Liu Tizhi alone amount to more than 6,000 pieces. This figure represents the collections merely of one author. Since 1949, well over 1,000 pieces of bronzes with inscriptions unearthed in different parts of China have been made known. These are all pre-Qin articles, and do not include those of the Qin-Han era. A *Jin Wen Zhu Lu Jian Mu* (*A Brief Catalogue of Bronze Inscriptions*) by Sun Zhichu was published in 1981, in which 7,212 bronze articles are listed, all of the pre-Qin period.

Chinese bronzes are not only vast in number, but also in variety and utility, featuring ritual vessels, weapons, tools for production and articles for daily use. Their appellations are difficult to recognize and remember because the original ancient names of the bronzes are used, and these have already disappeared from the vocabulary of modern Chinese. Below are a few principles for the nomenclature of the chief bronze articles and a brief description of their uses.

According to archaeological convention, an article should, as far as possible, be ascribed the name engraved on it. This is known as "self-naming." For example, a cooking vessel with a deep belly and three or four legs is called *ding* because this name has been found in the inscriptions of many such containers. For some articles no names have yet been attributed to them in any inscriptions, but on the basis of their descriptions in ancient books, names may be decided. For example, a wine vessel with a wide flared mouth, long body and circular legs, often found together with a *jue* and coinciding with the description in ancient books for *gu*,[2] is given the name *gu*.

A few bronze items were named wrongly to begin with, and these errors remained unchanged for a long time. The most obvious example is the *gui*.[3] This name, originally correct, was found on a bronze inscription during the Northern Song Dynasty, but was wrongly deciphered as *dui*.[4] It was not till the late Qing Dynasty that it was finally corrected to *gui*. Up to now, a few bronzes still have no proper names. In these cases, their forms are generally taken for names, for instance, "pitcher-shaped" or "vase-shaped."

Chinese bronzes are in the main divided into ten categories according to their uses: ritual vessels (including cooking vessels, food containers, wine vessels and water vessels), musical instruments, chariots and harnesses, weapons, tools, weights and measures, and miscellaneous articles.

RITUAL VESSELS Ritual vessels were used in complex ancient ceremonies. Some were exhibited in temples and ancestral halls, some were used at feasts for drinking or for ceremonial ablutions, while others were specifically made as burial objects. However, the ancients normally used lacquerware, earthenware or wooden receptacles for eating and drinking and very rarely used weighty bronzes, as these were regarded as sacred vessels, not to be used on ordinary occasions.

The first group of ritual vessels are cooking vessels —*ding*, *li*[5] and *yan*[6] (Fig. 6).

The *ding* is one of the most important types of bronzeware used for cooking meat. It may be three-legged and round (Pl. 3) or four-legged and rectangular (Pls. 4-6); it may or may not have a lid. The lidless type has two handles standing on the belly called "upright ears," (Pl. 7) while the type with a lid has handles jutting out from the belly called "side ears."

The size of *ding* varies from very small to extremely large. The Ying Lin De *ding* is about 10 cm tall and its inscription refers to it as a "tiny *ding*." The lid of a rectangular *ding* unearthed from the Yin ruins in 1975 measures only 6.3 cm lengthwise. Its inscription reads: "Made by order of the king for the girl to play," which indicates that it was probably a toy the King of Shang gave to a young girl. The largest *ding* so far discovered is the Hou Mu Wu rectangular *ding* (Pl. 8) unearthed in

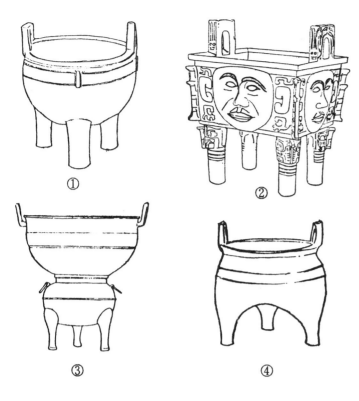

Fig. 6 Cooking vessels:
(1) round *ding*
(2) rectangular *ding*
(3) *yan*
(4) *li*

are in the set. In some books on ancient rituals, it is said that the Son of Heaven used 12 *ding*; in others, he is reported to have used nine. The inscription on the Han Huang Fu *ding* unearthed in 1933 at Kangjia Village in Fufeng, Shaanxi Province, states the number as being 11. It appears that the Zhou king possessed 12 *ding* and this figure decreased with each duke under him. A total of nine *ding* was discovered in a tomb of the State of Guo at Shangcunling in Sanmenxia, Henan, and the same amount in the tomb of the Marquis of Cai in Shouxian County, Anhui Province. From this, we can infer that the Zhou king must have had more than nine *ding* to his name, even though legend has it that the Xia king possessed only nine.

The *li* is another kind of cooking vessel characterized by its pouchlike hollow legs (Pls. 9-10). It is described in *Er Ya* (*Literary Expositor*) as "a *ding* with hollow legs." Liquids can flow to the legs and thus be heated more rapidly. *Li* are generally round; a few are rectangular. Some have ears, but most have none. As a cooking vessel, the *li* belongs to the category of *ding*. Those with ears of

3.

Ding with *taotie* (ogre-mask) motif, cooking vessel, late Shang Dynasty, excavated at Dayangzhou, Xingan, Jiangxi, height 70.2 cm.

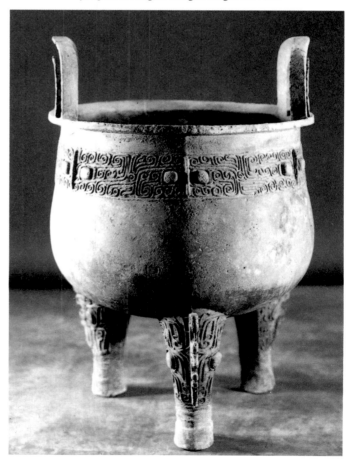

1939 from the Wu Family's Cypress Graveyard at Wuguancun, also part of the Yin ruins. It is 133 cm tall, 110 cm long and weighs 875 kg, and is of the most superb workmanship. It is the largest ancient bronze in the world to date. An Ox rectangular *ding* and a Deer rectangular *ding* were excavated from a large tomb at Xibeigang in Houjiazhuang, once again part of the Yin ruins. Their size is half of the Hou Mu Wu rectangular *ding* but large enough to cook an ox or a deer. *Zhu Shu Ji Nian* (*Annals on Bamboo Strips*) states that Duke Ai of the State of Qi was boiled in a *ding* in the third year of the reign of the Zhou Dynasty king Yi. This reveals that it must have been quite a large *ding* to be used as a means of execution.

Inscriptions engraved on *ding* were sometimes very long. The Mao Gong *ding* of the late Western Zhou, which was unearthed at Zhouyuan in Qishan, Shaanxi Province, and which is now kept in Taiwan, has an inscription of 497 characters, the longest on a single bronze item. However, this does not necessarily imply that a large *ding* always has a long inscription. In fact, some of the larger ones bear no inscription at all.

Often, a series of *ding* of varying sizes can denote the rank of the owner, depending on how many pieces there

4.
Fu Ji rectangular *ding*, cooking vessel, late Shang Dynasty, unearthed at the Yin ruins of Anyang, Henan, height 21.7 cm.

5.
Tai Bao rectangular *ding*, cooking vessel, early Western Zhou Dynasty, unearthed at Liangshan, Shandong, height 57.8 cm.

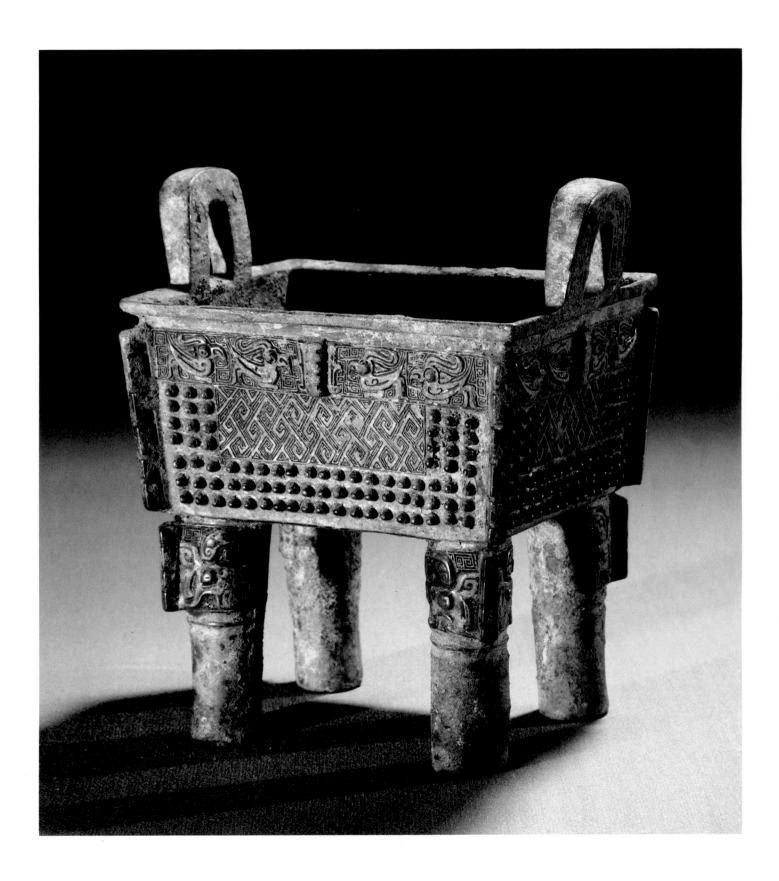

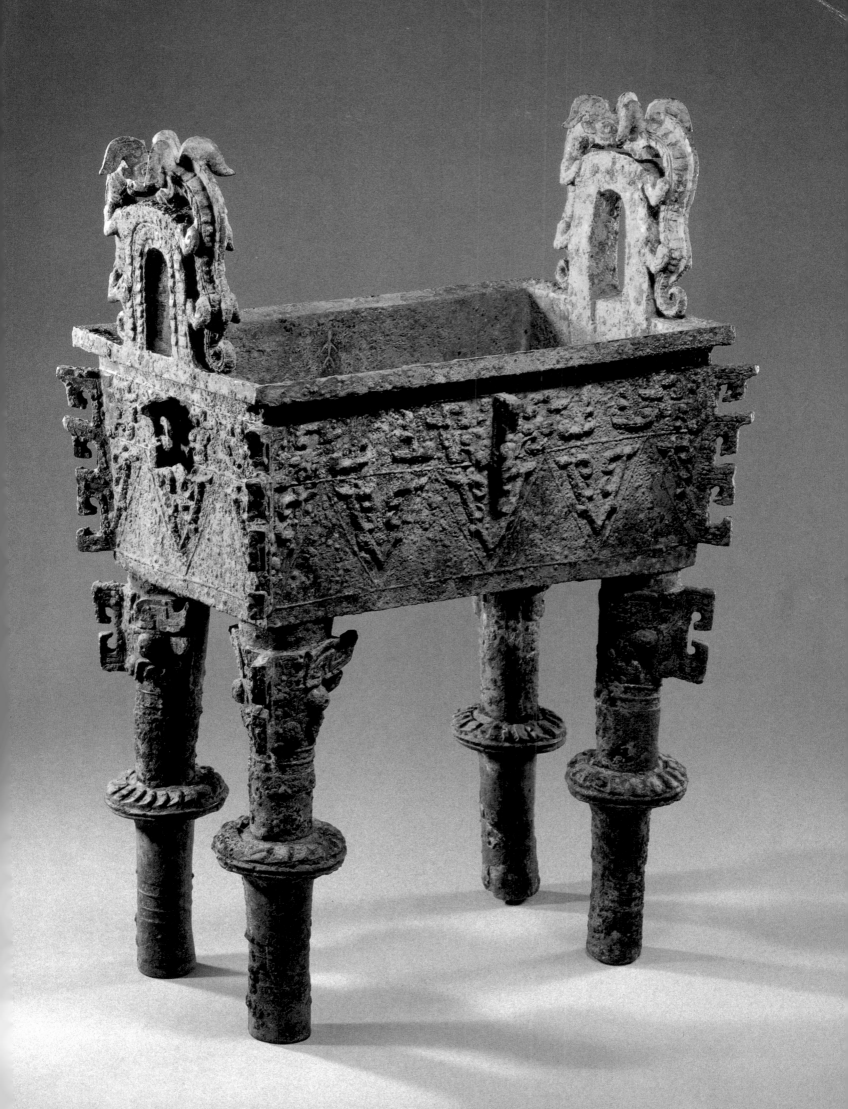

7.
Five-eared *ding* with dragon design, cooking vessel, early Western Zhou Dynasty, unearthed at Shijiayuan, Chunhua, Shaanxi, height 122 cm.

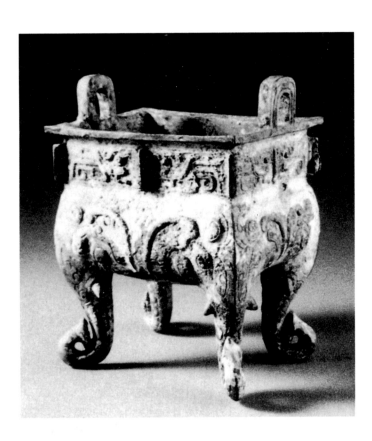

6.
Xiang Shou Zhu rectangular *ding*, cooking vessel, early Western Zhou Dynasty, unearthed at Liutaizi, Jiyang, Shandong, height 20.4 cm.

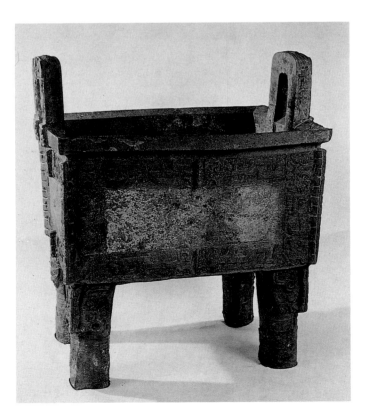

8.
Hou Mu Wu rectangular *ding*, cooking vessel, late Shang Dynasty, unearthed from Wu Family's Cypress Graveyard in Anyang, Henan, height 133 cm.

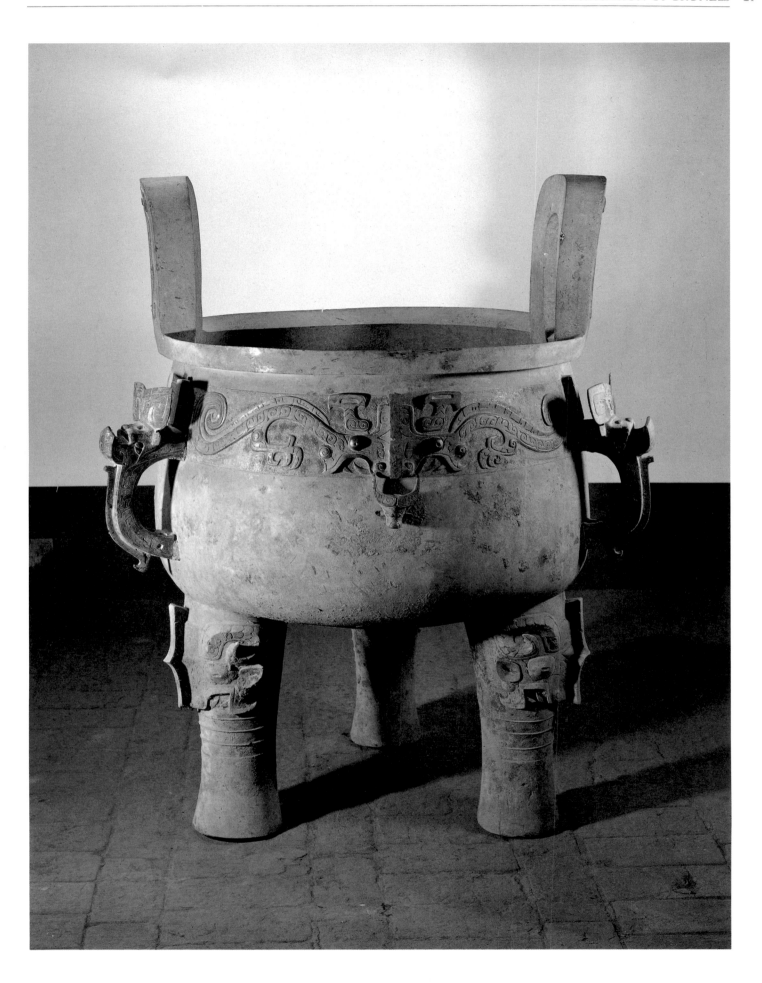

10.

Three-ram *li*, cooking vessel, late Shang Dynasty, unearthed at Zhengji, Hunan, height 22.8 cm.

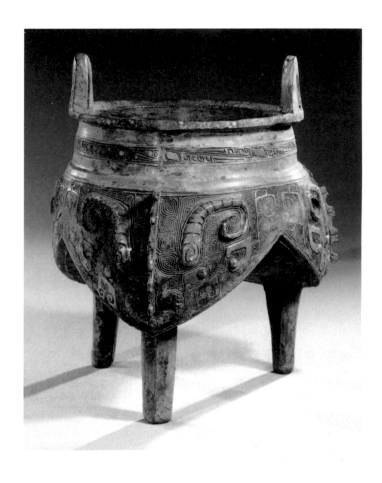

9.

Li with interlinking-bead design, cooking vessel, late Shang Dynasty, unearthed at Dayangzhou, Xingan, Jiangxi, height 39 cm.

the middle period of the Western Zhou Dynasty are self-named *zi ding*.

Ding and *li* often come with spoons (Pl. 11). The spoon has a long handle and a sharp tip, and is used for picking meat out of the cooking vessel.

The *yan* is a steamer. It has pouchlike legs which can be filled with water like a *li*. Its upper part is like that of a *ding*. A rack is affixed to the base of this section so that it can hold the food to be steamed. *Yan* are generally round and stand on three legs; a few are rectangular. The Palace Museum in Beijing keeps a rectangular *yan* decorated with four coiled snakes with raised heads, one on each of the four legs (Fig. 7).

The inscriptions on *yan* are not usually long. According to a book on bronzes of the Song Dynasty, however, a very lengthy inscription of great import was engraved on a *yan* excavated in Xiaogan, Hubei Province, but it was unfortunately lost long ago.

Knives and chopping blocks are often included with cooking vessels. Many bronze kitchen knives have been found, such as the elaborately decorated Shang bronze knife unearthed at Liulige in Huixian County, Henan Province. The bronze chopping block discovered so far

11.
Spoon (incomplete) with fish design, early Warring States Period, allegedly excavated in Shanxi, length 18.87 cm.

is designed with cicadas, according to the book *A General Survey of Shang and Zhou Bronzes* by Rong Geng. On the whole, most chopping blocks at that time were made of wood.

Food containers include *gui*, *xu*,[7] *fu*,[8] *dui* and *dou*[9] (Fig. 8).

The *gui* is the most common food vessel. It is a container for grain and other foodstuffs. Some have lids (Pls. 12-13) and two, three (very rare) or four ears (Pl. 14); others have none. The *gui* of the Zhou Dynasty has a circular base raised on a square stand (Pl. 15) to suit the ancient practice of sitting on the floor when eating. For the same purpose some *gui* have four ears which extend downwards to form legs, thus raising the vessel. The name *gui* has been retained to the present day in the Guangdong dialect. For instance, eight dishes served at a banquet are called "eight *gui*."

Gui can be large in size. The Hu *gui* (Pl. 16) discovered in 1978 at Qicun Village in Fufeng County, Shaanxi Province, is the largest known to us. It is 59 cm tall and weighs 60 kg. It was made by order of Hu, otherwise known as King Li of the Zhou Dynasty, in the 12th year of his reign. *Gui* usually bear lengthy inscriptions. Those

with lids have exactly the same inscription on the lid as the main part of the vessel. These are termed "parallel inscriptions" (other kinds of vessels may also have parallel inscriptions). Occasionally, when an inscription is too long, it may be engraved on two similar vessels, such as the one engraved on the Diao Sheng *gui*, and this is referred to as "continuous inscription."

The large majority of *gui* are round; rectangular ones are rare. During the later period of the Western Zhou, there appeared the *xu*, a rectangular round-cornered vessel with a lid. It had the same utility as a *gui* and is actually a variant of the latter; in some cases, *xu* are even called *gui* or *xu gui*. *Xu* existed for only a short stretch and ceased to be used by the middle of the Spring and Autumn Period.

The *fu*, a rectangular food container, also used for storing grain, has a lid similar in shape to its main body (Pl. 17). It was widely used during the late Western Zhou. It was thought that there had been no *fu* prior to that time. But the large *fu* with its vertical-line design kept in the Palace Museum is undoubtedly a relic of the early Western Zhou. Long before then, the *fu* had been made of bamboo; gradually this changed to bronze. *Fu* and *xu* appeared at different times but both became widespread during the late Western Zhou, and *fu* continued to exist even during the late Warring States Period.

After the middle Spring and Autumn Period, the *dui* gradually came into use. The *dui* of that time was round with a lid, just like the one belonging to the Marquis of Qi, which was unearthed in Yixian County, Hebei Province. In the Warring States Period it developed into an oval form, the lid being the same shape as the body, and it was popularly termed "watermelon *ding*." Recently, a

Fig. 7 Rectangular *yan* with a four coiled snakes design in the Palace Museum.

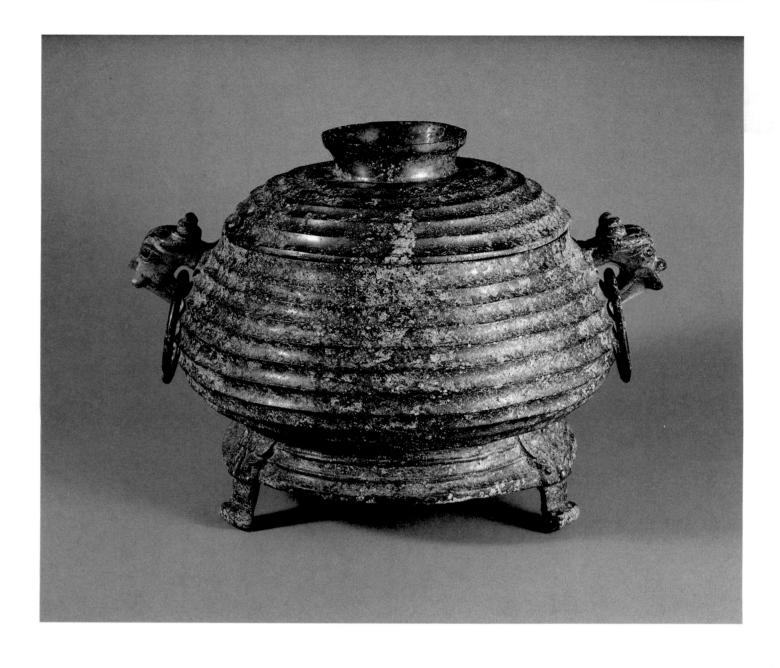

12.
Gui with tile design, food container, middle Western Zhou Dynasty.

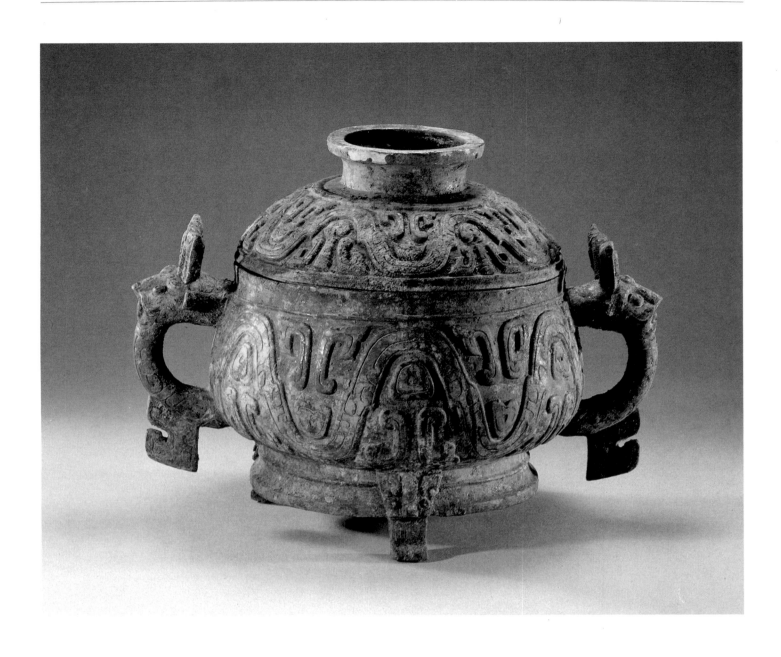

13.
Yu *gui*, food vessel, late Western Zhou Dynasty, unearthed at Pingding-
shan, Henan, height 26.5 cm.

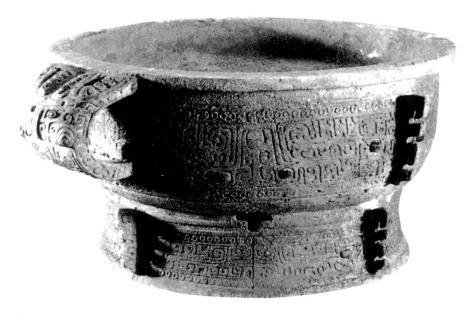

14.
Jia Fu *gui* with ogre-mask motif, food vessel, late Shang Dynasty, unearthed at Dayangzhou, Xingan, Jiangxi, height 17.5 cm.

15.
Tian Wang *gui*, food vessel, early Western Zhou Dynasty, reportedly unearthed at Qishan, Shaanxi, height 24.2 cm.

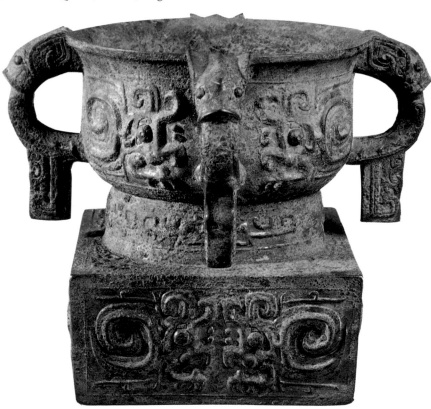

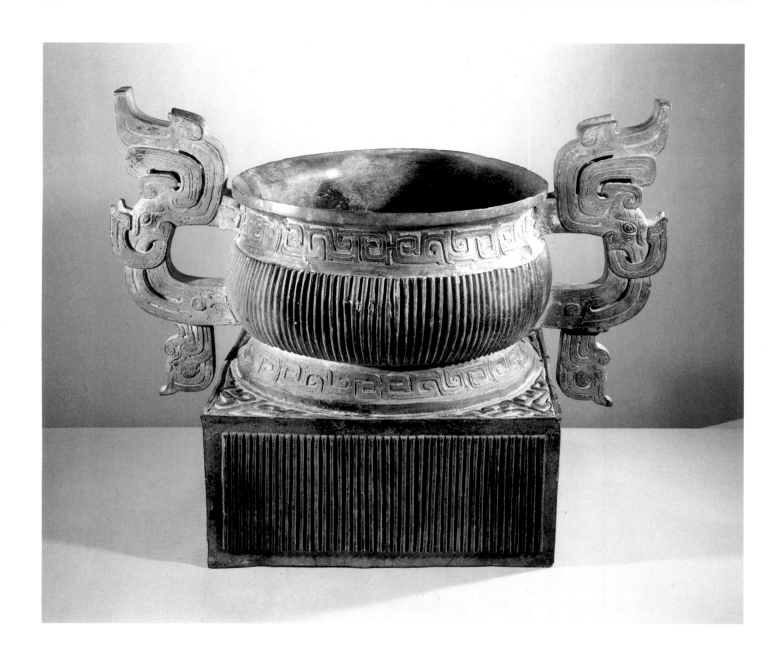

16.
Hu *gui*, food vessel, late Western Zhou Dynasty, unearthed at Qicun,
Fufeng, Shaanxi, height 59 cm.

17.
Elephant-head *fu* with animal design, food vessel, early Spring and Autumn Period, unearthed at Xiaowangzhuang, Feicheng, Shandong, length 26.7 cm.

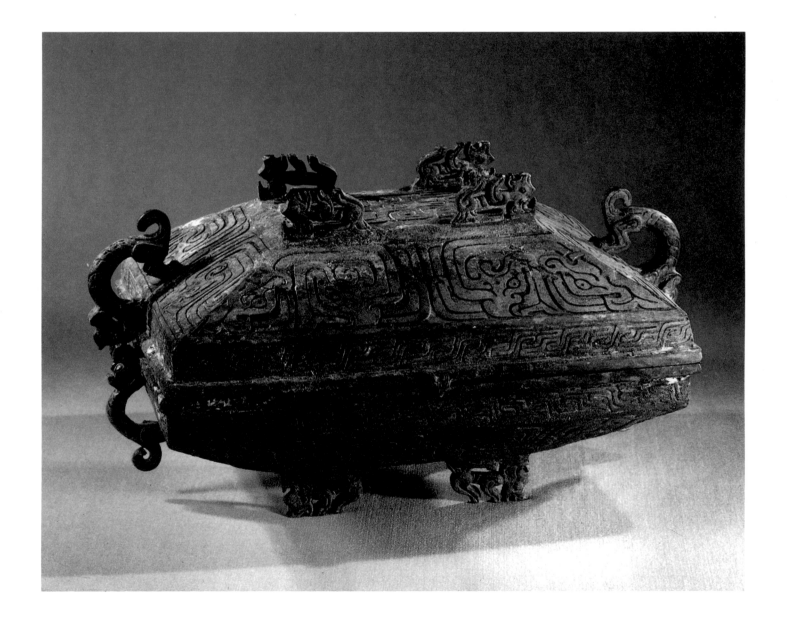

18.
Copper-inlaid *dou* with hunting motif, food vessel, early Warring States
Period, unearthed at Liyu, Hunyuan, Shanxi, height 20.7 cm.

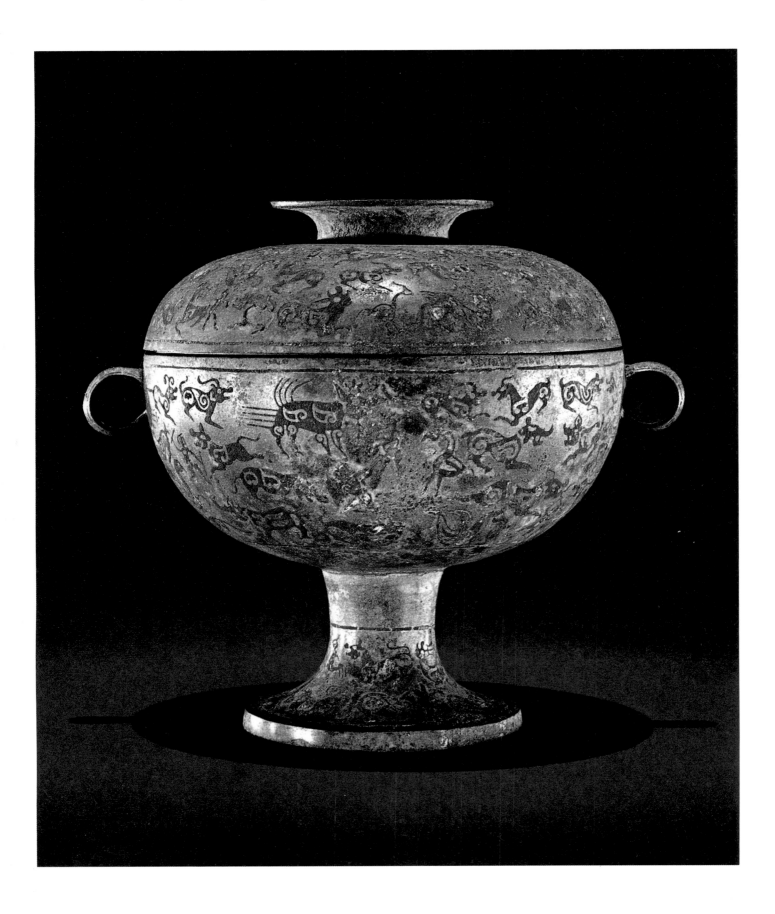

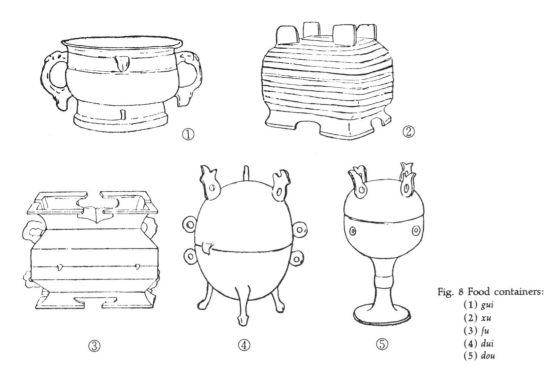

Fig. 8 Food containers:
(1) *gui*
(2) *xu*
(3) *fu*
(4) *dui*
(5) *dou*

group of bronzes like one half of a watermelon *ding* were found in a large tomb dating back to the early Warring States at Leigudun in Suixian County, Hubei Province. They are taken to be a variety of *dui*.

Dou, another kind of food vessel (Pl. 18), have deep bellies and are mostly fitted with a lid. Some are like shallow bowls. Ancient books say they were used for keeping minced meat. During the Warring States, a rectangular *dou* was called a *qi*[10] according to writings on bamboo strips found at Changtaiguan in Xinyang, Henan. The compressed version of the *dou* was called *pu*[11], or possibly *bian*,[12] as recorded in certain ancient documents. It was used to keep preserved fruit or meat.

Bronze wine vessels are of various kinds. A chapter in *Shang Shu (Book of Historical Documents)* relates the drinking customs of the people of Shang. Diverse wine vessels used as burial objects were found in the tombs of the Shang. Lately, a Shang distillery site was discovered at Taixi Village in Gaocheng County, Hebei. The wine vessels are of all shapes. However, variety was reduced when rulers of the early Zhou period restricted drinking.

The simplest set of Shang bronze wine goblets consists of a *jue* and a *gu* (Fig. 9). The *jue* is named after its shape—a sparrow, or *que*.[13] The ancient character *jue* had the same pronunciation as *que* and these two names were used interchangeably. It has a spout at the front like a beak, a tail at the back, and slender legs below the belly. Most *jue* have two small pillars and three legs; a few have one pillar or none (Pl. 19). There are also a

number of four-legged rectangular *jue*. *Jue* with lids are rare.

The *gu* has a simple shape. At first, it was rather dumpy and only later became long and slender. Rectangular *gu* are rare.

Jue and *gu* disappeared after the early Western Zhou. The bronze *jue* unearthed in 1976 at Zhuangbai in Fufeng, Shaanxi Province, dating from the middle to late Western Zhou was an exception. The owner's family were descendants of the Shang people and also official historians. It was perhaps for this reason that the family kept the style of the old *jue*.

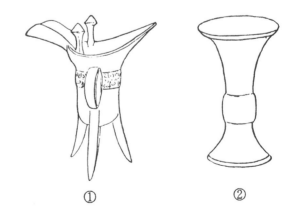

Fig. 9 Wine goblets:
(1) *jue*
(2) *gu*

the inner wall of its circular feet.

At the end of the Shang and the beginning of the Zhou, the *zhi*[15] (Fig. 10, (4)), another kind of goblet, replaced the *gu* in some places and joined the *jue* to form a set. It may come with or without a lid. The later ones, such as the three *zhi* of the State of Xu of the late Spring and Autumn Period, unearthed in the late Qing Dynasty in Gaoan, Jiangxi, have no lids.

Another drinking vessel called the *gong*[16] (Fig. 10, (3)) emerged at the same time as the *zhi*. It has a lid, a spout at the front and a handle at the back, and a square stand or four legs at the base. It is elaborately decorated, mostly with lively animal designs. It was considered a precious article at the time, especially the type with four legs, such as the Hou Mu Xin *gong*[17] unearthed from a tomb of the Yin ruins. Of primitive simplicity, yet unique in form, its whole body is cast into the shape of an animal in a

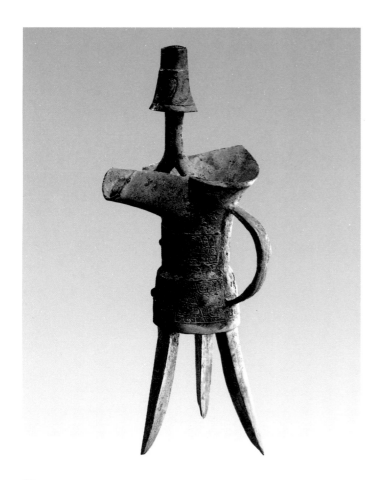

19.
Jue with ogre-mask motif and single pillar, wine goblet, late Shang Dynasty, unearthed at Guanyi, Feixi, Anhui, height 39.8 cm.

Jue, jiao and *jia*,[14] all used as goblets (Fig. 10, (1) and (2)), should be clearly distinguished from one another. The *jiao* has no pillar, and the spout and tail are both of the same shape, like triangular tips. The belly of the *jiao* is as large as the *jue*'s, while that of the *jia* is much bigger. In addition, the *jia* has two pillars, but has neither a spout nor a tail. It bears slighter resemblance to a *jue* than a *jiao*. Occasionally, *jue* and *jia* have lids.

Inscriptions are found mostly on the handles of these goblets, sometimes on the pillars. Lengthy inscriptions are engraved on the bellies. Some of these vessels are quite large, such as the Fu Hao *jia*, rectangular in shape, 68.8 cm tall, unearthed in 1976 from a tomb of the Yin ruins in Anyang, Henan. A particularly wide pillar cap of a *jia* with a diameter of nearly 8 cm was found at Taixi in Gaocheng, Hebei Province, from which we may surmise that the bronze *jia* to which it belonged was at least a metre tall. Such a heavy bronze could not have been used for drinking; perhaps it was intended only as an exhibition piece in an ancestral temple. The inscription on a *gu* is also simple, and is generally to be found on

Fig. 10 Wine goblets, (1), (2) and (4); drinking vessels, (3): (a) *jiao* (b) *jia* (c) *gong* (d) *zhi*

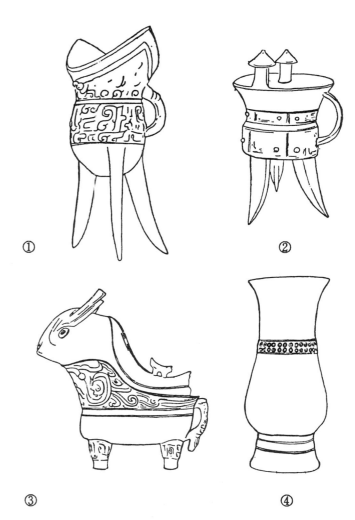

standing position. But the most splendid *gong* is the one kept in the Freer Gallery in Washington in the United States.[18] As described by Rong Geng in his *A General Survey of Shang and Zhou Bronzes*, "It has an ox head both at the front and the back of the lid, its body is decorated with *kui* dragons, vultures, owls, fish and birds; of the four legs, the two front ones are shaped as birds' claws and the two hind ones as human heads." It is a most exquisite and imaginative work of art.

Bronze *bei*[19] and *zun*[20] (drinking cups) appeared rather late, around the middle of the Warring States, and became popular in the Han Dynasty. The *zun* was also used to warm wine.

Wine containers include *zun*,[21] *you*,[22] *fang yi*,[23] *bu*,[24] *lei*,[25] and *hu*.[26] *Zun* and *you* (Fig. 11, (1) and (2)) were used together as early as the middle Shang. *Fang yi* (Fig. 11, (3)) appeared somewhat later and were also used together with *zun*. They existed for a long time until as late as the early Spring and Autumn Period (Pl. 21). *You*, which generally have loop handles and are dumpy or long and slender, became obsolete by the middle Western Zhou. *Zun*, normally round or square in shape (Pl. 20), disappeared from the Huanghe valley rather early too, but continued to exist south of the Changjiang (Yangtze River) down to the Warring States (Pls. 22-23).

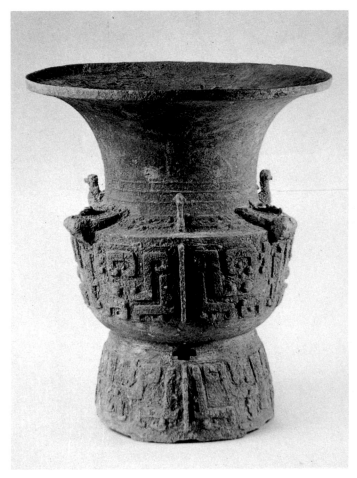

20.
Zun with three-bird and three-ox pattern, wine container, late Shang Dynasty, unearthed at Bagutai, Jiangling, Hubei, height 46.2 cm.

① ② ③

Fig. 11 Wine containers:
(1) *zun*
(2) *you*
(3) *fang yi*

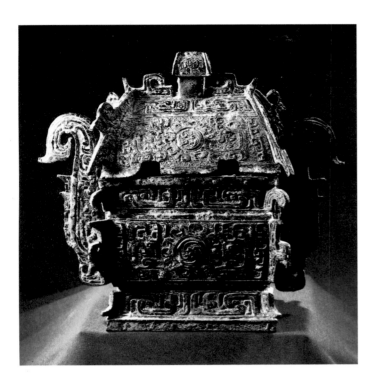

21.
Li *fang yi*, wine vessel, middle Western Zhou Dynasty, unearthed at Licun, Meixian, Shaanxi, height 18 cm.

22.
Zun with dragon-shaped ears, wine container, middle or late Spring and Autumn Period, unearthed at Nanling, Anhui, height 33.2 cm.

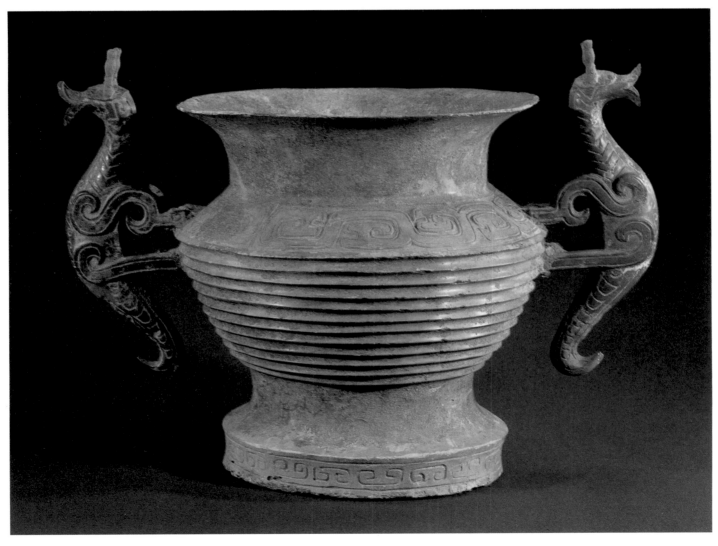

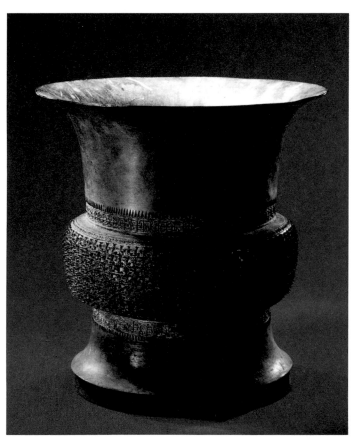

23.
Zun with coiled dragon design, wine container, late Spring and Autumn Period, unearthed at Yancheng, Wujin, Jiangsu, height 24.1 cm.

24.
Fu Hao paired *fang yi*, wine vessel, late Shang Dynasty, unearthed at Xiaotun, Anyang, Henan, height 60 cm.

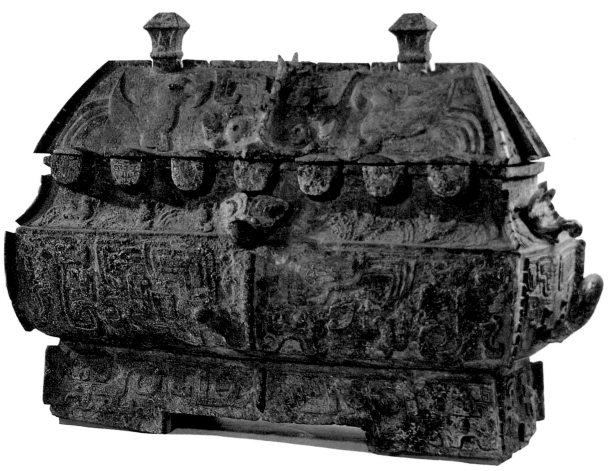

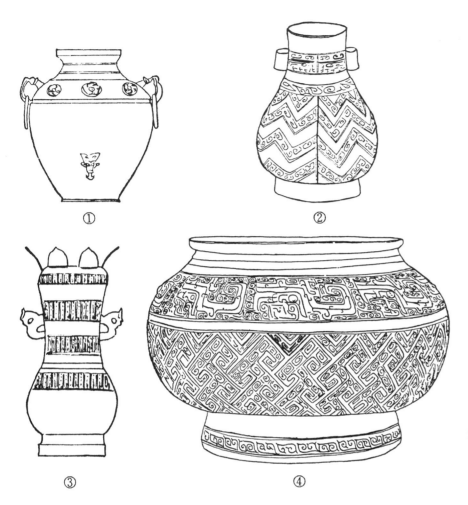

Fig. 12 Wine containers:
(1) *lei*
(2) thread-ear *hu*
(3) *hu*
(4) *bu*

Sets of *zun* and *you* or *zun* and *fang yi* were regarded as "respectable" wine vessels of ancient times. (The meaning "respect" of the character *zun* had its origin here.) They often bear long inscriptions, many of which, especially those dating from the early Western Zhou, are of great historical significance.

The lid of a *fang yi* is cast in the form of the roof of an ancient building. A large bronze one, unearthed from a tomb in the Yin ruins, is moulded in the shape of two *fang yi* joined together. Its lid shows distinctly the rafter framework of a roof. It is said that in the late Qing Dynasty a collector discovered a bronze which looked like a house with inscriptions on it, possibly similar to the "paired *fang yi*" (Pl. 24) described above. But this relic has been lost and no modern archaeologist has ever seen it.

Both *bu* and *lei* (Fig. 12, (4) and (1)) are like urns. Usually the *bu* is rather dumpy and the *lei* rather tall and slender (some with a nose in the lower part of the belly), but sometimes they are not easily distinguishable from each other. They were mixed with each other when a store of bronzes dating back to the early Zhou was discovered at Beidong in Kazuo, Liaoning Province. Long inscriptions on them are rarely seen. Another type of bronze ware which bears great resemblance to them both is the *fou*.[27]

The *hu* (Fig. 12, (3)) can be of three shapes: round (Pl. 25), rectangular or compressed. One with ring handles or tubular ears through which a cord can be threaded for carrying is called a "thread-ear *hu*" (Fig. 12, (2)). A round *hu* with a big belly dating after the Warring States is self-named *zhong*[28] according to its inscription. In the Han Dynasty, the rectangular *hu* was called *fang*,[29] and the compressed one was called *pi* beginning in the Warring States Period.

Some wine containers have a ladle attached to scoop up the wine. The ladle has a long handle leading to its bowl (Pl. 26). In 1976, a pair of ladles with the same inscription was found at Yuntang in Fufeng County, Shaanxi. The inscription reads: "This bronze *jue* was made by Bo Gong Fu."[30] Here, the word *jue* (which we met before when discussing wine goblets) refers to a ladle, or *shao*; the Chinese characters for both of these were originally similar in pronunciation.

In ancient China, many wine vessels were wrought into the shape of mythical birds and beasts, such as an owl, an ox, a rhinoceros, an elephant, etc. Such vessels are also called *zun*. *You* are often moulded in the shape of various creatures, such as that in Fig. 13 with two owls standing back to back. In the Shanghai Museum is a partly damaged *you* in the shape of two pigs with their backs to each other, supposed to have been unearthed in Guangxi.

The *jin*[31] is a rectangular stand which serves as a support for a wine vessel. Lately, a large bronze *jin* was unearthed from a Spring and Autumn Period tomb in Xichuanxiasi, Henan Province. Earlier, two large bronze *jin* dating from the early Western Zhou had been unearthed in Baoji, Shaanxi. The one from Doujitai in Baoji was discovered in 1901, complete with a whole set of wine vessels. It is now kept in the Metropolitan Museum in New York. The other, found in 1926 at Daijiawan, Baoji, is larger, measuring 126 cm long.[32] It has three oval openings intended to hold three wine vessels, of which there is no trace left. So far, vessels of a size to fit the openings have not yet been found in any museum.

Two common water vessels which always accompany each other are the *pan*[33] (bowl) and *yi*[34] (ewer) (Fig. 14, (1) and (2)). During ceremonial ablutions, the ancient people used *yi* to pour the water and *pan* to wash in. Archaeological findings in recent years show that, before the middle Western Zhou, *pan* were originally coupled with a *he*[35] (Fig. 14, (3)), a type of pitcher with a spout, and it was not until the late Western Zhou that this was replaced by the *yi*. The earlier *yi*, such as Xun *yi* and Cui *yi*, still used the name *he*. Sets of *pan* and *he* or *pan* and *yi* were frequently offered as dowries.

Because of the largeness of *pan*, long inscriptions could be cast on them. There was an ancient practice of casting a whole contract on a *pan* which could be handed down to posterity. The famous bronze San Shi *pan* of the late Western Zhou (Pl. 27) bears an inscription of 357 characters, which was a contract between two families —the San and the She—concerning the transfer of land and demarcation of boundaries. This is an example of "inscribing on a *pan* or *yu*[36] (jar)," as mentioned in ancient documents.

The *he* is rather like a modern wine pot (Pls. 28-29). Apart from being used in ceremonial ablutions, it also served as a container for water to dilute wine, and thus belongs to the category of wine vessels. This piece of bronze ware disappeared in the Spring and Autumn Period, but was succeeded by a derivative—an oval-shaped container with a handle, also called *he*[37], but

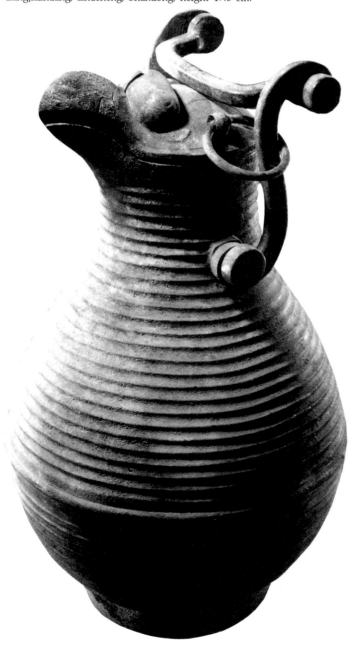

25.
Eagle-head *hu*, wine vessel, early Warring States Period, unearthed at Zangjiazhuang, Zhucheng, Shandong, height 47.5 cm.

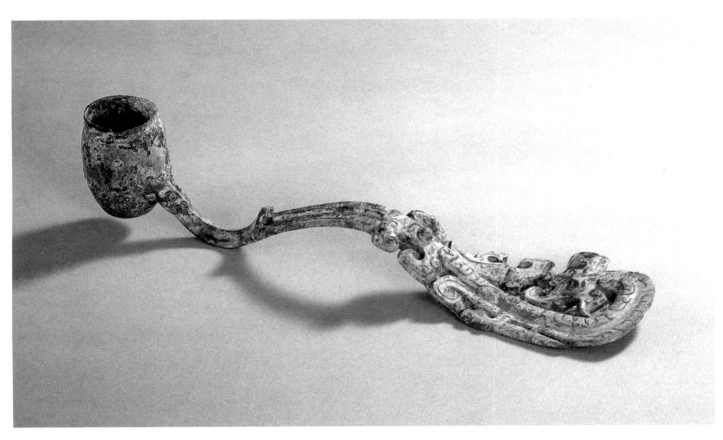

26.
Spoon with dragon design, early Western Zhou Dynasty.

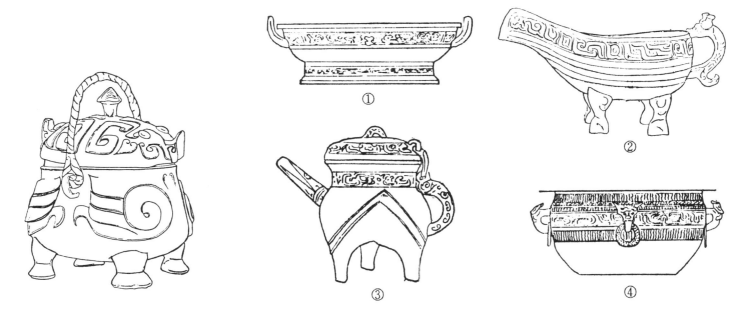

Fig. 13 Owl *you* wine container

Fig. 14 Water vessels:
(1) *pan* bowl (2) *yi* ewer (3) *he* ewer (4) *jian* basin

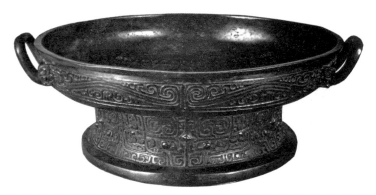

29.
Shi *he*, wine vessel, late Western Zhou Dynasty, unearthed at Qijiacun, Fufeng, Shaanxi, height 37.5 cm.

27.
San Shi *pan* water vessel, late Western Zhou Dynasty, diameter 54.6 cm.

28.
Duck-shaped *he*, wine vessel, early Western Zhou Dynasty, unearthed at Pingdingshan, Henan, height 26 cm.

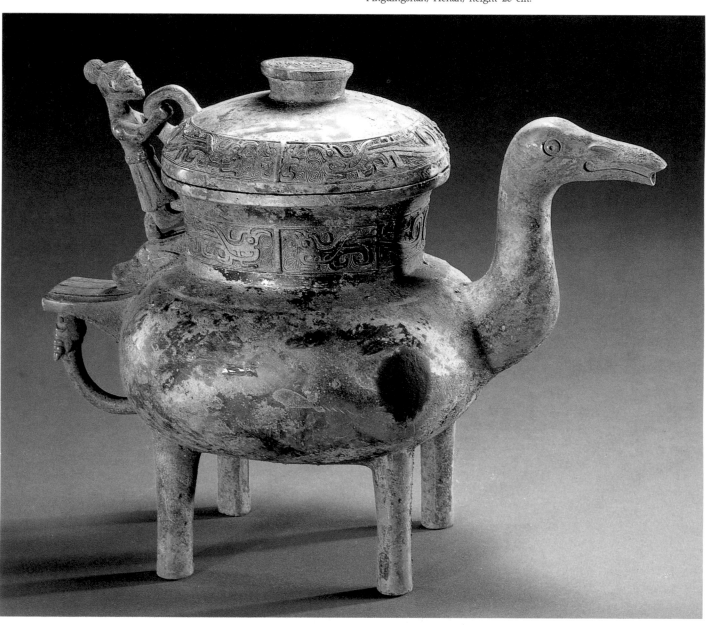

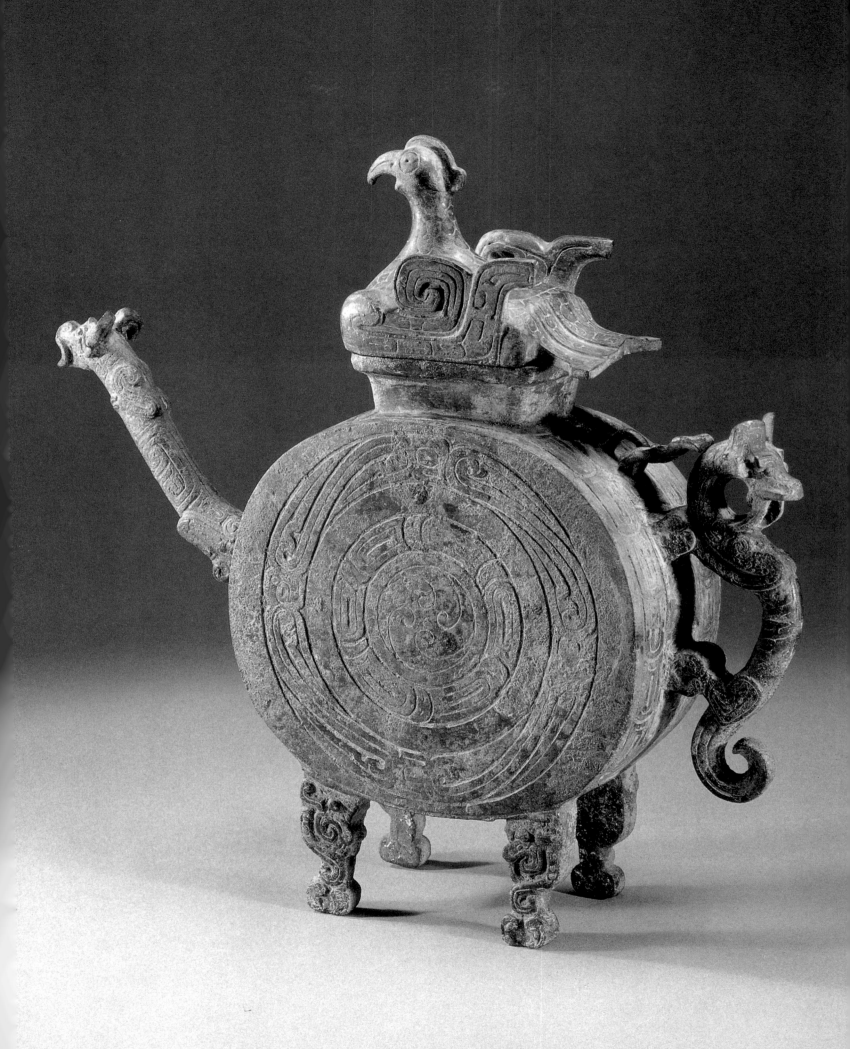

30.
Fu Chai *jian* basin of the King of Wu, water vessel, late Spring and Autumn Period, reportedly unearthed at Liulige, Huixian, Henan, diameter 76.5 cm.

represented by a different character in Chinese. Its owners were mostly official historians, who presumably used it to hold water for grinding an ink-stick while writing.

Another important water vessel is the *jian*[38] (Fig. 14, (4) and Pl. 30). With two or four ears, or none at all, it is a large basin used for three purposes: first, as a bath tub; second, as a mirror when filled with water; and third, for keeping ice, in which case it is called an "ice *jian*" according to *Zhou Li* (*The Rites of Zhou*). A pair of rectangular *jian* was unearthed at Leigudun in Suixian County, Hubei. Both have an openwork lid and can hold a rectangular wine flask: they were obviously used to cool wine. Some *jian* are provided with a ladle.

The base inside a *pan*, *jian* and other bronze water vessels is often embellished with a turtle, fish, coiled dragon or other designs. The turtle and fish rectangular *pan* of the early Warring States in Beijing's Palace Museum has on its base a relief of turtles and fish in flowing water. If the *pan* were filled with clear water, this would give the impression of turtles and fish swimming in it. Similarly, the *xi*,[39] a round water vessel popular in the Han Dynasty, rather like the wash-basin of today, often has two fish engraved on its interior.

MUSICAL INSTRUMENTS Bronze musical instruments include the *nao*,[40] *zhong*,[41] *bo*,[42] *gu*,[43] *chunyu*[44] and others.

The *nao* (Fig. 15, (1)) was in current use in the late Shang (Pl. 31). With its mouth facing upwards, it has a long handle which is set on a wooden stand and struck with a wooden mallet. A *nao* could be used as a single, large instrument, such as the big *nao* with an ogre-mask design unearthed in an old granary at Laoliangcang in Ningxiang County, Hunan—height 89 cm, weight 154 kg. It can also come in a set of several pieces, each with

a different note. A set is usually composed of three pieces, but lately, a set of five was discovered in a tomb of the Yin ruins. Some *nao* have simple inscriptions.

After the early Zhou, the *nao* was no longer used except in the south (Pl. 32). It was turned upside down and hung up, so that a clearer sound could be produced when struck. It then became known as a *zhong*, or bell (Fig. 15, (2)), which was fully developed during the Zhou Dynasty. The number of bells in a *bian zhong* (a chime of bells) gradually increased, so that it could play more complicated tunes.

Such bells are also called *yong zhong* and are hung up in an inclining position. There was another kind of *zhong* with a plane opening, known as a *bo* (Pl. 14 and Fig. 15, (3)) and found in the late Shang Dynasty (Pl. 33). Different from a *yong zhong*, it was hung vertically by a circular knob. Also known as *niu zhong*, this kind of bell was popular in the late Spring and Autumn Period. A whole shelf of *bian zhong* (Pl. 22), consisting of 19 *niu zhong*, 45 *yong zhong* and a *bo* (Pl. 34), was unearthed in a large tomb (of the Marquis of Zeng) dating back to the early Warring States at Leigudun in Suixian County, Hubei Province. They were accompanied by 6 T-shaped wooden mallets and two rods. Even now they can still produce a good tone when played.

The chapter "Records of the State of Wu" in the ancient book *Guo Yu* (*Anecdotes of the States*) records that, around the end of the Spring and Autumn Period, the armies of the State of Jin met with those of the State of Wu at Huangchi. By dawn, the Wu troops were lined up in battle formation, and Prince Fu Cha of Wu ordered all musical instruments—*zhong*, *ding ning*, *chunyu* and *duo* —to be struck to intimidate the Jin troops. These instruments were often used as signals by armies when orders were given. The *ding ning* is also referred to as a *zheng*.[45] Like the *nao*, it is struck with a mallet. The *chunyu* has a long body which widens upwards, and affixed to the top is a knob in the shape of an animal. The *duo* is like a *ding ning* in shape and resembles a modern hand bell.

Bronze drums, or *gu*, were scarce in the Huanghe valley. So far, only two bronze drums have been discovered dating back to the Shang Dynasty; one is mentioned in a catalogue compiled by Hamada Kosaku of Japan, the other was unearthed in 1977 in Chongyang, Hubei, each having a face on both sides.

CHARIOTS AND HARNESSES Ancient China's chariots and harnesses were adorned with a variety of bronze ornaments. Horse bridles (Fig. 16), or *danglu*, were sometimes inscribed, such as the one unearthed at Doujitai in Baoji, Shaanxi. An inscribed mouthpiece dating from the Warring States was unearthed in Hebei, but this is a rare

Fig. 15 Musical instruments (bells):
(1) *nao*
(2) *zhong*
(3) *bo*

31.
Nao with ogre-mask motif, musical instrument, late Shang Dynasty, unearthed at Dayangzhou, Xingan, Jiangxi, height 41.5 cm.

32.
Nao with ogre-mask and cloud pattern, musical instrument, early Western Zhou Dynasty, unearthed at Tangdongcun, Jiangning, Jiangsu, height 46 cm.

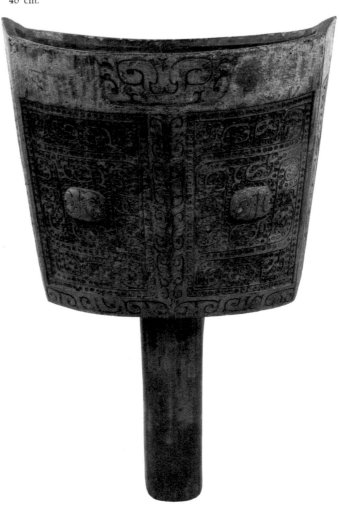

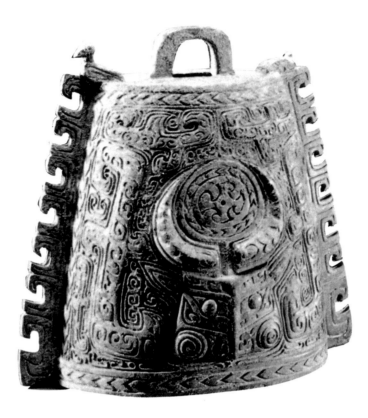

33.
Bo with ox-head pattern, musical instrument, late Shang Dynasty, unearthed at Dayangzhou, Xingan, Jiangxi, height 33 cm.

instance of such an object.

WEAPONS Of the bronze weapons, the *ge* (dagger-axe) is one of the most common and characteristic (Fig. 17). It is a development of the sickle and, employed in the same way, its edge is used for hooking, hence its other appellation, "hook weapon." The edge of the earliest *ge* was straight; later it was extended downward (to facilitate it to be fitted with a handle for longer-range manoeuvring) and became sharper. The *nei*, or tang, was originally added to balance the *yuan*, or blade, but was itself later whetted into a keen edge.

The *mao* (spear)[46] has the same function as a bayonet. By securing it to the top end of a dagger-axe handle, it can hook as well as bayonet. As a double-purpose weapon, it is called a *ji* (halberd).[47] From recent discoveries at Taixi in Gaocheng, Hebei, we have learned that the halberd was already used in the Shang Dynasty. During the Western Zhou, a kind of cruciform halberd appeared, and during the Warring States, there was a kind of halberd shaped thus: ⊦ (Pl. 35). In the earlier part of the Warring States there was still another type of halberd comprising three dagger-axes (Pl. 36).

Knives with long handles used as weapons appeared as far back as the Shang. In the Shang, too, a kind of

weapon combining dagger-axe and knife, commonly called a hook-halberd, existed, and became very popular in the early Western Zhou. Hook-halberds of the early Western Zhou have been discovered in several places, such as Doujitai at Baoji in Shaanxi, Xincun at Junxian in Henan, and Liulihe at Fangshan in Beijing.

The *yue* (axe)[48] (Pl. 37) was used both as a weapon of war, normally carried by kings during expeditions, as well as an instrument for execution (in the latter case because it symbolized power). The blades of large bronze axes of the Shang to the early Zhou generally (Pls. 38-39) measured more than 30 cm in width, and were capable of

34.
Yin Zhang *bo* of the King of Chu, early Warring States Period, unearthed at Leigudun, Suizhou, Hubei, height 92.5 cm.

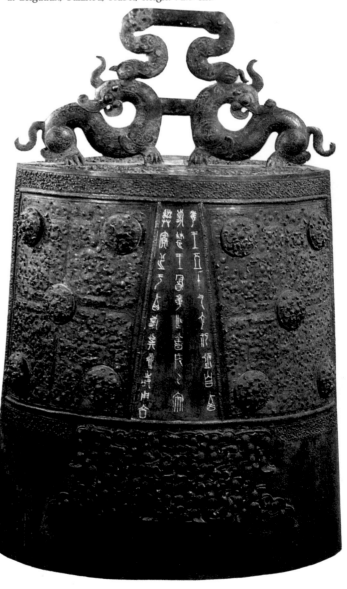

Fig. 16 Ornate bridle, Western Zhou Dynasty.

Fig. 17 Weapon
Technical names of the parts of a *ge* dagger-axe.

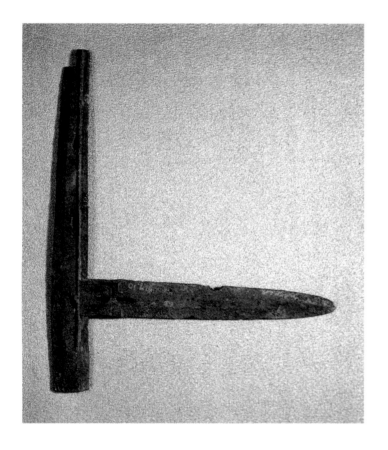

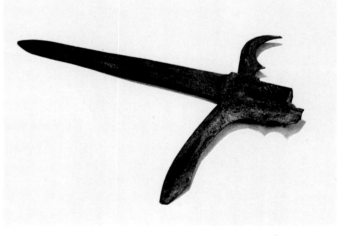

35.

⼘ -shaped *ge* (incomplete), weapon, middle or late Warring States Period, unearthed at the Second Capital of Yan, Yixian, Hebei, length 22 cm.

36.

Sword-shaped *ji*, weapon, middle or late Warring States Period, selected from Nanyang, Henan, length 34 cm.

cutting a man in half at the waist.

Bronze *jian* (sword)[49] (Fig. 18), so far as we know, existed as early as the Shang. *Yi Zhou Shu* (*Lost Records of the Zhou*) refers to this sword, used during the reign of King Wu of the Zhou Dynasty, as a *qing lu*. A sword in the shape of a willow leaf was discovered at Liulihe in Beijing along with its sheath in a tomb dating from the early Western Zhou. Similar sheaths had been found previously but were never assigned a date. The sword of the Eastern Zhou gradually increased to a length exceeding one metre (Pl. 40). Short swords, or daggers, were also made of bronze. A pair of bronze daggers with fairly long inscriptions are on display in the Museum of Chinese History in Beijing.

It is to be noted that, in the past, some of the short swords were in fact *pi*[50] with long handles, as confirmed by recent archaeological discoveries. Most *pi* are shaped like a willow leaf with a hole on the hilt. They were in current use in the late Warring States. Some *pi* have inscriptions.

38.
Yüe with cloud pattern, weapon, late Shang Dynasty, unearthed at Dayangzhou, Xingan, Jiangxi, height 36.8 cm.

Other bronze weapons include arrow-heads, emblazoned shields and helmets (Pls. 41-43).

TOOLS　Bronze tools of production can be divided into two categories: handicraft tools and farm tools. Handicraft tools include the *fu* (axe),[51] *ben* (adze),[52] *zhui* (awl),[53] *zuan* (drill),[54] *zao* (chisel),[55] *xiao* (scraper),[56] *ju* (saw)[57] and *cuo* (file),[58] employed mostly in carpentry. A complete set of tools for scraping bamboo strips was unearthed from a tomb at Changtaiguan in Xinyang, Henan. Farm tools consist of the *chan* (shovel),[59] *jue* (pickaxe),[60] *lian* (sickle)[61] and *yugou*[62] (fish hook). In recent years, many bronze farm tools dating back to the Warring States were found in Anhui, Jiangsu and Zhejiang provinces, including other implements like the modern sickle or hoe. A bronze ploughshare was found in Jinan, Shandong; its design indicates that it possibly belonged to pre-Qin times. Formerly it was believed that China had very few bronze farm tools. This is not correct. The fact that they were not used as burial objects and that broken ones were returned to the furnace to be recast accounts for the small number preserved.

WEIGHTS AND MEASURES　The ruler was an important measure. In 1926, a set of instruments was discovered at Chenggouyi in Dingxi, Gansu Province. They belonged to the time of Wang Mang's reign (A.D. 8-23).

37.
Yüe with ogre-mask motif, weapon, late Shang Dynasty, unearthed at Taixi, Gaocheng, Hebei, length 26.5 cm.

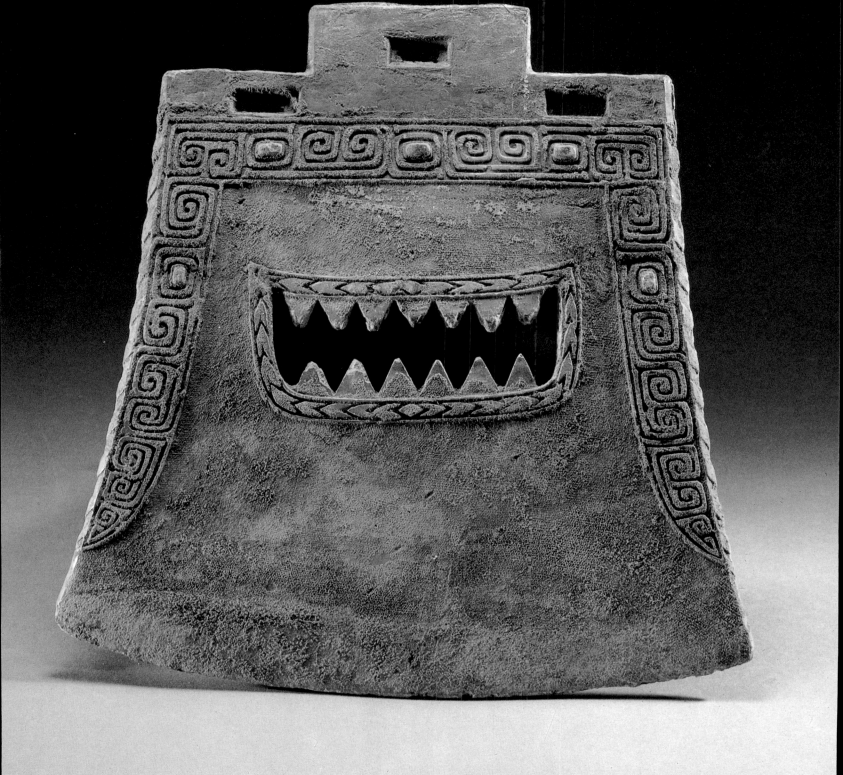

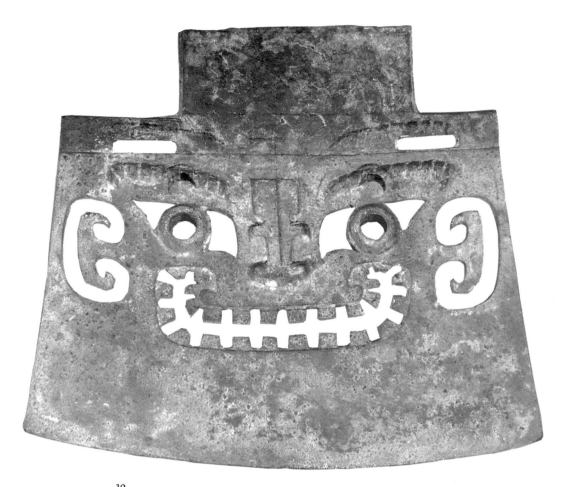

39.
Large human-faced *yue*, weapon, late Shang Dynasty, unearthed at Sufutun,
Yidu, Shandong, length 31.8 cm, blade width 35.8 cm.

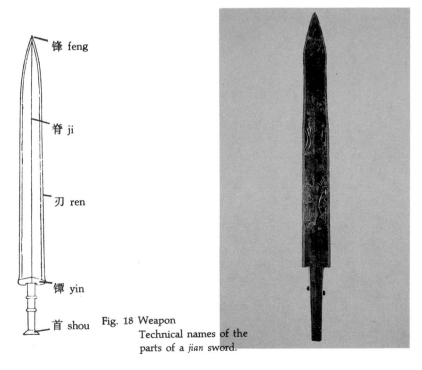

锋 feng

脊 ji

刃 ren

镡 yin

首 shou

Fig. 18 Weapon
Technical names of the
parts of a *jian* sword.

40.
Fan Yang Zhi Jin *jian* sword, middle or late Warring
States Period, unearthed at Kaixuanlu, Luoyang, Henan,
length 45 cm.

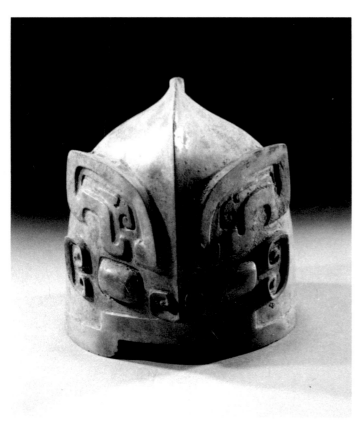

41.
Bronze *zhou* helmet, late Shang Dynasty, unearthed at Dayangzhou, Xingan, Jiangxi, height 18.7 cm.

42.
Tallies of King Qi of E, middle Warring States Period, unearthed at Qiujiahuayuan, Shouxian, Anhui, length of Zhou tally 31 cm, length of Che tally 29.6 cm.

43.
Du tiger tally, middle or late Warring States Period, unearthed at Beichencun, Xi'an, Shaanxi, length 9.5 cm.

Among them was a bronze ruler inscribed with an imperial mandate of 81 characters. This is the sole instance of such a discovery. The book *Investigations of Weights and Measures* by Wu Dazheng of the late Qing Dynasty mentions bronze callipers, also from Wang Mang's reign, on which were engraved 12 characters inlaid with silver. Their principle of application is somewhat similar to that of modern callipers. It is believed to have been unearthed in Shandong, but its nomenclature has not been discovered as yet.

There was a wide range of instruments for measuring volume (Pl. 44). Some of these instruments had rather long inscriptions on them and usually appeared in a set.

The *tianping*[63] (balance) was an important weighing apparatus. The inscribed arms of two balances dating from the Warring States were unearthed in the 1940s in Shouxian County. Among the relics of Wang Mang's reign found at Chenggouyi in Gansu was another bronze balance arm, 64.74 cm long, inscribed with an imperial mandate of 81 characters. Weights have different forms—spherical, semispherical, or rhomboid—and different weights (Pl. 45). According to *Mo Zi*, a work of the Warring States, China already had steelyards at that time, but this has not yet been confirmed by archaeological findings. As to whether there were steelyard weights

among the bronze weights, again, no conclusion has yet been reached.

MISCELLANEOUS ARTICLES This category includes objects for daily use, such as lamps (Pls. 46-47), stoves, censers, staff heads, combs, hairpins, belt hooks, and articles for medical use, such as kettles, burners and filters (Pls 48-49). Ornamental pieces for buildings and decorative accessories for coffins are also classified in the same group.

Bronze mirrors, belt hooks, seals and coins will be dealt with in a later chapter.

44.
Chen Chun *fu* cauldron, middle Warring States Period, unearthed at Lingshanwei, Jiaoxian, Shandong, height 39 cm.

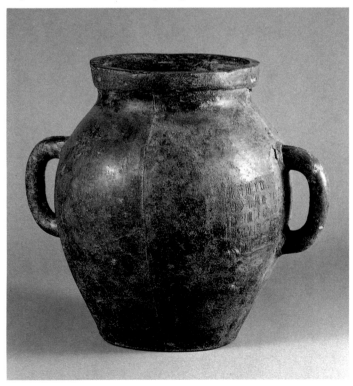

[1] Liu Tizhi, *The Xiao Jiao Jing Ke Rubbings of Bronze Inscriptions*, published by Xiao Jiao Jing Ke, 1935.

[2] 瓠 [3] 簠 [4] 敦 [5] 鬲 [6] 甗 [7] 盨 [8] 簋 [9] 豆 [10] 琦 [11] 铺 [12] 筥 [13] 雀 [14] 罦 [15] 觯 [16] 觥

[17] Anyang Work Team of the Institute of Archaeology of the Chinese Academy of Social Sciences, "The Excavation of Tomb 5 at the Yin Ruins in Anyang," *Archaeological Gazette*, No. 2, 1977, Pl. 8, (1).

[18] See *The Freer Chinese Bronzes*, Vol. I, 1967, pp. 1 and 45.

[19] 杯 [20] 樽 [21] 尊 [22] 卣 [23] 方彝 [24] 瓿 [25] 罍 [26] 壶 [27] 缶 [28] 钟 [29] 钫

[30] Zhouyuan Archaeological Team, "Storage of Bronzes of the Western Zhou at Fufeng County, Shaanxi Province," *Cultural Relics*, No. 11, 1978.

[31] 禁

[32] Tianjin Cultural Relics Administrative Department, "The *Kui* Dragon-Patterned Bronze *Jin* of the Western Zhou," *Cultural Relics*, No. 3, 1975.

[33] 盘 [34] 匜 [35] 盉 [36] 盂 [37] 钾 [38] 鉴 [39] 洗 [40] 铙 [41] 钟 [42] 镈 [43] 鼓 [44] 錞于 [45] 钲 [46] 矛 [47] 戟 [48] 钺 [49] 剑 [50] 鈹 [51] 斧 [52] 锛 [53] 锥 [54] 钻 [55] 凿 [56] 削 [57] 锯 [58] 锉 [59] 铲 [60] 镬 [61] 镰 [62] 鱼钩 [63] 天平

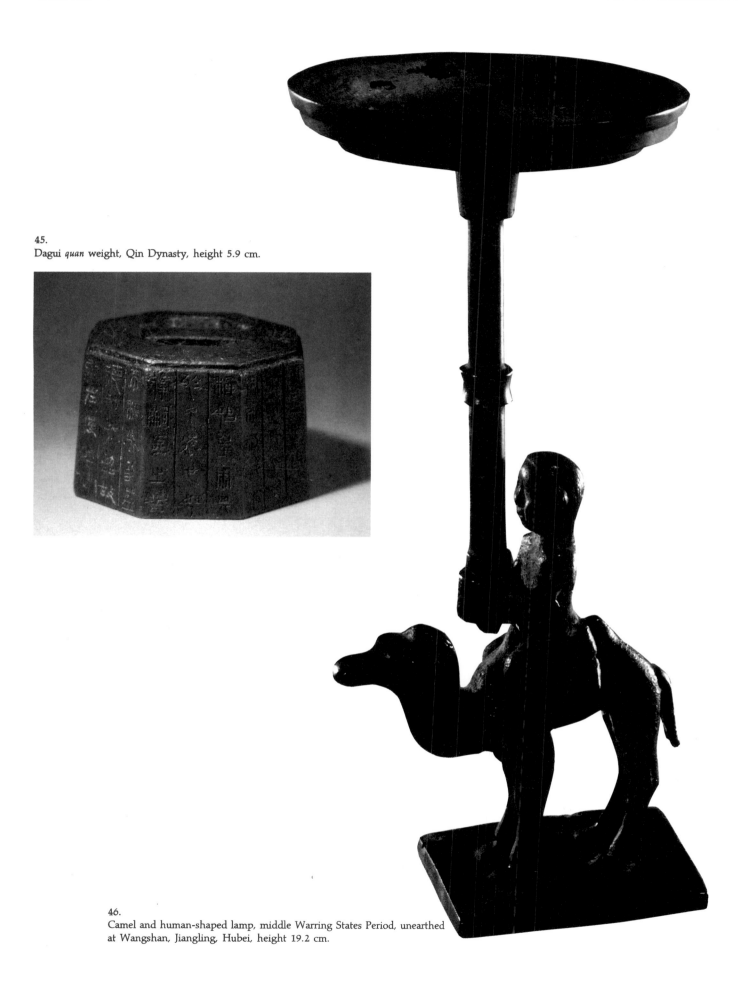

45.
Dagui *quan* weight, Qin Dynasty, height 5.9 cm.

46.
Camel and human-shaped lamp, middle Warring States Period, unearthed at Wangshan, Jiangling, Hubei, height 19.2 cm.

47.
Tree-shaped lamp, middle or late Warring States Period, unearthed at Sanji, Pingshan, Hebei, height 82.9 cm.

48.
Rectangular ornamental piece for buildings, middle Spring and Autumn Period, unearthed at Yaojiagang, Fengxiang, Shaanxi, length 31 cm.

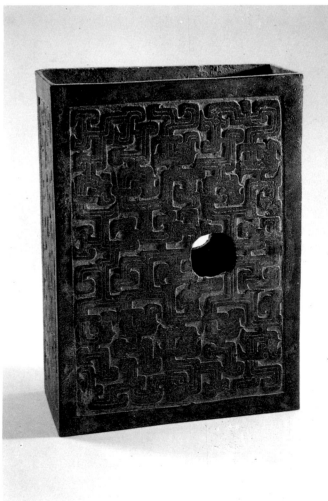

49.
Curved ruler-shaped ornamental piece for buildings, middle Spring and Autumn Period, unearthed at Yaojiagang, Fengxiang, Shaanxi, length 42 cm.

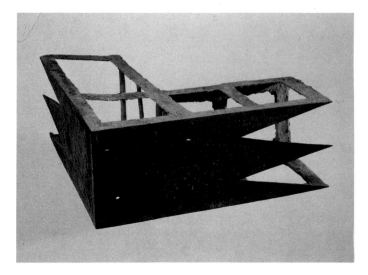

"The Earth Cherishes No Treasure"

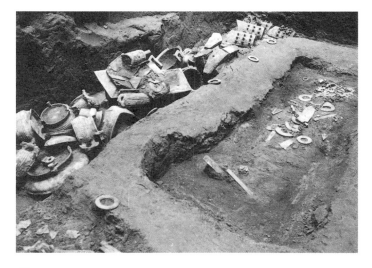

50.
Bronzes unearthed from Tomb 2001 at Shangcunling, Sanmenxia, Henan.

"THE earth cherishes no treasure" is an old saying often quoted in Chinese books on bronzes. It means that the earth does not care to keep her rich store of treasures; so long as man is persistent in his search, he will sooner or later discover them. Indeed, in the vastness of China no one knows exactly how large this underground treasury is, but certainly bronzes are a prominent feature. Chinese museums all over the country are housing tens of thousands of bronzes, many of which have not yet been mentioned in published works. To cite an example, the album of bronzes of Shaanxi and Henan provinces consists of 10 thick volumes and does not include the tremendous number of duplicated small bronze articles, such as arrow-heads or ornaments. Apart from these, an overwhelming number of bronzes have gone out of China in the past, and are now kept in museums, galleries, universities, research centres and by individuals in various countries.

In this chapter we shall look into the question of how these bronzes have been preserved and how they have reappeared.

Ancient Chinese bronzes have been unearthed mainly from tombs. Some were utilized by their owners in their lifetime, others served as ritual vessels for offering sacrifices or during feasts, still others were made expressly as burial objects. The burial ceremony of royal houses and aristocratic families was a most ostentatious and extravagant affair. The chapter entitled "Economical Burial" in Lü Shi Chun Qiu (Lü's Miscellany) states that the larger the state and the richer the family, the more elaborate the burial; tombs contained innumerable "articles of amusement, vessels and bells, chariots and harnesses, clothes and quilts, dagger-axes and swords." Scholar-officials of lower rank and common people also had a few bronze burial objects interred with them. The bronzes usually formed a set (Pl. 50) which, if intact, could supply complete information on the deceased.

The storage pit was another repository for bronzes. In a time of unrest, when a man of position was forced to flee, unable to carry his weighty bronzes with him, he would bury them in a certain spot to which he could return and retrieve them once the situation became favourable. Thus, a storage pit for bronzes came to exist. Often, a pit may contain a whole group of bronzes cast by a family through several generations, and these are of special significance to the study of bronzes.

Bronze ware has also been found on the sites of some ancient buildings where remnants of structural decorations and articles formerly housed in the buildings have been preserved; or on hilltops and riverbeds where ritual vessels were used for offering sacrifices to the mountains and rivers. Generally these are not found in such a great number as those from tombs or pits (Pl. 51).

According to ancient documents, numerous records of the discovery of bronzes existed as early as the Han Dynasty. In the preface to Shuo Wen Jie Zi (Analytical Dictionary of Characters) by the famous lexicologist Xu Shen, ding and other bronze vessels were often discovered in mountains or rivers at that time in each principality. The plundering of ancient tombs was also a frequent occurrence. Ge Hong's Xi Jing Za Ji (Notes of the Western Capital) recounts the looting of old tombs during the Han Dynasty. Some Han scholar-officials took up the collection of bronzes as a hobby, as evidenced by the recent discoveries in Hunan and elsewhere of bronze burial objects from the Shang Dynasty in the tombs of the Han.

The discovery of an important piece of bronze was

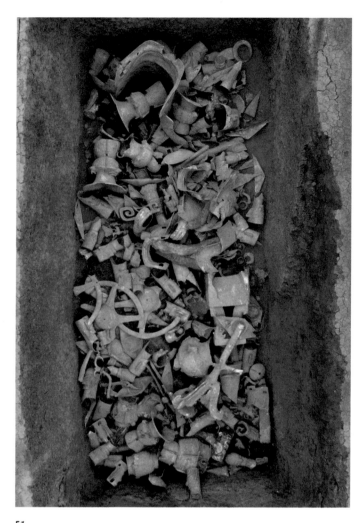

51.
Bronzes unearthed from Pit 2 at Sanxingdui, Sichuan.

event as a propitious one, proposed that a solemn ceremony be held and the bronze exhibited in the imperial ancestral hall, following the precedent of Wu Di. Zhang Chang, a court official, who had closely studied ancient scripts, differed with them. He deciphered the inscription, pointing out that the bronze had no particular sacred significance, but was cast by Yi Chen, a Zhou minister, commemorating honours bestowed upon him by the king. His interpretation was recorded in *Han Shu* (*History of the Han Dynasty*), in the chapter "Sacrifices Offered in the Out Country." Zhang Chang may be considered to be the earliest authority on bronze inscriptions. After him, Xu Shen of the Eastern Han, Guo Pu of the Jin and Liu Zhilin of the Liang Dynasty all devoted themselves to the research of bronzes and their inscriptions.

Of the bronze discoveries recorded in history from the Han to the Tang, some have supplied important clues for present-day archaeological excavation. For instance, a *ding* was unearthed during the reign of the emperor Wu Di of the Han Dynasty beside the ancestral temple of Houtu at Fenyin, Shanxi Province. According to *Han Shu*, it was larger than the ordinary *ding*. In the same area, two more *ding* were excavated during the reign of Xuan Zong of the Tang Dynasty. Both were greenish, and the larger one could contain a *dou* of grain. This location was the site of the famous ancestral temple of Houtu at present-day Ronghe, Shanxi Province. In the earlier years of the reign of the Qing emperor Tong Zhi (1862-74), a large collection of bronzes including 12 *Lü* bells were found there. They were from a group of tombs erected by the State of Jin of the late Spring and Autumn Period. The *ding* whose inscription was deciphered by Zhang Chang was unearthed from the Zhouyuan site between Qishan and Fufeng counties in Shaanxi Province. This site has been one of the most important places for the excavation of bronzes since the Qing Dynasty.

No complete information has been handed down as regards most of the discoveries of this period, but fragmentary records of ancient documents have shown certain of them to be of some significance. *Song Shu*, for example, states that Chen Qing, a native of Shanxian County in Guiji, found a beautifully shaped *zhong* (bell) from a well. It was inscribed with 18 characters of a strange script which nobody recognized at the time. It was probably a bell of the State of Yue. The same book also mentions that, during the reign of An Di of the Jin Dynasty, six bells inscribed with an ancient script of 160 characters were unearthed from Huoshan in Lujiang. Liu Zhilin, the bronze specialist of the Liang Dynasty, collect-

considered by the ancients as a good omen. In the summer of 116 B.C., a bronze *ding* was found in the present-day Fenhe basin in Shanxi Province. When the news reached the imperial court, the emperor Wu Di regarded it as an auspicious sign and renamed his reign. "Yuan Ding." Rulers in successive dynasties, too, looked upon bronzes as a symbol of good fortune. As soon as a bronze was found, it was delivered by the local officials and offered to the court, and this event would consequently be recorded in history as an "auspicious occasion." *Song Shu* (*History of the Song Dynasty*) includes a chapter on "Auspicious Signs" containing considerable material on unearthed precious bronzes.

Certain scholars rejected this superstitious concept, and chose, instead, to study the unearthed bronzes from an objective viewpoint. During the reign of Xuan Di of the Han Dynasty an inscribed bronze *ding* was found in Meiyang (in modern Shaanxi Province). It was delivered to the court, where most of the ministers, treating the

ed two *zun* (wine vessels) inlaid with silver, whose inscription indicated that it was made in the year when Marquis Rong Cheng of the State of Qin went to the State of Chu. The style of writing suggests that they must have belonged to the Chu, which was probably the case, because it was reportedly unearthed from Jingzhou (now Jiangling, Hubei Province) which was under the jurisdiction of that state. It is regrettable that these relics no longer exist.

The Song Dynasty marked the beginning of a new phase for the discovery and study of bronzes. The imperial house and scholar-officials of the Song were zealous collectors of bronzes. The acquisitions of the imperial court were especially profuse. Famous ministers, such as Kou Zhun, Wen Yanbo and Su Shi, all had large collections. Special treatises on bronzes began to appear in the late Northern Song. The earliest of these still extant is *Kao Gu Tu* (*An Illustrated Book of Antiques*) by Lü Dalin, written in 1092. The work lists a total of 210 bronze pieces, collected by the imperial court as well as more than 30 families, and handles each item in detail—its appearance, size and weight, the inscription it bears and its meaning, where it was unearthed, the name of the collector, etc., and each item is furnished with an illustration. Late works of the Song include: *Bo Gu Tu Lu* (*Illustrated Catalogue of Antiques*), *Li Dai Zhong Ding Yi Qi Kuan Shi Fa Tie* (*Inscriptions on Bronzes of Various Dynasties*), *Xiao Tang Ji Gu Lu* (*Xiao Tang Collection of Cultural Relics*), *Fu Zhai Zhong Ding Kuan Shi* (*Fu Zhai Collection of Inscriptions on Bronzes*), *Xu Kao Gu Tu* (*Sequel to the Illustrated Book of Antiques*), and *Jin Shi Lu* (*Notes from a Study of Inscriptions on Ancient Bronzes and Stone Tablets*), an expert discourse on bronzes by Zhao Mingcheng, husband of the famous poetess Li Qingzhao.

The reference in these books to places where bronzes were found has led to the discovery of significant archaeological sites in modern times. The most important one is the Yin ruins, which was the Hetanjia city referred to in the books.

Bronzes were highly valued during the Song Dynasty, and as a result, their price rose rapidly. It was said that one object could cost as much as several hundred thousand cash or even a million. Consequently, there were many cases of tombs being plundered and also bronzes being forged. Imitations made during the Song and Yuan times have been discovered more than once in recent years. These would be buried in the earth so that they would collect verdigris and thus have the appearance of antiques.

During the Yuan and Ming dynasties, the study of bronzes declined, owing to the change in trend in the academic field when neo-Confucianism came to the fore and the study of archaeology was neglected. Not until the Qing Dynasty, when textual research came to be respected, did the collection and study of bronzes again rise. The bronzes amassed by the Qing court were even more copious than those of the Song. Following is a list of works with the total number of bronzes handled by each:

Xi Qing Gu Jian (*Xi Qing Collection of Ancient Bronzes*), 1,436 pieces.

Ning Shou Jian Gu (*Ning Shou Collection of Ancient Bronzes*), 600 pieces.

Xi Qing Xu Jian Jia Bian (*Sequel to the Xi Qing Collection of Ancient Bronzes*, Part I), 844 pieces.

Xi Qing Xu Jian Yi Bian (*Sequel to the Xi Qing Collection of Ancient Bronzes*, Part II), 800 pieces.

There is no way of telling how many more bronzes there were apart from those mentioned in the above books. The best-known treatises of the Qing Dynasty, which had a host of private collectors and researchers of bronzes, are:

Ji Gu Zhai Zhong Ding Yi Qi Kuan Shi (*Ji Gu Zhai Collection of Inscriptions on Bronzes*) by Ruan Yuan;

Yun Qing Guan Jin Wen (*Yun Qing Guan Collection of Inscriptions on Bronzes*) by Wu Rongguang;

Que Zhai Ji Gu Lu (*Que Zhai Collection of Antiques*) by Wu Dacheng;

Jun Gu Lu Jin Wen (*Selections of Inscriptions on Bronzes*) by Wu Shifen;

Zhui Yi Zhai Yi Qi Kuan Shi Kao Shi (*Zhui Yi Zhai's Study of Inscriptions on Sacrificial Vessels*) by Fang Junyi;

Yu Hua Ge Jin Wen (*Yu Hua Ge Collection of Inscriptions on Bronzes*) by Sheng Yu (unpublished).

The work entitled *San Dai Qin Han Jin Wen Zhu Lu Biao* (*Bibliography of Works Dealing with Inscriptions on Bronzes of the Xia, Shang, Zhou, Qin and Han Dynasties*) by Luo Fuyi and published in 1933, lists 35 treatises written since the Song Dynasty and 5,780 pieces of bronzes. These only include inscribed bronzes already known to us. Those that have been discovered but not yet made known, especially those without inscriptions, must be innumerable. This is an indication of the vast amount of Chinese bronzes so far found.

Despite this fact, bronzes have suffered frequent plundering for various historical reasons. In the past, cultural relics were neglected and not properly preserved. Countless articles were either looted or destroyed. From the end of the Han Dynasty, the imperial court on several occasions destroyed bronzes in public, claiming that ancient bronzes created "evil spirits." This was simply a pretext; their real intent was to melt the bronze to make coins.

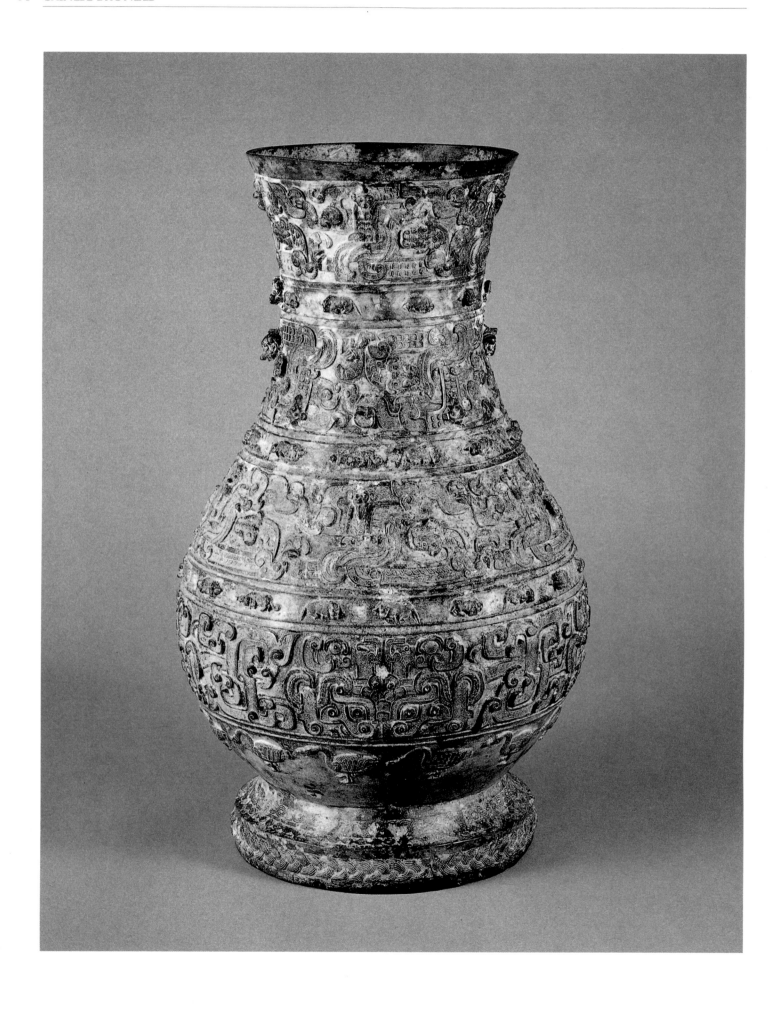

Bronzes owned by the people were also often left to rack and ruin. For example, the big bronze Buddha in Longxing Temple in Zhengding, Hebei Province, according to the story inscribed on the tablet there, was cast out of several thousand catties of ancient bronzes which had been found in a vegetable garden. Another reason why bronzes were not widely known was that certain collectors monopolized these cultural relics, secreting them from the public, as was the case of the famous Hu *ding* of the middle Western Zhou period. This bronze was treasured by its collector, and revealed only to a few privileged people; after it was lost, therefore, even a rubbing of its inscription was difficult to procure. Of the three Yu *ding* unearthed in Zhouyuan in the early years of the reign of the Qing emperor Dao Guang, two (namely, the well-known big and small Yu *ding*) were arbitrarily appropriated by a couple of magistrates. The third, a rectangular *ding*, was lost by other means. The third Yu *ding* in *Meng Po Shi Huo Gu Cong Bian* (*The Meng Po Shi Catalogue of Unearthed Relics*), compiled by Zou An, was actually a crude imitation. On the whole, no reliable records are available as to how bronzes were unearthed and what the other artifacts found together with them comprised. The lack of these details has hindered research into Chinese bronze ware.

Important discoveries of bronzes in China beginning from the 1920s are mainly as follows:

Articles dating back to the period between the Spring

52.
Hu with relief sculpture and decorations, wine vessel, early Warring States Period, unearthed at Liyu, Hunyuan, Shanxi, height 44.2 cm.

and Autumn Period and the Warring States, unearthed in 1923 at Liyu in Hunyuan County, Shanxi Province (Pl. 52).

Articles of the late Spring and Autumn Period found in 1923 at Lijialou in Xinzheng County, Henan Province.

Articles from the early Western Zhou discovered in 1926 at Daijiawan in Baoji, Shaanxi Province (Pl. 53).

Articles dating back to the Warring States found in 1928 at Jincun in Luoyang, Henan Province.

Bronze vessels of the early Western Zhou excavated in 1931 at Xincun in Xunxian County, Henan.

Articles dating from the late Warring States unearthed in 1933 at Zhujiaji in Shouxian County, Anhui.

These bronzes, each with its own characteristics, aroused attention both at home and abroad. But with the exception of those found in Xinzheng, which are now kept in China, practically all other bronze items have found their way to other countries.

Scientific excavation of bronzes in China began with the Yin ruins in the 1930s. At that time, the Academia Sinica discovered on 15 occasions about 200 pieces of bronze ritual vessels alone. These, together with bronzes unearthed in other places, are now kept in Taiwan. Most of the material connected with the excavations of the Yin ruins has been published in recent years.

After the founding of the People's Republic, with the introduction of laws and decrees for the protection of cultural relics, along with the rapid progress of archaeological work, a new stage has been opened for the discovery and research of bronzes. Many provinces, including remote regions where bronzes had never previously been found, have unearthed ancient pieces of bronze ware of the finest workmanship. Recently discovered bronzes have far exceeded those unearthed in the past both in variety and in scientific value. This is especially true of the unprecedented discoveries of large groups of important bronzes in the last few years.

Between 1963 and 1974, a site of the mid-Shang Dynasty at Panlongcheng in Huangpi County, Hubei Province, disclosed 159 pieces of diverse bronzes of the same date as the site. They supply a fairly systematic knowledge of the characteristics of bronzes of this period which had been hitherto little understood.

In 1976, from a previously undiscovered tomb of the Shang royal house northwest of Xiaotun, the centre of the Yin ruins in Anyang, Henan Province, about 200 pieces of fine bronzes were unearthed in one excavation. Many of them bore the characters "*Fu Hao*." Information gleaned from oracle-bone inscriptions tells us that Fu Hao was the concubine of the Shang king, Wu Ding. This fact intimates the date of these bronzes. The articles from

53.
Glazed mirror inlaid with jade, middle or late Warring States Period, allegedly excavated at Jincun, Luoyang, Henan, diameter 12.2 cm.

54.
San Nian Xing *hu*, wine vessel, late Western Zhou Dynasty, unearthed at Zhuangbai, Fufeng, Shaanxi, height 65.4 cm.

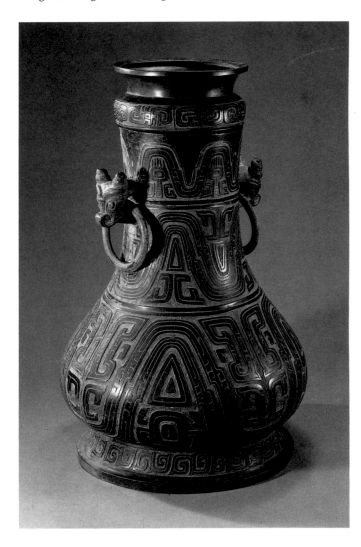

the tomb approximate in number the total yield from 15 previous excavations in the Yin ruins. Many are beautifully wrought with the most exquisite craftsmanship, and present a much broader picture of the late Shang bronzes.

In the same year, 103 pieces of Western Zhou bronzes, of which 74 were inscribed, were discovered in a storage pit at a Zhouyuan site at Baijiazhuang in Fufeng County, Shaanxi. This is one of the largest storage pits of Western Zhou bronzes. Its contents include artifacts made by four generations of the Wei family, and provide valuable material for the study of the periods of Western Zhou bronzes (Pl. 54). On the Shi Qiang *pan* (ritual water vessel) (Pl. 55) found in the pit was an inscription of 284 characters (Fig. 19) relating historical events that took place during the reigns of the Zhou kings--Wen, Wu, Cheng, Kang, Zhao and Mu—which is of great importance to the study of the history of the Western Zhou.

A year later in 1977, a large quantity of bronzes was found in a tomb containing an outer coffin buried in a large rock pit at Leigudun in Suixian County, Hubei Province (Pls. 22-24). Many of the items have unique forms never before seen. The prize of the collection is a *bian zhong*, a set of 64 bells suspended on a three-tiered rack with six bronze figurines carrying swords. The bells weigh a total of 2,500 kg, and the figurines, together with their stands, each weigh more than 300 kg. The inscriptions on the *bian zhong* were embellished with gold that has retained its lustre, and describe the temperament of the individual bells. The words engraved on a *bo* (giant

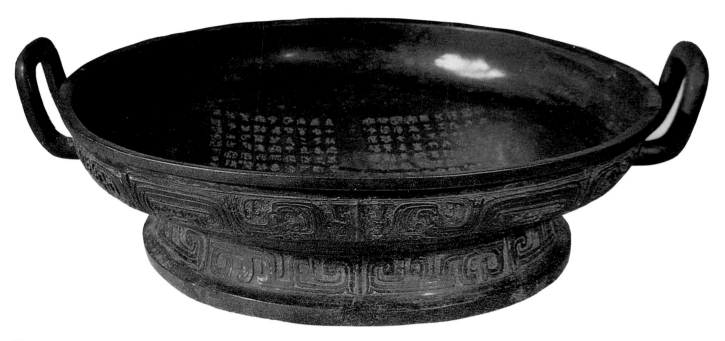

55.
Shi Qiang *pan*, water vessel, middle Western Zhou Dynasty, unearthed at
Zhuangbai, Fufeng, Shaanxi, diameter 47.3 cm.

Fig. 19 Rubbing of an inscription on Shi Qiang *pan* water vessel,
discovered in a storage pit at a site in Zhouyuan, Fufeng, Shaanxi Province,
in 1976.

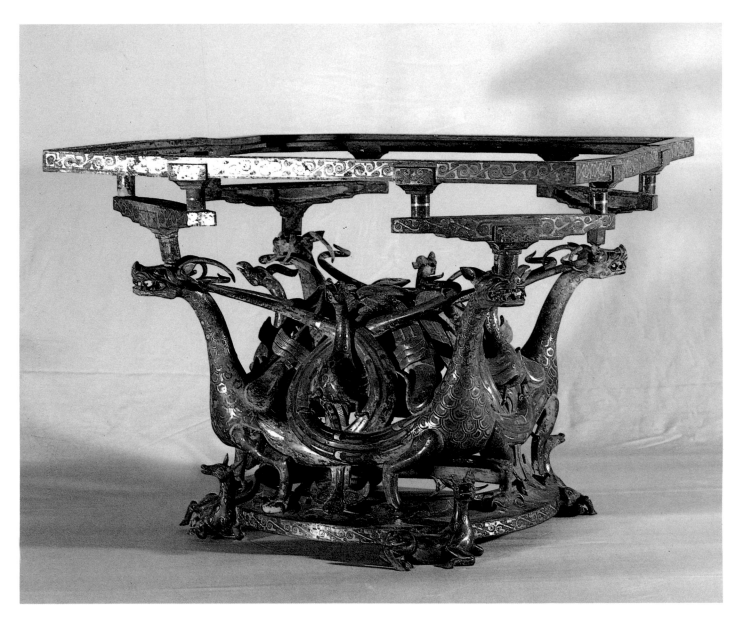

56.
Rectangular *an* with dragon and phoenix motif, stand supporting wine vessel, middle Warring States Period, unearthed at Sanji, Pingshan, Hebei, height 36.2 cm.

bell) on the rack indicate that this large tomb dates back to 433 B.C., in the early period of the Warring States.

Again in 1977, a large tomb at Zhongqiji in Pingshan County, Hebei Province, also revealed a great store of bronzes (Pls. 25-29). This tomb was the mausoleum of the Prince of Zhongshan of the middle Warring States Period. Many of the bronzes are inlaid with gold and silver and are cast in the shape of beautiful creatures (Pls. 56-57). A large *ding* and two *hu* bear long inscriptions of historical value, which suggest that the date of this large

tomb was about 309 B.C., 100 years later than the tomb at Leigudun.

The discovery of such a vast collection of bronzes has provided conditions for rewriting the history of the development of China's ancient bronzes on the basis of archaeological knowledge and to redivide the periods of her Bronze Age. This is the most important result of the study of bronzes.

In the following pages we shall describe the characteristics of bronzes of different periods.

57.
Winged mythological creature, middle Warring States Period, unearthed
at Sanji, Pingshan, Hebei, length 40.5 cm.

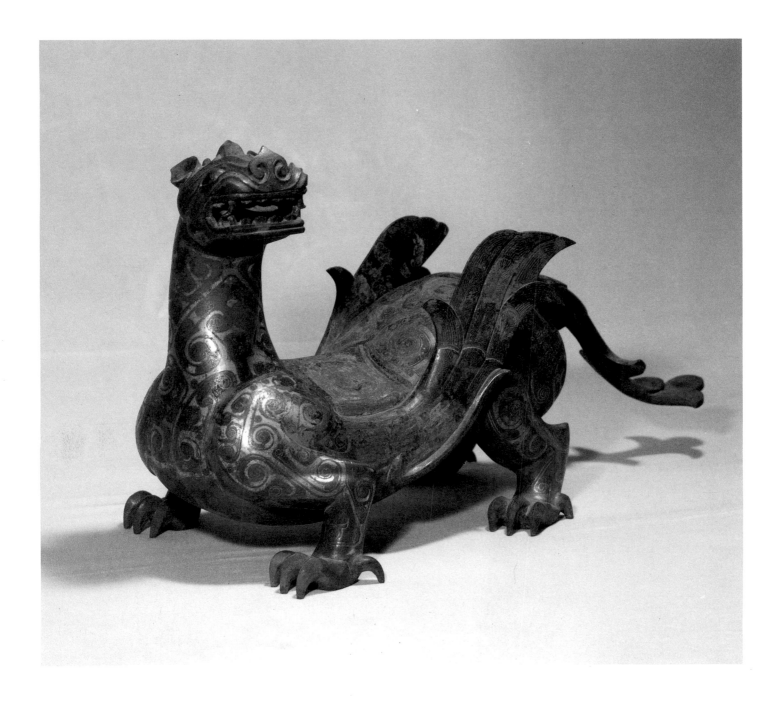

A Long History of Development

CONNOISSEURS of Chinese bronzes can generally, with a fair degree of accuracy, identify and classify antique bronzes according to their shape, decorative treatment, inscription and manufacturing technique. The bronzes of each period have quite distinctive features which provide a reliable guide in assigning each article a date. Studying these characteristics and defining each period are basics in this field of research.

Bronze vessels are classified into five periods according to the historical sequence of the dynasties and the stages of development of bronze casting. These are: the Xia-Shang, the Western Zhou, the Spring and Autumn, the Warring States and the Qin-Han periods. Each of the four periods from the Xia-Shang to the Warring States can be subdivided into three subperiods. The Qin-Han period can also be further divided into five subperiods —the Qin, the former period of the Western Han, the latter period of the Western Han, the Wang Mang interregnum and the Eastern Han. Broadly speaking, bronze vessels can be divided into 17 phases.

The Xia bronze ware, that is, bronzes of the Erlitou Culture, which we have already dealt with in the first section ("The Origin of Chinese Bronzes"), marks the beginnings of Chinese bronze casting. Its upper limits may very well be pushed further back in time, but at present we know very little about this stage and must await future archaeological discoveries.

The identification of an early period in Shang bronzes was a major achievement of scholars of New China. This does not mean that, prior to this, bronze ware of the middle Shang had not been found. On the contrary, bronzes of this period were noted in records and finds before, but they were erroneously placed much later in time, and sometimes had even been attributed to the Han Dynasty. In the 1950s, discoveries in Henan Province in the Shang ruins at Zhengzhou and at Liulige in Huixian County archaeologically established that these articles were of a much earlier date. They were bronzes of the middle Shang, otherwise known as the Erligang period.

A feature common to mid-Shang bronze vessels is their relatively thin walls. Their decoration trended towards bands and the most common motif was the *taotie* ogre-mask. There were also nipple and cloud patterns (Pl.

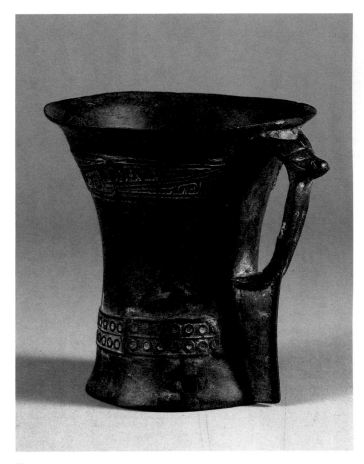

58.
Xie Jiao *bei* cup with cloud design, early Shang Dynasty.

58), but no background design, which Chinese antiquarians call "single layer design." The range of vessel types was already quite wide (*ding* included both round and rectangular ones). Objects of this period have been found in Henan, Shaanxi and Hubei provinces.

Up to n6w, the largest find of mid-Shang bronzes is a collection of 63 articles from a tomb at Lijiaju in the Shang ruins of Panlongcheng in Huangpi, Hubei Province.[1] These comprise four *ding*, one *li*, one *yan* and one *gui* food vessels, three *jia*, four *jue*, one *gu*, one *he* and one *lei* wine vessels, six *pan* bowls, and forty pieces of weaponry and tools (Fig. 20). This large hoard shows that considerable progress had already been made in bronze

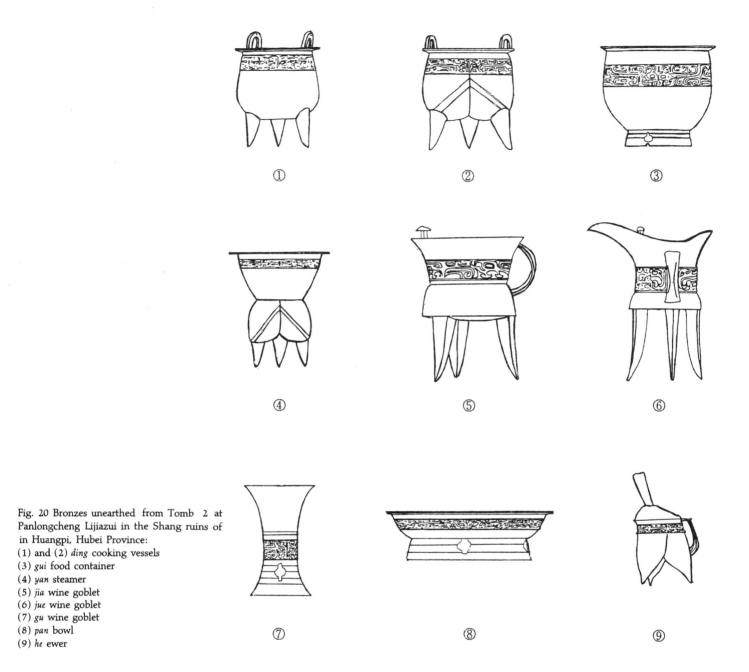

Fig. 20 Bronzes unearthed from Tomb 2 at Panlongcheng Lijiazui in the Shang ruins of in Huangpi, Hubei Province:
(1) and (2) *ding* cooking vessels
(3) *gui* food container
(4) *yan* steamer
(5) *jia* wine goblet
(6) *jue* wine goblet
(7) *gu* wine goblet
(8) *pan* bowl
(9) *he* ewer

metallurgy, and nowhere is this more impressively shown than in the big round *ding* measuring 55 cm high, and an axe 41 cm long. The legs of the *ding* are tapered and the bases of the *jia* and *jue* are rather flat, both of which are characteristic of the bronzes of this period.

The largest vessels of this period to have come to light are two rectangular *ding*, found in 1975 at Duling in Zhengzhou. The bigger of the two is 100 cm high and weighs 86.4 kg (Pl. 59). The weight itself in proportion to its size tells us that the walls are relatively thin. The two "ears" appear rather heavy but are actually hollow inside. The body is almost square, its belly is deep, and the ogre-mask and nipple motifs form a composition very similar to the later rectangular *ding*. Earlier, in Zhengzhou, a damaged mould for casting large rectangular *ding* with nipple patterns had been found. So it appears that these two large *ding* were products of the locality.

The walls of bronzes from the early Shang tend to be thick, with the band pattern evolving into one covering the whole surface of the body. For example, in 1954 at the East Gate of the People's Park in Zhengzhou, a *zun* wine vessel was unearthed. Its body has an over-elaborate ogre-mask motif and rather ornate flanges. In San Francisco and Seattle there are two rectangular *ding* alike to each other and dated a little later than the

afore-mentioned two *ding*, with three bands of decorations covering the entire surface of their bodies, but their bellies are not as deep as those of the bronze vessels found in Duling. Rather more developed examples of this type have been found in Lingbao and Mixian counties in Henan Province, Funan in Anhui Province and Gaocheng in Hebei Province.

Late Shang refers to the period after King Pan Geng moved the Shang capital to Yin in present-day Anyang, Henan Province. The most typical bronzes of this period come from the ruins of the city, which is why this phase is also known as the Yin Ruins Period.

Marked progress was made in bronze casting from the early Shang to the late Shang. In the tombs of the early Yin Ruins Period, mid-Shang forms can be observed, such as the *ding* with tapered legs, and the squat

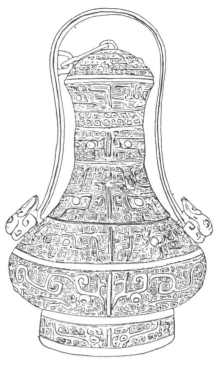

Fig. 21 Slender-necked *you* with a bail handle, unearthed from Tomb 260 in the Yin ruins.

59.
Large rectangular *ding* with ogre-mask and nipple designs, cooking vessel, early Shang Dynasty, unearthed at Zhangzhaiqianjie, Zhengzhou, Henan, height 100 cm.

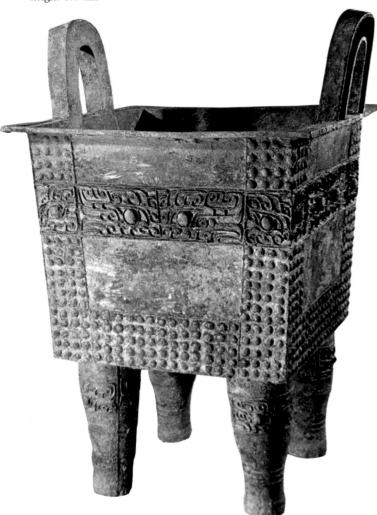

gu. Several bear similar decorative designs too. But many new types of vessels also appeared, such as the pair of finely cast rectangular *jue* found in Tomb 331 at Xiaotun in Anyang. They have a flat base and ogre-mask motif, and along with the rectangular *you* wine vessel with ogre-mask motif and flanges discovered from the same tomb, are completely different from those of the early Shang. Particularly noteworthy are the multi-layered decorations, with the main theme enhanced by a floral under-pattern, which gives the vessels added resplendence. On the whole, in the later Shang, types of bronze ware were increased and their decoration grew more elaborate. The techniques of casting reached a very high level of development by the end of the Shang Dynasty.

The largest group of bronzes of this period so far discovered is that from the Fu Hao tomb described in the third section ("The Earth Cherishes No Treasure"). The tomb is only of medium size compared to those measuring some 300 to 400 square metres found earlier, but the wealth discovered in this particular tomb leaves one to wonder what priceless hoards the larger tombs might have contained had they not been wantonly plundered.

The large rectangular Hou Mu Wu *ding* (Pl. 5) (cf. second section on the "Classification of Bronzes") was accidentally stumbled upon in a passageway to the afore-mentioned large tomb in the Wu Family's Cypress Graveyard at Wuguancun. It must have taken several

hundreds of skilled and well-organized craftsmen co-operating closely to have cast it. It is certainly one of the masterpieces of later Shang bronzes. When this tomb, designated as Tomb 260 of the Yin ruins, was formally excavated in 1984, not many cultural relics were found because of the robberies done hitherto.

A number of extremely elegant vessels have been found in the Yin ruins, among them, a slender-necked *you* with a bail handle (Fig. 21). The neck is detachable from the lid and the belly of the vessel, and when inverted, can be used as a drinking cup. This ingenious design of combining receptacle with cup makes the vessel self-contained, as it were, and easy to carry around.

Every one of the vessels recovered from the royal tombs of the Yin is of exquisite form and bears decorations of unsurpassed beauty. The large rectangular Hou Mu Wu *ding* is a perfect example; despite its huge size, it is a splendidly finished work of art. The three rectangular *he*, the Ox and Deer *ding* and the set of toiletries, unearthed from separate tombs at Xibeigang in Houjiazhuang, are of various sizes but their fine workmanship is undeniable. Excavated at the same time were a single-handled *ding*, also a *yu* with a dragon inside, which can rotate on the base to which it is affixed, and other vessels which are as yet unidentified. These all belong to the royal house of the Shang and are seldom matched by finds in other sites of the same dynasty. Of the Shang bronze vessels that have been brought out of China, the many spectacular ones are all from the Yin ruins. It is greatly probable that the Shang kings monopolized the most skilled craftsmen. The artistic standard achieved in vessels of the royal tombs of the Shang is far above that of vessels possessed by ordinary aristocrats and is an indirect indication of the political status enjoyed by the royal family.

In this same period, there appeared lively bronzes in the shape of animals. The owl *zun*, the elephant *zun* (Pl. 60), the rhinoceros *zun*, and the pig *you* and owl *you*, and even the rectangular *ding* with a stylized human face as its main decorative element (Pl. 61) are of an amazing vivacity and flamboyance that classes them as supreme works of art.

The bronzes of the Western Zhou are direct descendants of the Shang tradition. There had once been a vain attempt to establish an independent line of development for Zhou bronzes. Its failure was inevitable, as archaeological evidence proves that the Zhou culture was the natural development of the Shang's. The pre-Zhou culture was nothing more than a regional culture on Shang territory, which in fact occasionally causes difficulty in distinguishing bronzes of the later Shang from the early

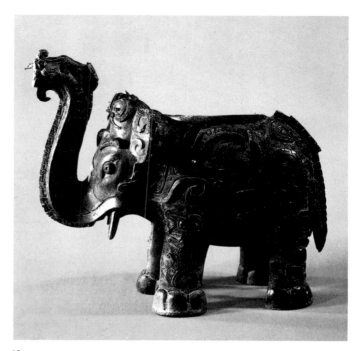

60.
Elephant-shaped *zun*, wine vessel, late Shang Dynasty, unearthed at Shixingshan, Liling, Hunan, height 22.8 cm.

Western Zhou.

However, this is not to say that early Western Zhou bronzes did not have their own distinctive features. For example, the *gui* of the Western Zhou mostly have rectangular stands which were cast as an integral part of the vessel, a trait which is not found in Shang bronzes. But by and large, there is nothing to show that Shang and Zhou bronzes are derived from fundamentally different traditions.

In the past, it was claimed that plainness was the hallmark of the Shang and elaborateness that of the Zhou. Some books on ancient bronzes have declared that Western Zhou bronze decorations were much more elaborate than those of the Shang. Neither of these views correspond with facts. Elaborate decorations were in vogue in the later Shang right up to the early Western Zhou. In regard to inscriptions, it is true that those on Shang vessels were brief, whereas with the coming of the Zhou they suddenly extended into long passages. But this change in no way affected the quality of Zhou bronzes.

On the whole, the types of vessels of the early Western Zhou are basically similar to those of the later Shang, except for some minor differences. The *gu*, for example, which had always formed a pair with the *jue*, was replaced by the *zhi* in many places; the *ding* became fuller and more rounded at the lower half of its belly, a trend which showed itself also in the *zun*, the *you*, the rectan-

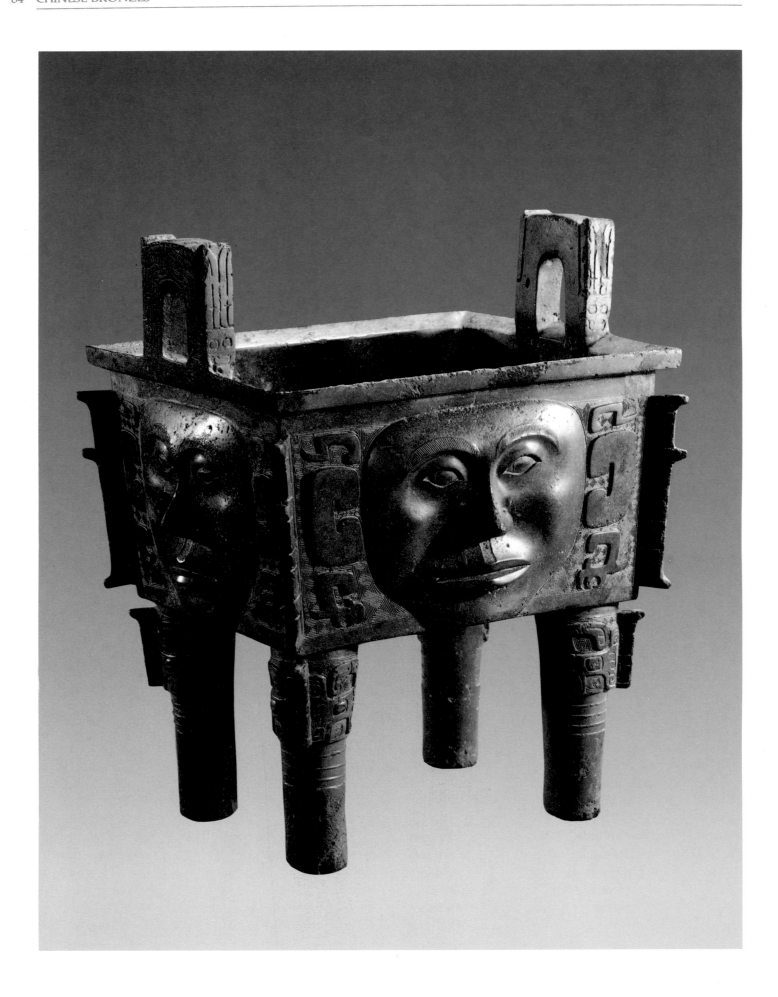

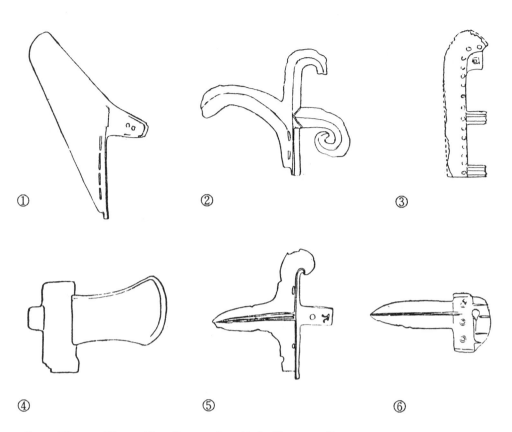

Fig. 22 Weapons, Western Zhou Dynasty. From Baifu, Changping, Beijing:
 (1) *ge* dagger-axe
 (2) *ji* halberd with a curled tang and a hooked shaft finial
 (3) *dao* knife
 (4) *fu* axe
 (5) *ji* halberd with a hooked shaft finial
 (6) *ge* dagger-axe with attachment for haft

gular *fang yi* and other receptacles. As concerns decorations, they were already quite intricate by the later Shang, although the more common elements had been confined to the ogre-mask, bird, *kui* dragon, and cloud-and-thunder motifs. These persisted into the early Western Zhou, with changes only in their composition.

Bronze weapons displayed considerably greater development. Early Western Zhou weapons discovered recently at Baifu and other places in Changping County, Beijing, appeared in many unique shapes (Fig. 22). This may be due to the fact that the State of Zhou was then busily engaged in fighting with its neighbours and therefore paid more attention to producing weapons.

In studying collections of early Western Zhou bronzes, it must be remembered that Shang bronzes were frequently mixed up with them. Inscriptions on bronzes found in caches of this period vary and often bear family

names, which contrasts sharply with the more or less homogeneous tendency of Shang Dynasty inscriptions. For example, in a set of drinking vessels found towards the end of the Qing Dynasty at Doujitai in Baoji, Shaanxi Province, the inscriptions are not unified; nor are the decorative elements in harmony. Some scholars were led to believe that these were collections amassed and mixed by antique dealers. Such a conglomeration in the finds of this period is not rare. We can see this in the hoards of early Western Zhou bronzes unearthed at Kazuo in Liaoning Province and the bronzes from Baicaopo in Lingtai, Gansu Province. This phenomenon is explained by the fact that the State of Zhou occupied territory to its east, and capturing an immense amount of spoils, assembled them into collections or used them as funerary objects. Only a small part of the bronzes had actually been cast in Zhou times. Ancient books speak of "dividing up the vessels of Yin," and the discoveries of this period can verify this description.

The most important finds of early Western Zhou bronzes in recent years were located at Liulihe in Fang-

61.
Rectangular *ding* with human-mask motif, cooking vessel, late Shang Dynasty, unearthed at Huangcun, Ningxiang, Hunan, height 38.5 cm.

Fig. 23 Bird motif.

Fig. 24 *Taotie* (ogre-mask) motif on Ban *gui* food container.

shan, Beijing, at Xizhang Village in Yuanshi, Hebei Province, at Machanggou, Beidong and Shanwanzi in Kazuo, Liaoning Province, at Hejia Village in Qishan and at Gaojiabao in Jingyang, both in Shaanxi Province, and at Baicaopo in Lingtai, Gansu Province.

The early Western Zhou spanned the reigns of Wu, Cheng, Kang, and Zhao, while the middle Western Zhou covered the rule of Mu, Gong, Yi and Xiao. A salient feature of bronzes of the middle Western Zhou is the simplicity of their decoration (consisting usually of the plain band pattern) despite the longer inscriptions, and a deterioration in their manufacturing technology verging on the crude. After King Gong, the delicacy of the earlier bronzes was noticeably lacking. The Western Zhou Dynasty reached its zenith at the time of Zhao and Mu, but with the latter's love of war and journeying, the government grew steadily weaker and state affairs were neglected, leading to the gradual decline of the Zhou Dynasty. This social and political decline is detected in the bronzes of this period.

During the reign of King Mu, the bird motif (Fig. 23) became quite popular, a trait handed down from the reigns of Kang and Zhao. Its distinctive feature was the head of a bird looking back. The bronzes of this period, such as the Ban *gui*, frequently had a *taotie*, or ogre-mask, motif in fine raised lines (Fig. 24). These are traces of earlier styles, but by the time of Gong and Yi, they had all vanished.

Of the middle Western Zhou bronzes discovered in recent years, the most important were those found at Baijiazhuang in Fufeng, Rujiazhuang in Baoji, Pudu Village in Chang'an and Lijia Village in Meixian—all in Shaanxi Province. A major achievement in the bronzes of the middle Western Zhou was the appearance of the musical instrument *zhong*, which, as described elsewhere above, evolved from the *nao*. The sets of three *zhong* found at Rujiazhuang in Baoji and at Pudu Village in Chang'an are the oldest chimes of bells yet discovered in China. A horse-shaped *zun* with a small lid on its back and an inscription on its chest found at Lijia Village in Meixian County, can be considered one of the best

examples of this period. Several collections unearthed at the Zhouyuan site also afforded a few important bronze vessels with long inscriptions.

The simple style which evolved in the middle Western Zhou was continued into the late Western Zhou and even to the early Spring and Autumn Period.

The late Western Zhou included the reigns of Yi, Li, Gonghe, Xuan and You. New types of bronzes, such as the *xu*, and novel motifs, such as the circular pattern which emerged in the reign of Xiao, became very common in the late Western Zhou. The varied new styles, and the bold innovative spirit of the Shang and early Western Zhou periods had completely vanished by this time. The forms of the late Western Zhou bronzes were

62.

Mao Gong *ding*, cooking vessel, late Western Zhou Dynasty, reportedly unearthed at Qishan, Shaanxi, height 53.8 cm.

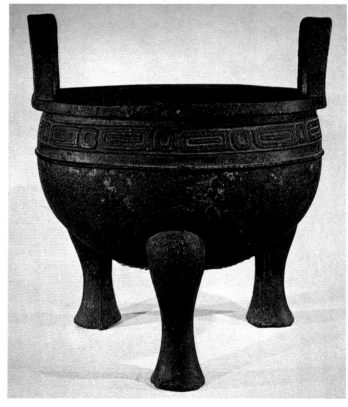

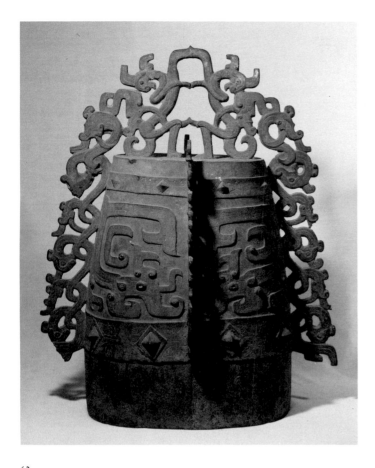

63.
Ke *bo*, musical instrument, late Western Zhou Dynasty, reportedly unearthed at Renjiacun, Fufeng, Shaanxi, height 63.5 cm.

much the same; even the important Mao Gong *ding* (Pl. 62) with its long inscription of 497 characters has no aesthetic appeal. Some groups of bronzes of this period, such as the Liang Qi collection found in the 1940s at Zhouyuan, had inscriptions containing inverted or wrong characters which indicates only too clearly the degenerating quality of contemporary craftsmanship. There was a certain degree of revival in bronzes during the reign of King Xuan following a political resurgence, but apart from the appearance of a few exciting specimens, nothing of great notability was produced.

Most late Western Zhou bronzes have been retrieved from hoards unearthed in Guanzhong, Shaanxi. As a result of rebellions staged by the people, King Li was driven away. Later, in the last years of the reign of King You, tribes from the west overran the Zhou kingdom and toppled the dynasty, whereupon the Zhou royal house moved its capital east. During these two tremendous upheavals the aristocracy was scattered and forced to leave behind their caches of bronzes. Since the Qing Dynasty, many hoards have been found around Zhouyuan alone, of which the most important were discovered

in Renjia Village in 1890 (Pl. 63), Kangjia Village in 1933, Renjia Village in 1942, Qijia Village in 1960, Qiangjia Village in 1974, Dongjia Village in 1975 and Zhuangbai in 1976. Most hoards belonged to a single family of aristocrats and were often the collection of many generations. Many bear significant inscriptions and have been of enormous value to historical research.

Dazzling displays of bronzes of the most exquisite workmanship have been found in many tombs of the Shang royal family, but no royal tomb of the Western Zhou Dynasty has so far been found. It is said that there is a record of the tomb sites of the kings of the Zhou Dynasty, but its accuracy is still highly dubious. The only bronzes found and identified as pertaining to the Zhou kings are two *zhong* and a *gui*, cast for King Li. The inscriptions on both bear the character 麩 (*hu*), which is homonymous with King Li's name 胡 . One of the Hu bells that bears a long inscription and is known as the "Cong Zhou Bao Zhong" (The Precious Bell of the Zhou Capital) is housed in the Palace Museum in Taiwan. The Hu *gui* is a particularly large, rectangular-based vessel as described before.[2] We can conclude from this, that in the Western Zhou period too, kings possessed magnificent bronzes of a quality incomparable to those of the aristocrats. And this may be only the first of many yet to be discovered.

Up to the present, however, the great majority of Western Zhou bronzes so far unearthed are those that had been cast for ministers and high officials of the royal court, while very few have been found belonging to principality rulers. Moreover, few of the bronzes belonging to these rulers bear long inscriptions. By 770 B.C. however, when the Zhou house was forced to move its capital east and the authority of the throne was greatly weakened, the power of the princes and their ministers rose correspondingly and this historical change was reflected in the bronzes of the time. Fewer royal bronzes have been found dating from this period and finds show that bronze casting proliferated instead in the various principalities. Bronzes have been recovered even in lesser states such as Deng of the Man Clan, Ruo of the Yun Clan, Zhu of the Cao Clan and so on.

The bronzes of the early Spring and Autumn Period are basically continuations of the late Western Zhou period. Insignificant changes are evidenced, such as the two halves of the *yan* being cast separately instead of together. The decorations remained much the same as in the Western Zhou period. Some rather important bronzes of this phase have been unearthed at Shangcunling in Sanmenxia, Henan Province, at Nanfu in Huangxian, Shandong Province, and at Sujialong in Jingshan, Hubei

Fig. 25 Rubbing from a gold-inlaid inscription on Luan Shu *fou* wine container, now in the collection of the Museum of Chinese History.

Province.

Mention must be made of the hoard of bronzes found in 1978 at Taigongmiao in Baoji, Shaanxi Province. This cache contained three *zhong* and five *bo* marked "Qin Gong" (Prince of Qin) belonging to the early Spring and Autumn Period. Studies reveal that the owner was Prince Wu of the Qin who ascended the throne in 697 B.C. The forms and decorations seen in this collection are much more analogous in tradition to the Western Zhou period than any of the bronzes of the more eastern princely states. This was because the State of Qin had built on the site of the ruins of the Western Zhou and had little to do with neighbours to its east, so it maintained many of the characteristics of the Western Zhou bronzes.

Another big change in bronzes took place in the middle of the Spring and Autumn Period. Whether in form, in main motif, in type of script used or in manufacturing technique, they all manifested new developments, creating a new phase in the world of bronze making. Not many representative works of this period have been recovered, but a brief description of a few follows.

In Tengxian County in Shandong, a set of Feng Shu bronze vessels including a ladle with an animal motif inlaid in copper was found. At that time, this type of inlaid decoration was stylistically as well as technically novel, and became widespread by the late Spring and Autumn Period.

In the middle Spring and Autumn Period, the coiled

64.
Square *hu* with lotus and crane motif, wine container, middle Spring and Autumn Period, unearthed at Lijialou, Xinzheng, Henan, height 118 cm.

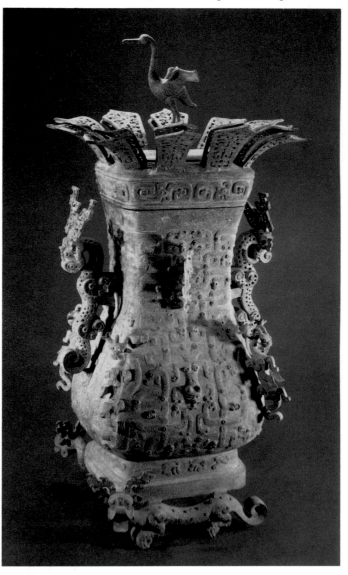

dragon motif was dominant and became increasingly stylized. A number of large bronze vessels were cast at this time, such as the *jian* water container of the Marquis of Qi (which was part of the dowry for the Marquis' daughter) found in a ditch at Zhongzhou in Luoyang, Henan. In the late Northern Song Dynasty at Linzi, capital of the State of Qi (in present-day Shandong Province), a Shu Yi *bo*, and 13 Shu Yi *zhong* were found with a total of 492 inscribed characters. Unfortunately, there is not a trace of these left today.

Among late Spring and Autumn bronzes, the discovery of a set of bronzes at Lijialou in Xinzheng County, Henan Province,[3] once created a tremendous stir both at home and abroad. There were altogether a hundred pieces, among which a pair of rectangular *hu* attracted the most attention (Pl. 64). The profile of these rectangular *hu* followed the tradition set in the Western Zhou, but on the lid of the *hu*, standing erect at the centre, is a beautiful solitary white crane and on the sides of the *hu* are two dragon-shaped ears. Together with the beast lying at the base the whole piece was a completely new artistic concept.

Some important finds were made in recent years at Shangma Village in Houma, Shanxi Province, and in the tomb of the Marquis of Cai (died 491 B.C.) near the West Gate of Shouxian County, Anhui Province. Inside the tomb were several bronzes wrought in novel shapes such as the *dui* food vessel, whose form is very similar to those of the subsequent Warring States Period. Most of the bronzes in this cache have finely cast decorations. At the time, the technique of copper inlay had become quite widespread, evidenced in the decorations in all the *zun, fou, dui* and *dou* found in the tomb. The style of these bronzes can be said to have undergone a radical change.

The late Spring and Autumn Period to the early Warring States witnessed the start of a significant era in ancient Chinese history known as "the hundred schools" period, bringing to the fore such great thinkers as *Lao Zi* (Lao Tzu), Confucius, Sun Wu and *Mo Zi* (Mo Tzu). Culture, science and the arts made tremendous progress. The bronzes of this time were creations of superb artistry, and attained a grandeur and magnificence almost without parallel. In the previous section we mentioned the excavation in 1923 at Liyu[4] (Pl. 65) in Hunyuan County, Shanxi, of bronze objects dating from this period. The discovery created an immediate sensation in academic circles. Formerly, the solemn grandeur of Shang and Western Zhou specimens had made a vivid impression in the bronze world. When the bronzes in Hunyuan were found to be so totally different from them, this new style

was, at first, attributed to the Qin Dynasty. Later, the bronzes were proven to be of Spring and Autumn-Warring States origin and representative of a northern style of this period, a revelation which made an equally deep stamp in the history of Chinese bronzes.

Due to social and political causes, bronzes cast between the Spring and Autumn and Warring States periods can be more or less categorized into two major streams: the southern and the northern schools. All discoveries made after the liberation of the country in 1949 at Jiagezhuang in Tangshan and at Beixinbo in Huailai, both of Hebei Province, pertain to the northern school. The unprecedented discovery at the Leigudun tomb in Suixian County, Hubei, contained representative works of the southern school. The bronzes of these two schools differ in style and form, but they do have one trait in common, namely, their decorations. Instead of the flat linear patterns of the past, there were now relief decorations (Pl. 66), and even intricate three-dimensional designs (Pl. 67). Inlaid inscriptions, together with inset precious stones and metals, produce a most striking overall effect.

A salient feature of the early Warring States bronzes was the widespread use of inlay and decorative motifs depicting lively scenes of the main aspects of social activity in those days. These were cast or incised (Pl. 68), as is the case of the *hu* (Pl. 20) found at Baihuatan in Chengdu, Sichuan Province, bearing three registers of illustrations showing an archery contest, people picking mulberry leaves, a banquet scene and a military attack.

The early Warring States Period covers approximately the latter half of the 5th century B.C. With the coming of the 4th century B.C., that is, the middle Warring States Period, certain changes could be observed. In recent years, bronzes from tombs at Changtaiguan in Xinyang, Henan Province, and at Wangshan in Jiangling, Hubei Province, have been recognized as being representative of the southern school. On the other hand, those unearthed at Baijia Village in Handan, Hebei Province (Pl. 69), and in Prince Zhongshan's tomb at Zhongqiji in Pingshan, also in Hebei, are typical of the northern school. Apparently some of the bronzes found earlier at Jincun Village in Luoyang, Henan, should also be included in this period.

The elaborate relief patterns which had flourished in the early years of the Warring States Period became more rare (Pl. 70). Most of the vessels of this period tended to have thinner walls.

A prominent feature of the bronzes of the middle Warring States Period was the popular use of gold and silver inlay. This is exemplified by the bronze vessel stand of a tiger devouring a deer unearthed at Pingshan

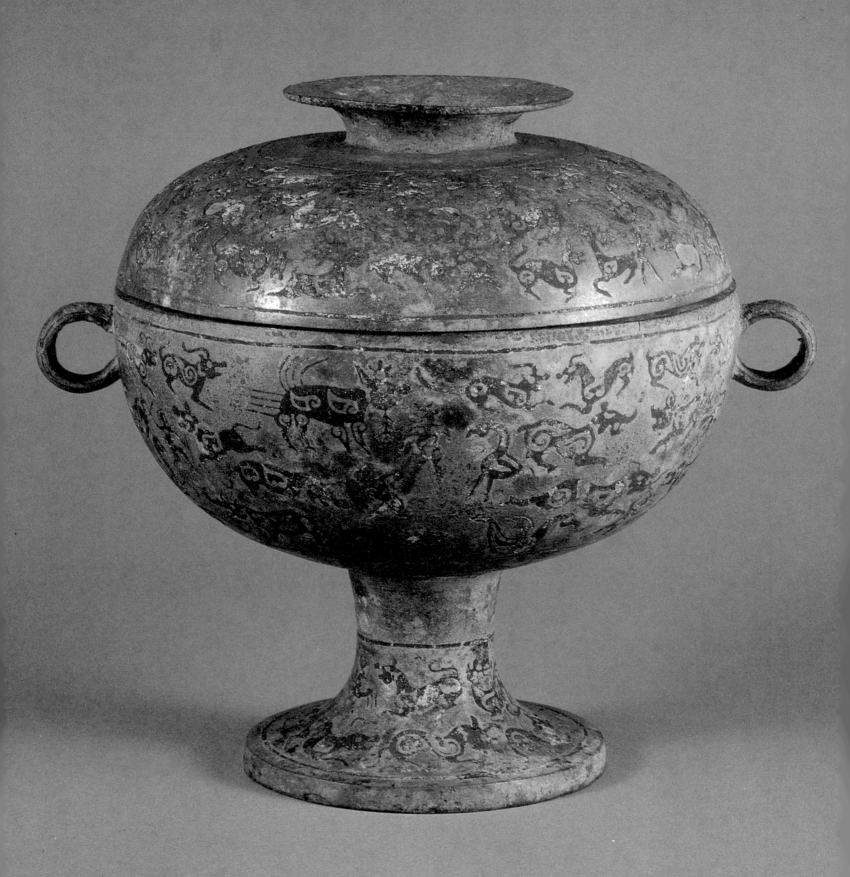

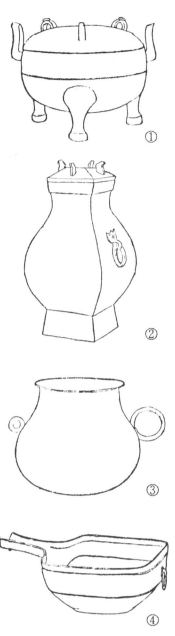

Fig. 26 Bronzes of the Qin Dynasty
unearthed in 1975 at Yunmeng,
Hubei Province:

 (1) *ding* cooking vessel
 (2) *fang* wine container
 (3) *mou* cooking vessel
 (4) *yi* ewer

66.
Pu shou knocker with relief decoration, middle or late Warring States Period,
unearthed at Laolaotai, Second Capital of Yan, Yixian, Hebei, length
74.5 cm.

65.
Copper-inlaid *dou* with hunting design, food container, early Warring
States Period, unearthed at Liyu, Hunyuan, Shanxi, height 20.7 cm.

in Hebei (Pl. 28), and the inlaid *ding* with cloud patterns found at Baijiazui in Xianyang, Shaanxi Province. The gold and silver inlay complement each other perfectly and generally cover the whole vessel.

In the late Warring States Period, that is, during the 3rd century B.C., the State of Qin was pre-eminent and gradually annexed the six states to its east through a series of wars. The bronzes basically followed the style of the middle period without much development being evidenced. The large tomb discovered earlier at Zhujiaji in Shouxian County, Anhui (in all probability that of Prince You of Chu who died in 228 B.C.), contains bronzes inherited partly from earlier generations of Chu princes.[5] The bronzes Prince You himself had had cast were generally simple and plain, showing the decline of the power of the State of Chu and an inability to innovate.

There are other caches of late Warring States bronzes. In the ruins of the second capital of the State of Yan in Yixian County, Hebei, caches of bronze weapons had been found previously, of which those bearing inscriptions were mainly of the states of Yan and Zhao. More have been unearthed in recent years in the same locality. Also, the former ancient capital of the State of Han at Xinzheng in Henan Province has offered up hoards of weapons. Most of the weapons are partly damaged or

67.
Ding with hollowed-out interlaced hydra design, cooking vessel, early Warring States Period, unearthed at Liuquan, Xinjiang, Shanxi, height 50 cm.

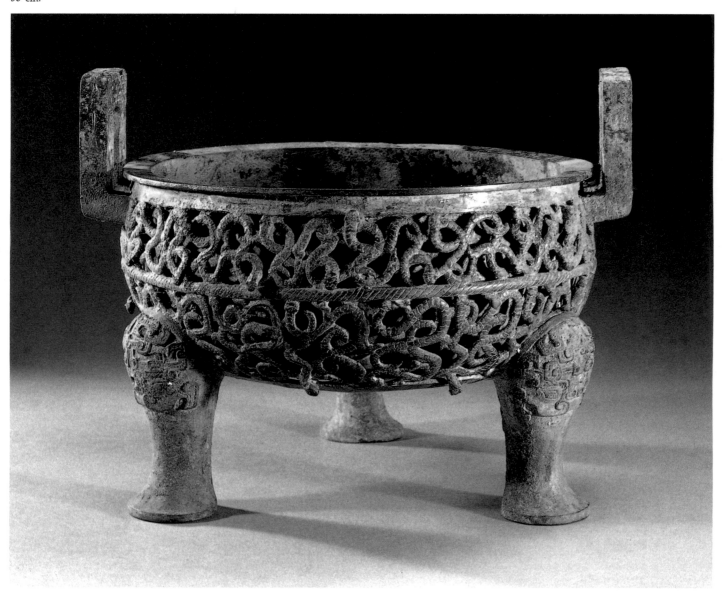

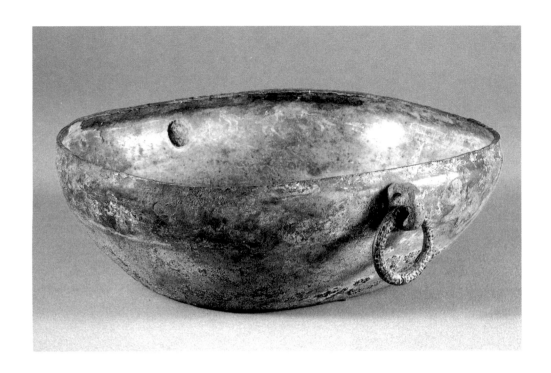

68.
He (and detail) with incised design, wine vessel, early Warring States
Period.

69.
Yue of the Marquis of Zhongshan, weapon, middle Warring States Period,
unearthed at Sanji, Pingshan, Hebei, length 29.6 cm.

70.
Triangular *dui* with cloud design, food container, middle Warring States
Period, height 25.4 cm.

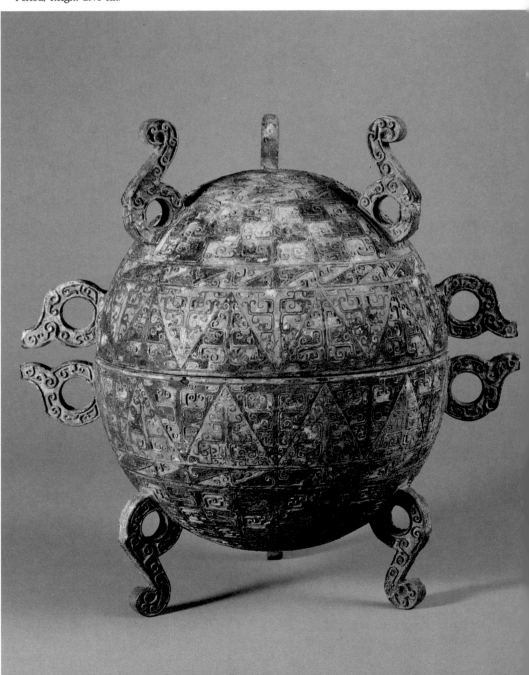

71.
Elliptic measure, Qin Dynasty, length 23.3 cm.

72.
Fish-shaped oblate *hu*, wine vessel, Western Han Dynasty, height 31.8 cm.

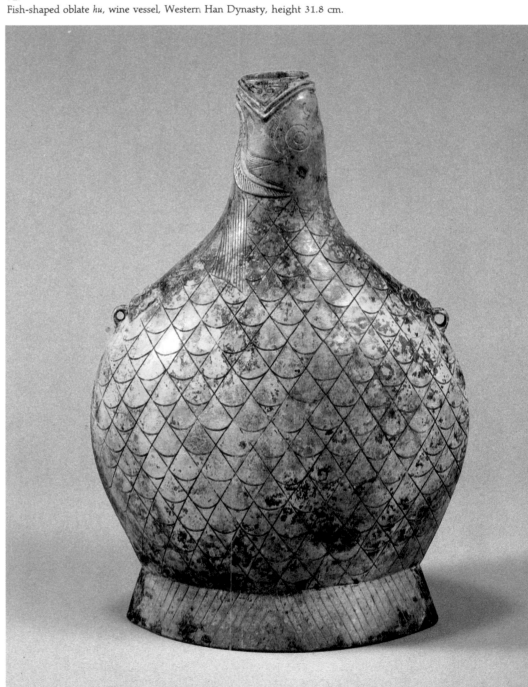

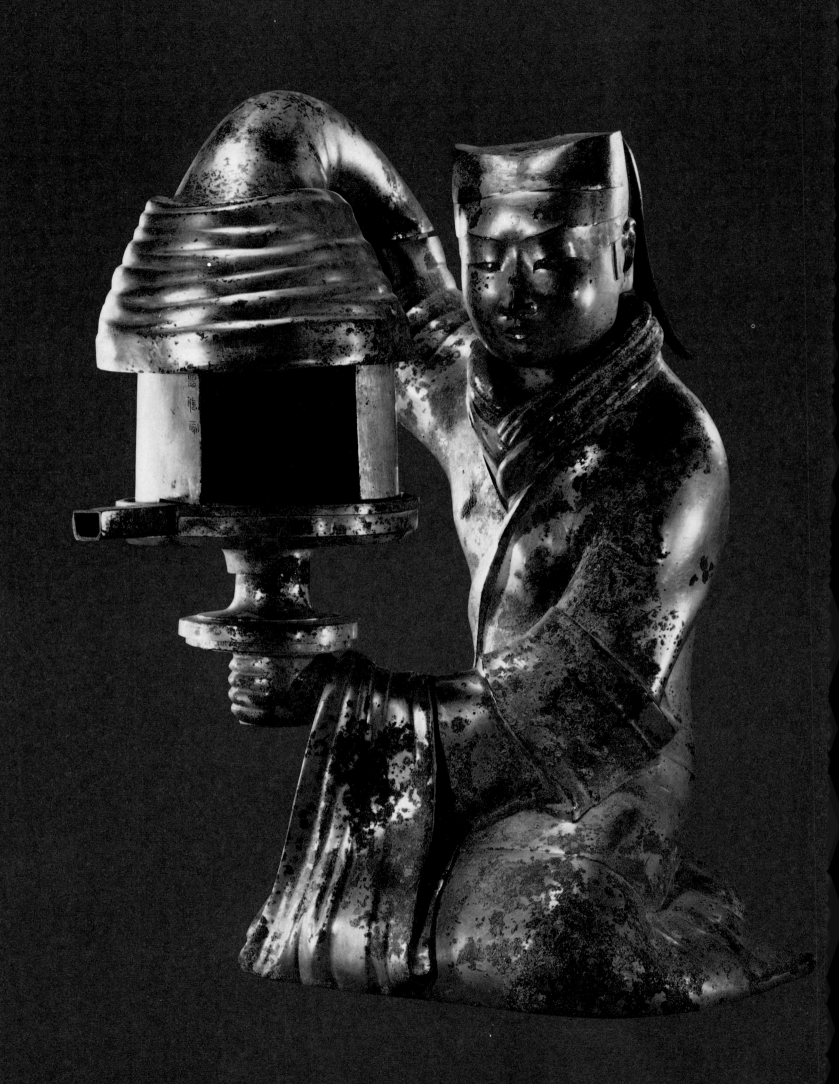

73.
Changxin (Eternal Fidelity) palace lamp, Western Han Dynasty, unearthed at Lingshan, Mancheng, Hebei, height 48 cm.

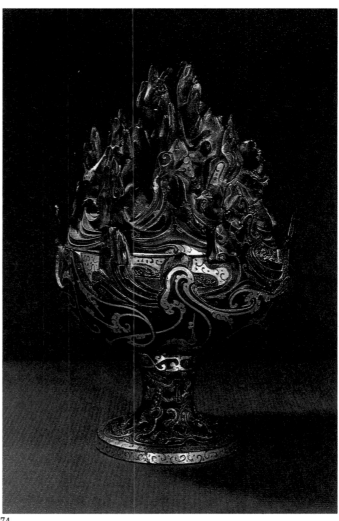

74.
Boshan incense burner with gold inlay, Western Han Dynasty, unearthed at Lingshan, Mancheng, Hebei, height 26 cm.

broken, and are probably remnants left behind when the State of Qin overran these lesser states towards the end of the Warring States Period.

The Qin Dynasty lasted a brief 15 years and we know very little about the bronze ware of this period. The greater part of the bronzes found dating from this time has consisted of weights and measures, with imperial edicts on unifying the country's weights and measures inscribed on them (Pl. 71). Towards the end of 1975, a number of Qin tombs were discovered in Yunmeng, Hubei, containing clearly dated bronzes (Fig. 26) of the Qin Dynasty. People's knowledge of the Qin bronze ware had steadily increased ever since.

After the Qin, bronze played an increasingly lesser role in social life and, as more bronzes were made for secular use, although the level of artistry of many vessels remained high (Pl. 72). The best bronzes of the Western Han Dynasty are probably represented by those excavated from the tomb of Prince Liu Sheng of Zhongshan Principality at Mancheng in Hebei, of which the gold-plated Changxin (Long Fidelity) palace lantern (Pl. 73) and the gold-inlaid Boshan incense burner (Pl. 74) are superb examples. Of Eastern Han bronzes, undoubtedly the most attractive is the remarkable bronze galloping horse (Pl. 75) unearthed in 1969 from a tomb at Leitai in Wuwei, Gansu Province, along with a collection of bronze horsemen and chariots (Pl. 76). The latter reproduce in miniature the complete cavalcade led by the deceased¹ in his lifetime. However, from the technical viewpoint, the bronzes cast in the reign of Wang Mang were much more elegant than those of the Western Han, which preceded it, and the Eastern Han, which followed it.

At the end of the Eastern Han Dynasty, ceramics played an increasingly greater role and the usefulness of bronze vessels in daily life assumed a less important position. With the rising prestige of iron tools and vessels, bronze ware fell slowly into disuse. Subsequently, only the casting of bronze mirrors made any headway at all. Thus, as regards China alone, research into ancient bronzes ends with the Eastern Han Dynasty.

¹ Hubei Provincial Museum, "Bronzes of the Erligang Period in the Panlongcheng Shang Ruins," *Cultural Relics*, No. 2, 1976.

² Fufeng County Museum, "The Hu *Gui* of Western Zhou King Li Found in Fufeng County, Shaanxi Province," *Cultural Relics*, No. 4, 1979.

³ Sun Haibo: "Xinzheng Bronze Vessels."

⁴ Shang Chengzuo, "Illustrations of Hunyuan Bronze Vessels."

⁵ Beijing History Museum, "Chu Antiques, Exhibition Catalogue."

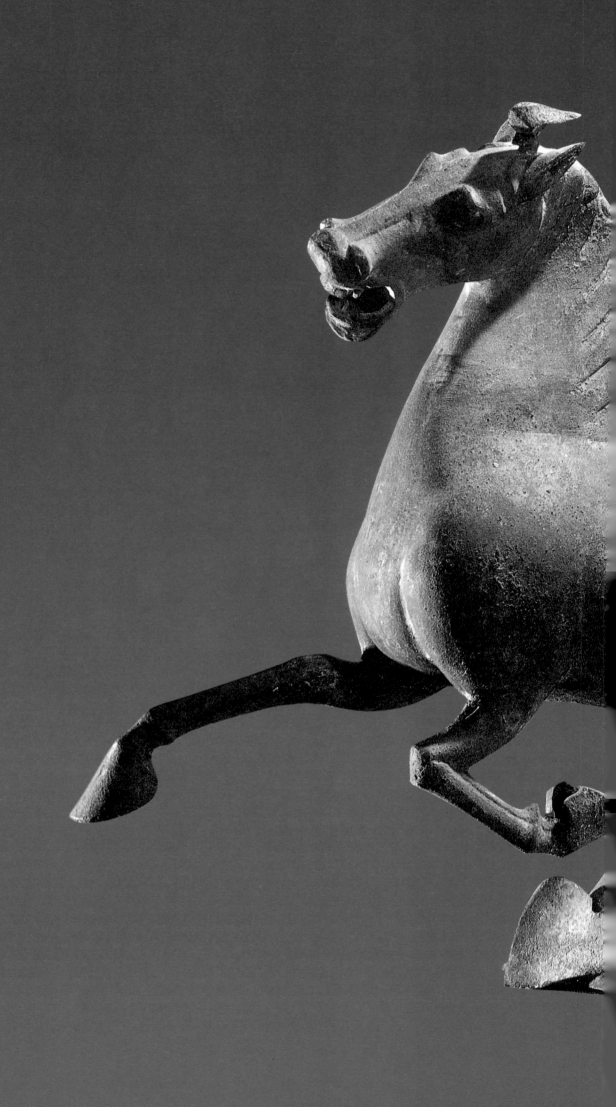

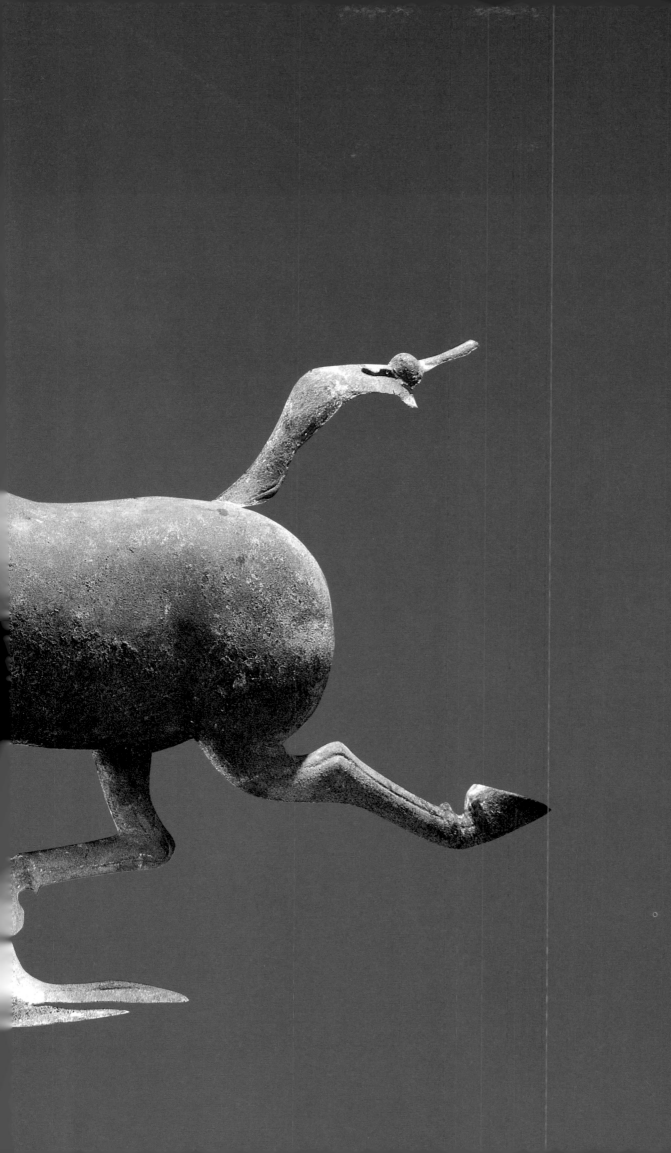

◀ 75.
Bronze galloping horse, Eastern Han Dynasty, unearthed
at Leitai, Wuwei, Gansu, height 34.5 cm.

76.
Bronze horse, chariot and figurine, Eastern Han Dynasty, unearthed at
Leitai, Wuwei, Gansu, height 42 cm.

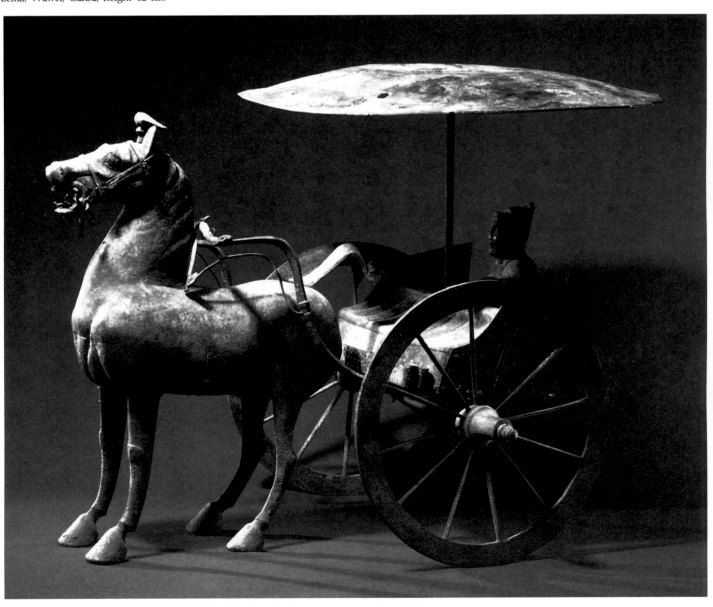

Testaments of Ancient History

CHINA'S ancient bronzes are invaluable not only as outstanding works of art but also as important historical attestations. In the latter case, we refer specifically to bronzes bearing inscriptions. (However, this does not imply that those without inscriptions are inconsequential, as was the opinion of certain epigraphers of the Song and Qing dynasties, who contented themselves merely with examining rubbings from bronzes, paying no attention at all to their workmanship, decorative pattern or function.) In order to acquire a thorough knowledge of bronzes, a critical analysis must be made of both their physical aspects, including their manufacturing technique, and the inscriptions they carry.

In most cases, inscriptions were cast on bronzes. Characters were mostly sunk into the surface—this was known as intaglio—but were occasionally executed in relief. Characters on bronzes dating back to the Shang and Western Zhou dynasties were usually cast on the vessels; only in a few instances were they incised with sharp tools. On display in the Shaanxi Provincial Museum is a huge *ding*[1] of the late Shang period which has seven characters cast on it. To their left are another two lines of about ten characters which were obviously added later. The first seven are in the style of the Shang, while the others appear to be in the style of the early Zhou. In all probability, the vessel was originally made by the Shang but seized as a war booty by the Zhou, who then carved the other two lines. So far, carved inscriptions like this are rare.

By the Spring and Autumn Period, inscriptions wholly enchased with tools appeared. In 1893, a set of four bronzes—a *ding*, a *dui*, a *pan* and a *yi*—used by the Marquis of Qi at his daughter's wedding ceremony were found in Yixian County, Hebei. They are now kept in New York's Metropolitan Museum of Art. The workmanship and decorative pattern of the *ding* indicate that the vessel was made in the middle Spring and Autumn Period. It also bears a carved inscription, which a scholar by the name of Liu Xinyuan of the late Qing Dynasty had once considered as forged. Among the bronzes found in 1963 at Yangshan in Linqu, Shandong Province, was another *ding* very similar in shape to the one

mentioned above, except for its flat lid, and a chain-handled *hu*, which has an inscription of six lines enchased on it. These examples supply adequate proof that carved inscriptions on bronzes had already existed in the Spring and Autumn Period. Towards the middle of the Warring States Period, most bronze inscriptions were incised. The three sacrificial vessels unearthed in Pingshan, Hebei Province, from the tomb of the Prince of Zhongshan were all inscribed with knives, and the splendid workmanship with which this was executed again demonstrates the high level of perfection attained in this particular field.

Inscriptions on bronzes were frequently mentioned in ancient Chinese books. Bronze was a solid and long-lasting material, so bronze ware was used for recording events and texts to be long remembered, including rewards and appointments received by the owner from the king, meritorious exploits in war, treaties, oaths, and instructions and admonitions for future generations. These inscriptions today serve as important data in studying China's ancient history.

Of all literary works handed down from ancient times on the history of the Shang and Zhou dynasties, the most important ones are the authentic articles contained in *Shang Shu* (*Book of Historical Documents*). The longest articles in "The Records of the Zhou" contain only 1,000 words each, while others such as "The Metal-Bound Coffer," "The Numerous Officers" and "Against Idleness" total no more than 500 words each. However, bronzes like the Shu Yi *zhong* and *bo*, the Mao Gong *ding* and the *ding* of the Prince of Zhongshan, all bear fairly lengthy inscriptions consisting of about 500 characters. In this respect, bronze inscriptions are comparable to celebrated historical works in the amount of detailed information they embody.

Many a time, historical records are confirmed by inscriptions on unearthed bronzes. Such was the case with the Li *gui* and He *zun* (Pl. 9) recently recovered.

The Li *gui* referred to was found in 1976 at Lingkou in Lintong, Shaanxi Province. On the interior of its belly is an inscription of 32 characters divided into four lines. It describes how King Wu of the Zhou Dynasty launched a punitive expedition against King Zhou of the

Shang Dynasty on the day of *jia zi*[2] and occupied the latter's territory. The article "Oath Taken at Mu" in the *Book of Historical Documents* was the oath taken by King Wu before his final assault on King Zhou. The article entitled "Captives" in *Yi Zhou Shu* (*Lost Records of the Zhou*) also relates the expedition against King Zhou in the early days of the Zhou Dynasty. Both accounts describe how King Wu led his army to attack the Shang capital. Early on the day of *jia zi* in the second month of the lunar calendar, he took an oath to confront the Shang army for a decisive battle. The latter suffered a great defeat. The King of Shang, realizing that all was lost, climbed onto Lutai Terrace and burned himself that very night, marking the end of the Shang Dynasty. This historical event has been proven by a detailed rendering of it, including the actual day on which the decisive battle was fought, in the Li *gui* inscription.

Another article in *Lost Records of the Zhou* entitled "Building the Capital" tells of how King Wu spent a sleepless night after returning from the victorious battle to the State of Zhou in the west. The official in attendance reported this to his brother, the Duke of Zhou. When the latter went to pay his respects to the king, the king confessed that the dynasty was far from being consolidated despite his having vanquished the Shang. He suggested that Zhou build a new capital on the ruins of the former Xia Dynasty in the area of the Yishui and Luoshui rivers. According to "The Announcement of the Duke of Shao" and "The Announcement Concerning Luo" in the *Book of Historical Documents*, the Duke of Zhou carried out King Wu's plan after his death, and the Duke of Shao was sent to the Yishui and Luoshui rivers to survey the region and determine the actual location of the new city. Accordingly, the Eastern Capital of the Zhou was later built, and this city was the origin of present-day Luoyang. Although it had long been known that the new city was constructed at the will of King Wu, yet there was no reliable evidence supporting this belief. Ordinary history books, therefore, reproduced only that part of the story from the *Book of Historical Documents* which states that the Eastern Capital was constructed by the two dukes, Zhou and Shao, and made no mention of King Wu's plan for the new city.

Then, in 1963, a beautifully wrought bronze *zun* (He *zun*) was brought to light at Jiacunyuan in Baoji, Shaanxi Province (Pl. 77). Thirteen years later, in 1976, it was sent to Beijing, where a highly important inscription of 122 characters divided into 12 lines was discovered in its interior after a thick layer of rust had been removed from its base. It registers King Wu's report to Heaven about his plan of establishing the Eastern Capital, from where

he would exercise his rule over the people living all around. This account, corresponding with the relevant descriptions in "Building the Capital," reveals the foresight with which King Wu set up his project.

The two bronze inscriptions mentioned above have offered nothing new that has not already been dealt with in historical records, but they have proved beyond a doubt the authenticity of the stories narrated in ancient books. In this sense, bronze inscriptions are buried evidences of ancient history.

Generally speaking, apart from verifying information contained in historical chronicles, inscriptions on bronzes often furnish details on given historical events.

The expedition south of King Zhao of the Zhou Dynasty is recounted in several history books, including the well-known *Zuo Zhuan* (*Annals of Zuo Qiuming*). When King Zhao succeeded to the throne, in order to carry on the cause of his predecessors, King Cheng and King Kang, he tried to expand the power of the Zhou Dynasty and sent expeditionary forces against the State of Chu in the south. According to the ancient edition of *Zhu Shu Ji Nian* (*Annals on Bamboo Strips*), this incident took place between the 16th and 19th year of King Zhao's reign. His armies set out in the 16th year and, after fording the Hanshui River, encountered on the opposite bank a huge, black rhinoceros. In the 19th year the climate took a strange turn and six armies under Zhao were wiped out in the river valley. Legend has it that the people living along the river shore so greatly resented being harassed by these intruders that they made a wooden boat, assembling all the parts with glue. The king boarded the boat which, when it reached the middle of the river, fell apart, thus sinking all and sundry.

In 1118, the first year of the reign of Chonghe of the Northern Song Dynasty, six bronzes were found in Hubei Province in the locality of Xiaogan, originally called Anzhou, hence they were popularly known as the "six vessels of Anzhou." Careful study of their inscriptions was made in recent years, and it was finally confirmed that they all discussed the same theme of King Zhao's southward expedition. Similar accounts were also inscribed on other bronzes. When all the pieces of information were connected the story became clear: King Zhao was quite successful with his expedition at first. His army set out from the State of Tang, located to the north of present-day Suixian County in Hubei Province, and headed south through the states of Li and Zeng (that is, the State of Sui). Envoys were sent to the vassal states along the middle reaches of the Yangtze. The king travelled upstream and reached Kui, located in modern Zigui. According to the inscriptions, this was

supposed to have occurred in the 19th year, which happened to be the last year of King Zhao's rule. The bronze inscriptions and ancient chronicles corroborate and complement one another and have enriched our knowledge with important details of the history of that period.[3]

Occasionally, bronzes record historical events not mentioned in any history book or document, which gives them added value.

In March 1978, a number of bronzes with lengthy inscriptions were excavated from a tomb dating back to the Western Zhou in Xizhang Village, Yuanshi County, in Hebei Province. Among them was a *gui* (Fig. 27), named after a minister called Jian, made during the period of King Cheng's rule to King Kang's. Its inscription relates how, after the Marquis of Xing had led his army in repulsing the massive offence launched by the Rong tribe from the State of Di, a minister by the name of Jian was sent to Di to govern the state. The marquis in this story was the son of the Duke of Zhou, and his fief was located in Xingtai, south of Yuanshi. Most of the Rong tribe, a minority people, lived in scattered communities all over Shanxi, with the majority in the eastern part of the province. The establishment of the State of Xing was a political move to check the southward drive of the tribe. Di was also a vassal state under the Zhou Dynasty, though this fact had never been recorded in ancient writings. The location of the State of Di, judging from the site where the bronzes were buried, was near the Dishui River in Yuanshi County. After the Marquis of Xing had curbed the Rong tribe's attack, Jian was appointed to supervise the Marquis of Di, and the State of Di was consequently turned into a dependency of Xing. This event had never been entered in historical annals, and it was not until the discovery of the *gui*'s inscription that it was finally made known.

In November 1974, another group of bronzes were brought to light from the tomb of Prince Zhongshan in Hebei Province, including a *ding*, a square-based *hu* (Pl. 25) and a *hu* made by the heir-apparent. These new findings are of great significance in studying the history of the Warring States Period. Originally known as Xianyu in the Spring and Autumn Period, the State of Zhongshan was formed by the Baidi, a minority people living in the northern part of China. By the Warring States Period, Zhongshan had bordered upon three states, namely, Yan, Qi and Zhao. Small in area but strong in military force, it was once ranked equal to the powerful states of Yan, Zhao, Han and Wei, and held sway over the region. Unfortunately, the scanty information on Zhongshan contained in ancient books was too

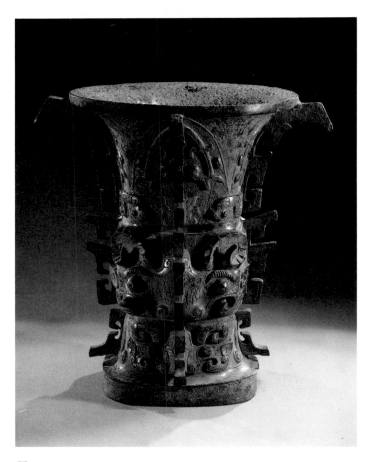

77.
He *zun*, wine vessel, early Western Zhou Dynasty, unearthed at Jiacunyuan, Baoji, Shaanxi, height 38.8 cm.

fragmentary to form a complete picture of the history of the state. The inscriptions on the three bronzes found in Pingshan, apart from offering a detailed review on the genealogy of Zhongshan and major historical events that occurred at the time, give a particularly precise description of the expedition by Zhongshan against Yan, which was completely omitted from historical records.

Prior to the study of the inscriptions, it was known only that the State of Qi had sent a punitive expedition against Yan. In 320 B.C., Kuai was instated Prince of Yan. But Zizhi, the old prime minister under the previous monarch, was still in charge of state affairs and arrogated all powers to himself. Advised by some of his ministers to put into practice the prevailing idea of voluntary abdication at the time, Kuai handed the crown to Zizhi in 316 B.C. and became a minister under him. Two years later, the crown prince and general Shibei of Yan gathered forces to launch an assault against Zizhi. In his counterattack Zizhi killed them both and the State of Yan was thus plunged into internal chaos. The State of Qi, taking advantage of this turmoil, attacked Yan and

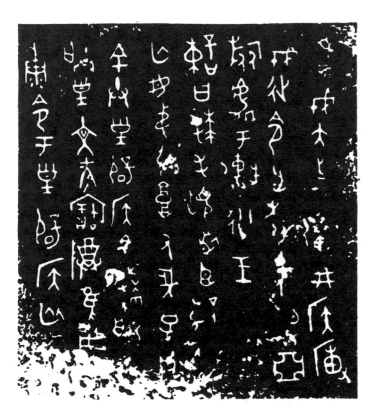

Fig. 27 Rubbing from an inscription on Jian *gui* food container, excavated from a Western Zhou tomb in Xizhang Village, Yuanshi County, Hebei Province.

captured its capital within 50 days. Both Kuai and Zizhi were slain. Yan would surely have ceased to exist then, had it not been for the intervention of other princes.

According to the Pingshan bronzes, the State of Zhongshan had also participated in the expedition against Yan. The prime minister of Zhongshan led three armies into Yan, occupying large areas of land and several dozen cities and towns.

Inscriptions can often be a valuable source of material for the study of ancient China's social economy. In 1975, a vault on the Zhouyuan site in Dongjia Village of modern Qishan was found containing four bronze objects. They belonged to Qiuwei, a petty official who was responsible to the imperial court for the making of fur products. Three of the bronzes—a *he* and two *ding*—cast during the reign of King Yi of the Zhou Dynasty, record three deals between Qiuwei and an aristocrat by the name of Jubo.

The first deal took place in the third year of Yi's rule. Once, the king set out to Fengjing to hold a ceremony. Jubo dispatched his men to Qiuwei for a jade *zhang*-tablet to be presented to the king as a gift when having an audience with him. At the same time, he wanted the men to ask Qiuwei for two orange-coloured tiger skins,

as protocol in ancient times required that jade tablets always be placed upon expensive furs. The jade tablet was valued at 80 strings of cowry and the furs at 20 strings, for which Jubo had to give Qiuwei 10 plots of his land in return.

In the fifth year of Yi's reign, Qiuwei's eyes fell on another plot of land of Jubo's with water running through it. Qiuwei proposed to barter five plots of his land for that particular plot. Jubo agreed. The two sides took an oath and marked off the land together. When they had completed all the necessary procedures their exchange was finally approved by court officials.

Four years later, Qiuwei and Jubo struck a third deal. Once in the imperial ancestral temple, King Yi was presented with captives from Guaibo, the ruler of a vassal state under the Zhou Dynasty. On such an important occasion, Jubo, as an aristocrat, was obliged to attend. So he ordered from Qiuwei a set of gears made of leather and hide for his horse and carriage. In payment, Jubo ordered his men to hunt foxes and other fur-bearing animals from his own forest to be delivered to Qiuwei.

In the past, it was widely believed that in the time of the Western Zhou the possession of land could not be transferred. Bronze inscriptions supply convincing proof to the contrary, that in actual fact, by the middle of the Western Zhou, not only had the practice of exchanging and trading in land already existed, but land had already been valued in terms of currency.

The countless inscriptions on bronzes already unearthed are a treasure-house of historical data, yet many of them remain unsolved mysteries. These will surely be unravelled in time as the study of bronzes progresses, and will throw more light on the unanswered questions in the history of ancient China.

[1] See Shaanxi Provincial Museum and Shaanxi Provincial Cultural Relics Committee: *Bronzes in Pictures*, Fig. 71.

[2] The first of a cycle of sixty in an old time-marking system.

[3] See also Li Xueqin: "Important Symbols for the Classification of Bronzes of the Middle Western Zhou Dynasty," *Journal of the Museum of Chinese History*, No. 1, 1979.

From Pictographs to Seal and Clerical Scripts

CHINA possesses a wealth of palaeographic material, the earliest known being the earthenware of remote antiquity. Pottery vessels with incised symbols have been discovered at the two closely located sites of the 6,000-year-old Yangshao Culture at Banpo near Xi'an City and at Jiangzhai in Lintong County, both in Shaanxi Province. Some scholars maintain that these symbols, or at least a part of them, represent the origin of Chinese written language. Pottery vessels with inscribed symbols have also been brought to light from quite a number of the sites of the later New Stone Age, although these symbols are often impaired or time-worn and some of them have yet to be ascertained as written language.

Available information reveals that the inscription of bronzes dates back to the early period of the Shang Dynasty—although this practice was rare at the time—as shown by the Fu Jia *jiao* in the collections of Liu Tizhi and H. S. Rubens.[1] A *lei* unearthed at Baijiazhuang in Zhengzhou has three frogs engraved just below the neck. Certain connoisseurs believe them to be pictographic characters, but they are probably simple ornamentation patterns, for decorative whorls are discernible in the centre of the three figures and also because no other bronze vessels found so far bear three identical inscriptions symmetrically positioned on the same vessel.

The inscriptions of the later Shang period were generally plain and succinct, recording mainly the family and first names of the owner of the vessel and the form of address of the ancestor to whom the sacrificial vessel was being dedicated. Family names were usually represented by pictographic characters (Fig. 28). For example, *yu* (fish) was written in the shape of a fish with carefully drawn lines for the head, tail, scales and fins; and *lu* (deer) took the form of a deer with its two antlers branching out. This does not imply that the existent form of writing had not advanced beyond the stage of primitive pictographs. Comparatively more elaborate than the simple scripts found on oracle bones of the same period, its style demonstrated a tendency towards the search for artistic beauty and an attempt to use certain pictographs as

Fig. 28 Pictographic inscriptions, Shang Dynasty.

family emblems. At the same time, the pictographic characters reveal the general outline of earlier hieroglyphs.

The form of address of the deceased is given below the pictographic family name, such as Zu Jia (Grandfather Jia), Bi Yi (Mother Yi), Fu Bing (Father Bing) and Mu Ding (Mother Ding).

In ancient China, each person had a clan name as well as a family name. For instance, the people of the Shang tribe all had the clan name Zi and those of the Zhou tribe all had the clan name Ji.

Bronzes bearing a common family name have been unearthed from several Shang tombs. Between 1969 and 1977, groups of tombs were excavated at the Yin site of Xiaomintun in Anyang, Henan Province. Five bronze vessels buried in two tombs were inscribed with the character "Fu" (負), while ten vessels in another three had the character "Gong" (共) engraved on them.[2]

The practice of inscribing family names on bronze vessels continued for a protracted period of time. In the early fifties, a set of bronze vessels of the early Spring and Autumn Period were discovered at Taipu Village in Jiaxian County, Henan Province. The inscription on one of the vessels was pictographic, and constituted an image of the sun above another of a human figure, rather like the character "Hao" (昊). It was perhaps an example of the latest form of pictograph.

However, not all inscriptions on Shang bronzes were related to family names. Such is the case with the three large square *he* found in a tomb at the Yin site in

Houjiazhuang. These vessels bore respectively the words "right," "middle" and "left," obviously referring to their positions at sacrificial ceremonies.

A few Shang and Zhou bronze vessels had numbers engraved on them, such as those discovered at Zhouyuan in Shaanxi Province. Similar inscriptions were also found on bones or tortoise shells and pottery moulds unearthed at the Yin ruins and on oracle bones of the Western Zhou period found in Shaanxi Province. Judging from available materials, three $\overset{x}{x}$ were used for a single divination and six $\overset{x}{x}$ for a double one. The numbers on the bronzes, too, are grouped in threes or sixes, but are limited to the digits "one," "five," "six," "seven" and "eight." Alike to the symbols in the *Book of Changes*, these numbers were probably used in predicting the future or casting fortunes.

None of the Shang bronze inscriptions discovered so far exceeds 50 characters. It was not until the end of the Shang Dynasty that longer inscriptions appeared, whose form and style of writing were very much like those of the oracle bone divinations. Representative of the period of King Zhou of the Shang are the three Bi Qi *you* (Fig. 29) in the Beijing Palace Museum, whose inscriptions are of a peculiar and archaic style, yet are executed with sturdy and forceful strokes.

Bronze inscriptions of the early Western Zhou can be divided into two categories pertaining to a former and a latter period. The form of writing of the inscriptions during the reigns of King Wu and King Cheng was similar to that of the Shang days, consisting of very even thick and thin strokes. An example of this can be seen on the square *ding* unearthed at Daijiawan in Baoji, Shaanxi Province, which bears an inscription about the Duke of Zhou's eastern expedition against Bogu and other princely states. Towards the end of King Cheng's reign, there emerged a new style of writing that in some respects bore a slight resemblance to the *bo zhe* (thick-tipped strokes) of the Han Dynasty's *li shu* (clerical script). This novel style is conspicuous in the He *zun* found at Jiacunyuan, Baoji. The same style can also be witnessed on the big Yu *ding* made in the 23rd year of King Kang's reign and the vessels of a certain official named Ling during the reign of King Zhao. Typical of the *bo zhe* style is the inscription on the Shu *you* (Fig. 30), in which the last strokes of the second to fifth characters on the second line from the right are thickly drawn, as is the first stroke of the first character on the third line.

The multi-character inscriptions of the middle Western Zhou period usually had their characters arranged in regular square formations, as shown in the Ban *gui* food vessel of King Mu's time and the Shi Qiang *pan* of King

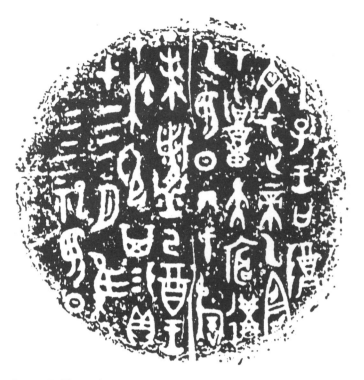

Fig. 29 Rubbing of an inscription on Bi Qi *you* wine container, Shang Dynasty.

Gong's time. The writing of a number of inscriptions dating back to the rules of King Yi and King Xiao was somewhat casual and followed no set formation. From the middle Western Zhou onward, there appeared an increasing number of inscriptions with fairly rigid patterns, recording the appointments of officials and the bestowals of rewards on them by Zhou kings. A few inscriptions of the late Western Zhou period possessed a slender type of script, as shown on the Mao Gong *ding*.

Legend has it that, during the reign of King Xuan in the late Western Zhou period, an eminent historian by the name of Zhou created a form of writing which later came to be known as the Zhou script or *da zhuan* (greater seal characters). The 15 pieces under the heading "Grand Historian Zhou" in the *Han Shu* (*History of the Han Dynasty*) were compiled by Zhou for teaching. Grand Historian Zhou did in fact exist in history, as can be proven by the inscription on a bronze *ding* housed in the Shanghai Museum, in which a certain historian named Zhou is mentioned. Some of the bronze inscriptions of the reign of King Xuan—the Guo Ji Zi *pan* (Pl. 78) in the collection of the Museum of Chinese History, for instance—represent a new form of writing, both even and ordered, similar to the Zhou script referred to in the *Shuo Wen Jie Zi* (*Analytical Dictionary of Characters*). This form of writing was continued during the Spring and Autumn Period in the State of Qin which had arisen in

the political heartland of the Western Zhou Dynasty.

Some of the lesser eastern states in the early Spring and Autumn Period used scripts of a very strange nature that were difficult to decipher. This was due probably to the rarity of the practice of casting inscribed bronzes and also to the lack of educated people in these states. Inscriptions found in the lesser states of Jiang, Huang and Zeng between the Huaihe and Hanshui are often very confused and disorderly, quite unlike those found in the culturally more developed states of Qi and Lu (in present-day Shandong Province).

After the middle Spring and Autumn Period, an even and highly artistic oblong type of script gradually came into vogue, as typified in the bronze inscriptions unearthed from the tomb of Marquis Zhao of the State of Cai in Shouxian County, Anhui Province (Fig. 31). This artistic style of writing remained popular right up to the early Warring States Period in the states of Chen, Cai,

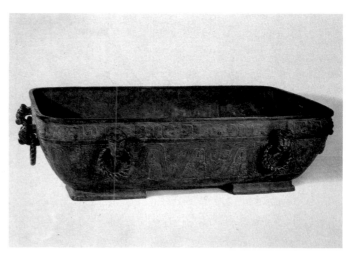

78.
Guo Ji Zi Bai *pan*, water vessel, late Western Zhou Dynasty, reportedly unearthed at Guochuansi, Baoji, Shaanxi, length 137.2 cm.

Chu, Xu and Wu in the Yangtze River valley.

Also fashionable in these southern states was a form of writing called *niao shu* (bird script) with rather ornate strokes, especially in the shape of birds. Inscriptions written in this style are generally inlaid with gold, and have been found in the former states of Wu, Yue, Xu, Chu, Song and Cai, most of them dating from the late Spring and Autumn to the early Warring States Period. Bird script is extremely difficult to decipher, and that used on the Neng Yuan *zhong* discovered in the late Qing period in the Jinjiang, a river in Gaoan, Jiangxi Province, still remains a challenge to palaeographers to this day. This form of writing prevailed for the longest period of time on the bronzes of the State of Yue, typical specimens being the inscriptions on the swords of Prince Gou Jian of Yue (Pl. 19) and those of Prince Zhou Gou. The characters of the silver-inlaid inscriptions on the three swords of the Prince of Yue unearthed recently in Huaiyang, Henan Province, are much simpler in form, and are supposed to date back to the middle Warring States Period; they are very probably an example of this script in its latest stage of development.

In contrast to the bird script of the south, there emerged a new form of writing in the State of Jin in the north, as can be seen on the Shao Ju sword found in Hunyuan County, Shanxi Province, as well as the famous Zhi Jun Zi *jian* and Zi Zhi Long Niao *zun*. The strokes of the characters of their gold-inlaid inscriptions have thick midlines and pointed ends, which give them the appearance of tadpoles. The same script can also be found on the contracts (written with a brush on pieces of jade) recovered in recent years in Houma City, Shanxi Province, and Wenxian County, Henan Province. This

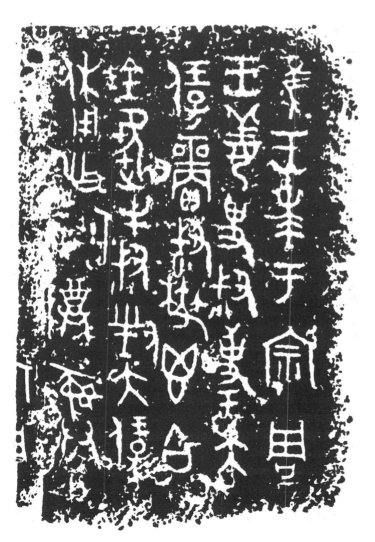

Fig. 30 Rubbing of an inscription on Shu *you* wine container, Western Zhou Dynasty.

form of writing is probably what is known as *ke dou wen* (tadpole script). The ancient copies of *Shang Shu* (*Book of Historical Documents*) and *Zuo Zhuan* (*Annals of Zuo Qiuming*) discovered during the Western Han Dynasty were believed to be written in the tadpole script, which, according to investigations made so far, was a style of writing popular in the north between the Spring and Autumn and the Warring States periods.

Later, the six eastern states of the Warring States Period adopted the *liu guo gu wen* (the ancient script of the six states) (Fig. 32) which, with its complicated structural modulations, is the most difficult of the ancient scripts. Many of the *liu guo gu wen* characters discovered so far still baffle interpretation. This particular script evolved from the written languages of the north and south, and often varied stylistically from state to state, each having its own way of writing the same character. The content of inscriptions had become much simpler by now, most of them being the comments of the makers of the bronze vessels themselves.

While the script of the six eastern states was in the process of constant change, the written language of the State of Qin in the west was increasingly standardized. The written language of the Qin during the Warring States Period was not much different from that of the Spring and Autumn Period, although there had appeared a tendency towards the *li shu* (clerical script), as manifested in the inscriptions on certain bronzes, such as the Shang Yang *fang sheng* (square measure), the Zhang Yi *ge* and the Wei Ran *ge*. *Li shu* had been traditionally believed to be created by Cheng Miao in Emperor Qin Shi Huang's time, but had actually been in use long before. In all likelihood, it was Cheng Miao who made improvements to the script. After Qin Shi Huang unified the country's written language, only the standard scripts, that is, the *xiao zhuan* (lesser seal characters) and *li shu*, were used in bronze inscriptions, and the *liu guo gu wen* virtually disappeared except for a few vestiges that remained in certain characters.

The evolution of the form of writing applied in bronze inscriptions not only provides important material for the study of the development of the Chinese written language but also serves as a reliable yardstick for chronologizing ancient bronze ware.

[1] See Luo Zhenyu, *An Anthology of the Bronze Inscriptions of the Three Dynasties*, 16, 42, 2.

[2] Anyang Work Team of the Institute of Archaeology of the Chinese Academy of Social Sciences, "Report on Excavations of a Shang Site from 1969 to 1977," *Archaeological Gazette*, No. 1, 1979.

Fig. 31 Rubbing of an inscription on the bronze *pan* bowl of Marquis Zhao of the State of Cai, unearthed in Shouxian County, Anhui Province.

Fig. 32 A specimen of the *liu guo gu wen* ancient script.

Myth and Reality

EQUALLY valid in computing the dates of bronzes are the various types of decoration found on them, for the embellishment of bronze ware underwent modification through the centuries, and sometimes were even replaced completely by novel designs. To this extent, just like bronze inscriptions, bronze ornamentation can also be regarded as a "language," which, once deciphered, will reveal the artistic concepts and trends of its own age.

The decorative elements used on bronzes came into existence long before bronzes themselves appeared. Many of the motifs are direct derivatives of those found on Neolithic pottery. Some scholars have suggested that the thunder-and-cloud design, one of the most common motifs, originated from the fingerprints left unintentionally on the wet clay by the potters. These whorls were reproduced on bronze ware and gradually evolved into the thunder-and-cloud design. The raised nipple design, the triangular linear design and the lozenge design featured on bronzes of the Erlitou Culture and slightly later in time derived their ancestry from the pottery designs of the Longshan Culture some 4,000 years ago. Some of the earthenware vessels discovered at Liangcheng, Rizhou County, in Shandong Province, bear very fine-line lozenge and the thunder-and-cloud patterns similar to those found on early bronzes.[1] Also unearthed in Liangcheng was a bevelled stone adze of the Longshan Culture.[2] Dark green in colour, the upper half has a rather complicated *taotie* (ogre-mask) motif incised on both its sides. This proves that the *taotie* motif had already emerged in the Neolithic Age. There must certainly have been many more kinds of motifs, such as those often encountered on painted earthenware vessels and wooden artifacts. Complicated overall patterns, including the *taotie*, were found on painted pottery of the early Shang discovered in a site at Fengxia in Beipiao, Liaoning Province, but such voluted motifs do not appear on any bronzes of the same period in the Central Plain.

The chief stylistic feature of bronze decor in the Shang is its mystical, awe-inspiring hieratic quality. The people of the Shang were known to be believers in spirits. The dominant theme of the ornamentation conformed with the primitive ancestor worship practised in those days.

The Shang kings used mysticism and terrifying rituals to awe and control the people, and this is clearly reflected in the bronzes cast at the time.

The *taotie* motif (Pl. 79) has a grotesque appearance and a pronounced mystic mien. In the *Lü Shi Chun Qiu* (*Lü's Miscellany*), a work compiled by Lü Buwei towards the end of the Warring States Period, there is a passage referring to the *taotie* which runs thus: "The Zhou *ding* bears a *taotie* with a head, but no body. It is depicted devouring a man, but before it can swallow him, its own body is destroyed." This is undoubtedly a description of the *taotie* motif. Most of the books on bronzes in the Song and succeeding dynasties used the term *taotie* to describe all animal-mask motifs on bronze vessels, although many present-day scholars doubt its appropriate-

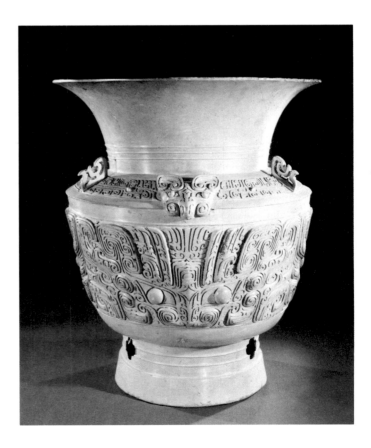

79.
Zun with ogre-mask motif, wine vessel, late Shang Dynasty, unearthed at Runhe, Funan, Anhui, height 47 cm.

ness. The *taotie* motif has already been found on bronze vessels of the Erlitou Culture. The *taotie* motif on bronzes in the Shang and Zhou periods consisted of dragons, tigers, oxen, sheep, deer and even birds and human beings. The dragon design was generally composed of two *kui* dragons with heads fused into one, and so are the ox and tiger designs.

In Qinghua University in Beijing there is a *ding* dating from the Shang period with a design of two tigers (Fig. 33). This is a very rare variant of the *taotie* motif.

The image of this fabled beast is even more clearly displayed on a *you* bearing a crouching *taotie* with gaping maw, about to devour a human being clutched in its two front paws. Three such bronze *you* have been found: one is now in Japan,[3] another in France and a third, not quite intact, still remains in China. Their casting technique strongly suggests all three must have been made in the region of Hunan Province.

At Xibeigang in Houjiazhuang in two large Yin tombs, a couple of sculptured stone *taotie* were found with fangs bared, but no human victim figures in the design.

Another common mythical creature seen on Shang bronzes is a *xiao* bird, often referred to as the owl motif. In a tomb of the Yin ruins at Xiaotun, there is a pair of bronze *zun* (Pl. 80) featuring these birds. Jade artifacts with similar designs were found alongside them. Another such bird sculpted in stone and complemented with a *taotie* was discovered in a large tomb at Houjiazhuang. From these examples it can be seen that the *xiao* bird also occupied a prominent position in Shang mythology.

Even more familiar are the dragon and phoenix. The characters *long* (dragon), and *feng* (phoenix) on oracle bones prove that these mythological creatures existed in the minds of the people at a very early time. The dragon of later times has a body of a serpent, the antlers of a deer and five claws on each of its four feet. The Shang dragon was basically the same, except for the antlers, most of which, instead of branching out, were shaped in a solid column which bulged out at the lower part and was called "bottle horn." The horns of the bronze dragon motif are mostly like this. A decorated stone horn of this form was found in the Yin ruins and was probably a part of a carved wooden dragon head from which it had been detached. The *feng*, or phoenix, had a long tail and a crown, characteristically similar to a peacock. Rather primitive representations of these have been found on the Ox *ding* and Deer *ding* unearthed from the Shang tombs at Houjiazhuang.

The *kui* is another mythological beast, depicted on bronzes as a dragon with a single foot. In the late Spring

Fig. 33 Tiger motif on a *ding* of the middle Shang Dynasty.

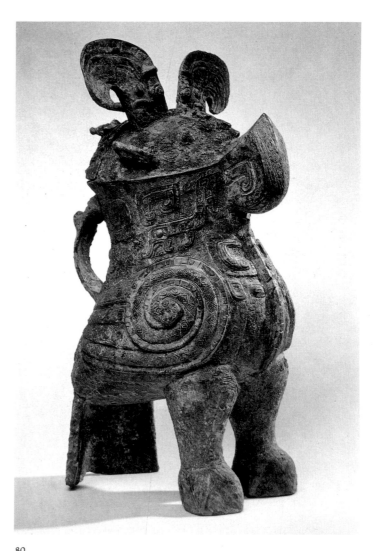

80.

Fu Hao owl-shaped *zun*, wine container, late Shang Dynasty, unearthed at Xiaotun, Anyang, Henan, height 45.9 cm.

81.
Zun with nine-elephant design, wine vessel, late Shang Dynasty, height
13.2 cm.

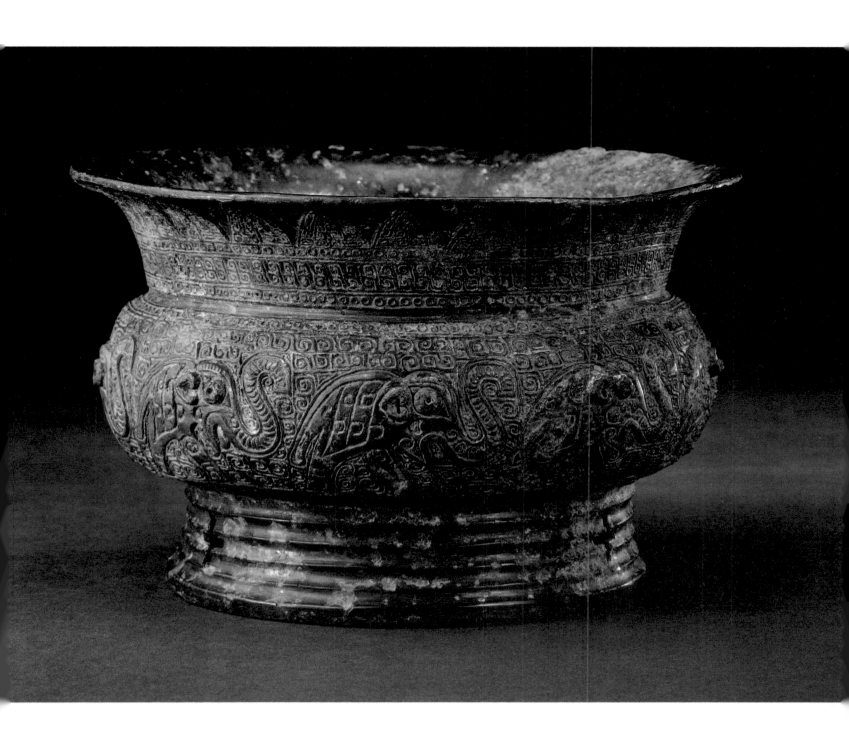

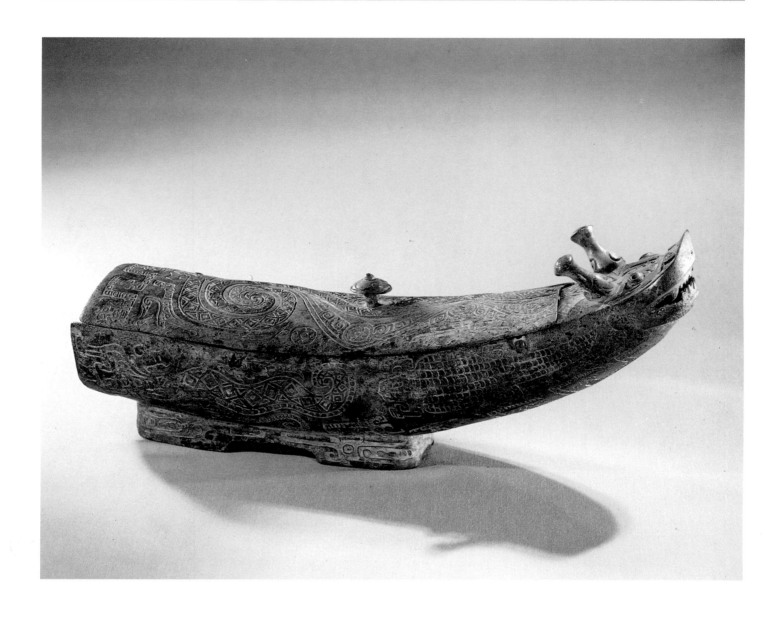

82.
Gong with crocodile design, wine vessel, late Shang Dynasty, unearthed
at Taohuazhuang, Shilou, Shanxi, height 24.1 cm.

and Autumn Period, when asked what a one-legged *kui* (*kui yi zu*) was, Confucius, opposed to belief in mystical powers and imaginary things, answered that the *kui* was a very able minister of the Yao court, whom the emperor could rely upon solely and completely because of his great capabilities (*kui yi zu yi* in ancient Chinese can mean "one man named Kui is enough"). However, this was pure invention on Confucius' part.

Rhinoceros, elephant (Pl. 81) and crocodile (Pl. 82) motifs also appear on Shang bronzes. Although these animals exist in the natural world, they were quite rare in China, so the people of the Shang included them in the decoration of their bronzes, regarding them almost as legendary beasts.

The mystic element in Western Zhou bronze motifs grew steadily less pronounced, although the dragon and phoenix still persisted as the main theme in several designs. In actual fact, the many highly stylized motifs that appear on bronze ware are for the most part variations and combinations of the dragon and the phoenix and can thus be roughly divided into two categories.

For example, the imbricated pattern obviously evolved from the representation of scales on the body of a dragon or snake, as did the repeated circles of the spiral design (Fig. 34). The meander pattern (Fig. 35) which enjoyed the most popularity during the middle and late Western Zhou is very likely a stylized representation of a curling double-tailed dragon.

The *chan*, or cicada, is another common motif encountered in Shang and Western Zhou bronzes. It continued into the Spring and Autumn Period but in a slightly distorted form. No satisfactory explanation has yet been found as to why this particular insect should have figured so widely at that time.

In the Spring and Autumn Period, *pan chi* or the intertwining dragon design (Fig. 36) rose to popularity and gradually almost displaced all other motifs. There are many variants of this pattern, but its chief characteristic is that each whorl is composed of two or more small intertwining dragons, of which there is little previous occurrence. The *pan chi* pattern is highly pictorial, stripped of all mysticism, and is, without a doubt, of tremendous significance in the development of bronze ware designs.

During the transitional stage from the Spring and Autumn Period to the Warring States Period, mythical animals still appeared on certain vessels, such as the tortoise and fish square *pan* now in the Palace Museum. It has a beaked and winged creature perched on top of it, and a single-horned creature suckling a goat, probably

Fig. 34 Spiral design.

Fig. 35 Meander design popular during the middle and late Western Zhou Dynasty.

Fig. 36 Intertwining dragons, or *pan chi*, motif.

83.
Hu with hunting design, wine vessel, early Warring States Period, height
42 cm.

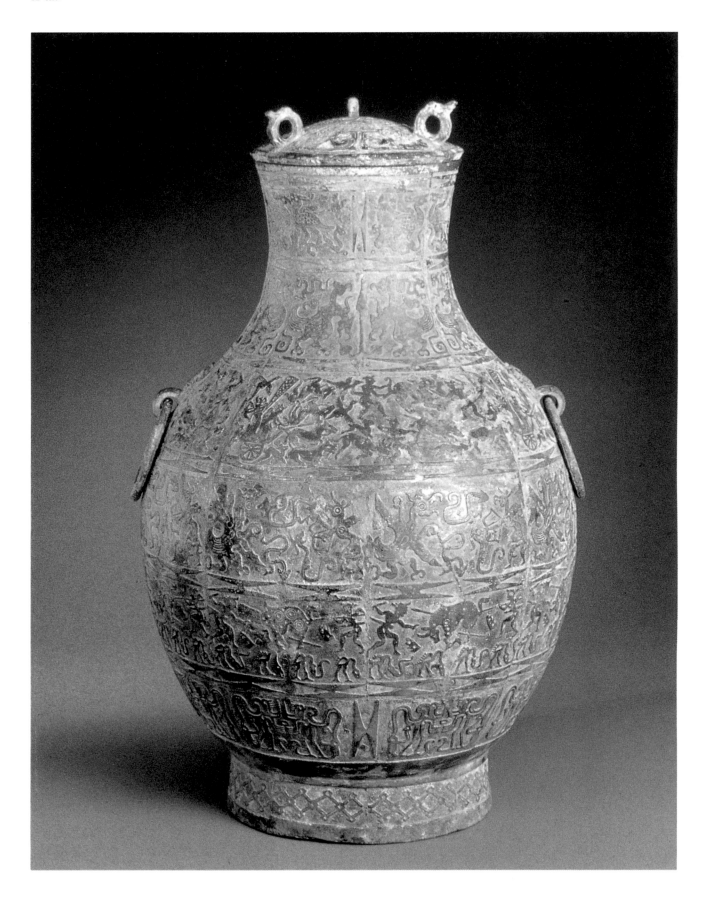

To the left is the target, which has been hit by two arrows. On the right-hand side of the top register is a picture of people picking mulberry leaves. Some are perched on the branches plucking the leaves, one is about to climb onto a tree and the rest are on the ground collecting the leaves in baskets. On the right of the second register is a hunting scene. To the left are four archers shooting wild fowl (probably geese or swans) with arrows attached to a line, and to the right is a tent for the hunters to change and rest. On the left of the second register is a banquet scene in two layers. Above stands an imposing edifice where the master is seen reclining on a low side-table and behind him an attendant with a long-handle fan, while in the foreground, two persons raise their goblets ready to drink. On the right are four persons whirling lances, and at the bottom is a small group of musicians playing the *zhong*, drums, chimes, *sheng* and flutes. On the left of the third register is a picture of a siege. The attackers mount the wall of the beleaguered city. Armed with shields, they prepare to storm the city, while their adversaries shoot arrows and rain rocks down on them in a desperate attempt to defend their city. On the right of the third register is an attack by boat and on land. This highly informative work renders this piece of exceptional value as material for studying the life of those times.

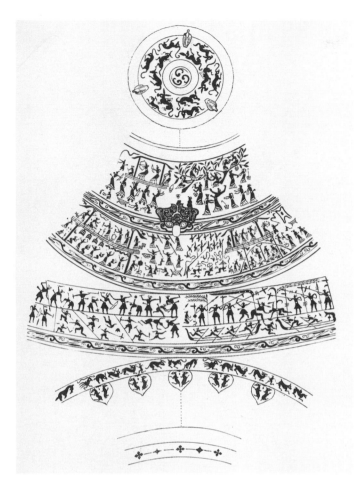

Fig. 37 Designs engraved on a bronze *hu* wine container, excavated from Baihuatan, Chengdu, Sichuan Province.

an illustration of a myth. However, these later mythological creatures are no longer the weird, fearsome beasts of the Shang whose purpose was to evoke terror and superstition, but the aesthetic products of a subsequent age which enhanced the beauty of the bronze vessels on which they were cast.

The emergence in this period of realistic pictorial designs is indicative of the artists' extrication from the zoomorphic motifs of the Shang. They now use fine lines to create elaborate designs vividly depicting scenes from real life, such as a boar hunt (Pl. 83), a banquet or a battle.

Representative of this period is the bronze *hu* unearthed at Baihuatan in Chengdu, whose design, executed in relief, covers the whole vessel (Fig. 37) and delineates various aspects of human activity.[4] The decoration on the *hu* is symmetrically balanced, with three registers divided into left and right, making up six designs in all. On the left of the top register an archery contest is in process. In the building at the top of the scene two men stand side by side practising with bows. One has just shot his arrow, and the other is taking aim.

Fig. 38 Swirling cloud motif.

Most pictorial designs of this period vividly depict scenes of everyday life. They are illustrative of the new realism which emerged after the Shang and the Western Zhou, and contrasts sharply with the designs of these two preceding dynasties.

During the Warring States Period, the *yun qi*, or cloud motif, appeared and grew in popularity as a new cloud design quite distinct in composition and form from the thunder-and-cloud design mentioned earlier. The *yun qi* motif (Fig. 38) is a representation of swirling clouds and is closely associated with the new idea of striving to

84.
Rectangular *lei* with check and cloud design, wine vessel, middle or late
Warring States Period, height 14.5 cm.

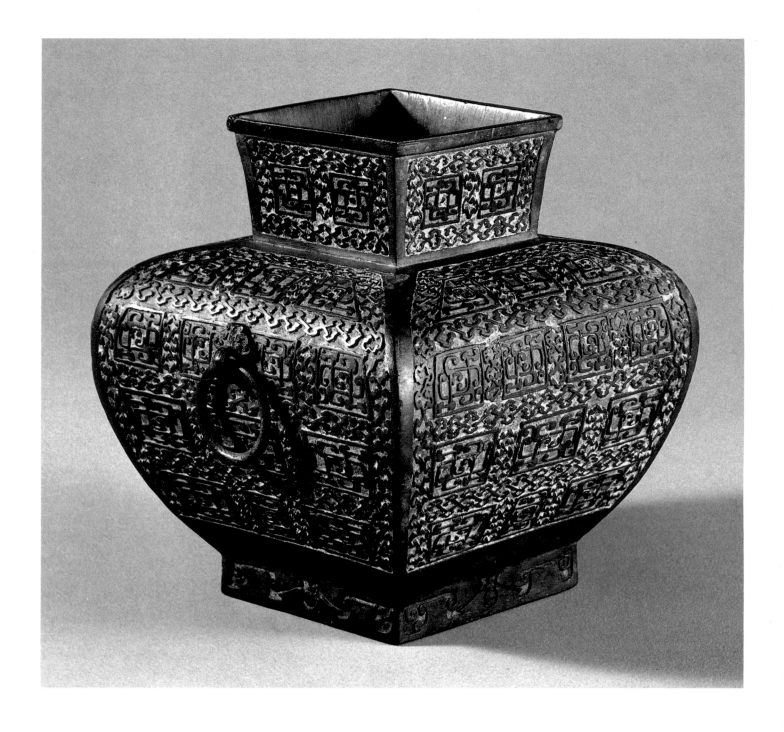

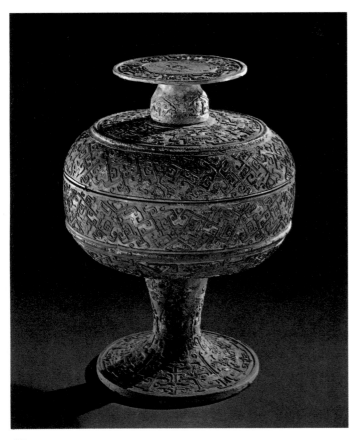

85.
Gou Lian *dou* with cloud design, food container, middle or late Warring States Period, unearthed at Xin'ao, Xiangxiang, Hunan, height 24 cm.

become immortals. In the book *Zhuang Zi* there is a passage describing immortals: "They have skin like ice and snow. Gentle as virgin maids, they live not on grain but on dew and breathe the wind, riding on clouds or on flying dragons, roaming over the Four Seas." During the Warring States Period *yun qi* motifs symbolizing immortals appeared on a wide range of bronze (Pl. 84) and lacquer ware. It was most commonly used in the State of Chu (Pl. 85), where Taoism had developed, and where Lao Zi and Zhuang Zi, the founders of this school of thought, exerted immense influence on the culture.

The popularity of the *yun qi* motif persisted to the Qin and Han dynasties. On the bronze rim of a lacquer vessel of the Qin found in 1976 at Yunmeng, Hubei Province, is a gold and silver inlaid *yun qi* motif, evidence of Chu influence in the area.

At Lingshan, in Mancheng, Hebei Province, in the tomb of Liu Sheng, Prince of Zhongshan in the 1st century B.C. of the Western Han Dynasty, a gold-inlaid Boshan incense burner was found (Pl. 34). It is an expression in bronze of the then prevalent belief in immortality. The censer takes the shape of a mystical fairy mountain, probably Penglai, the fabled abode of

immortals in the distant east. The mountain is shrouded in exhalations of cloud vapour represented by gold *yun qi* motifs. Both immortal spirits and celestial creatures can be seen on each of the censer's seven registers. According to the *Xi Jing Za Ji* (*Miscellany of the Western Capital*) Zhao Feiyan, the favourite concubine of Emperor Cheng Di of the Han Dynasty, is said to have had in her possession a nine-tiered Boshan incense burner. Its form and decoration would have been much more elegant and elaborate, but its artistic concept was in all likelihood very similar.

Western Han chariot fittings found in another Zhongshan tomb at Sanpanshan, Dingxian County, Hebei Province, featured this very popular mystical mountain motif. The fittings have four registers of pictorial designs completely inlaid with gold and silver and studded with precious stones.[5] The motifs depict immortals riding on elephants and camels, mythical creatures such as dragons and phoenixes, and other animals, like tigers, bears, boars, antelopes, etc. Between each of these creatures occurs the *yun qi* design, symbolizing an enchanted world of immortals. These embellishments are masterpieces of bronze decoration of the Han Dynasty, and this particular work of art has won the admiration of many during exhibitions both in China and abroad.

Apart from the ornate gilded vessels, most bronzes of the Han Dynasty were rather plain or had very simple decorations. However, variations of designs on the mirrors of this period were without number and continued through to the Eastern Han, Wei and Jin dynasties, marking the vicissitudes of contemporary society. This shall be discussed in greater detail in a later section.

[1] See Guo Moruo, *Chinese History*, Vol. I, Fig. 12.

[2] See Liu Dunyuan, "Two Stone Implements Found at Liangcheng Ruins," *Archaeology*, No. 4, 1972.

[3] See Rong Geng, *A General Survey of Shang and Zhou Bronzes*, 651.

[4] See also Du Heng, "Comments of Pictures on a Bronze *Hu* Found at Baihuatan." *Cultural Relics*, No. 3, 1976.

[5] See *Selections from the Exhibition of Archaeological Finds of the People's Republic of China*, Pl. 85.

Technique of Bronze Casting

As bronzes grew more popular through the ages, their casting technique correspondingly reached a higher degree of sophistication, earning Chinese bronze ware an elevated position among the bronze cultures of the world. Their exquisitely beautiful forms and intricately conceived designs are the very embodiment of the extraordinary ingenuity of ancient Chinese craftsmen.

The technique of bronze casting with pottery sectional moulds was fully developed in ancient China, as evidenced by some of the early copper objects unearthed so far. There is reason to assume that moulds were developed simultaneously with the dawn of copper making. From the Erlitou Culture period to the Shang, casting was done with the aid of sectional moulds in all these foundries, as can be proven by the great number of pottery moulds that have been unearthed.

The method of casting with sectional moulds already reached a certain degree of perfection during the Shang period. Malachite was the principal ore from which copper was obtained. The fuel used was chiefly charcoal, which could raise the temperature of the molten ore to over 1,000 °C. The container for smelting the ore in Zhengzhou was an open-mouthed vessel, and in the Yin ruins a special pottery crucible, commonly referred to as a "general's helmet."

First, a clay model of the object to be cast was made; next, the decorative designs were drawn on the model with red ink. The negative impressions of the design were carved with a knife, and the positive impressions sculpted with clay and then attached to the model. Unfinished models of this kind have been found in storage pits at the Yin ruins. It can be reasonably assumed that models of wood, earthenware and stone were also used. When the model was completed, a layer of clay was spread over it. This clay cover was then cut into sections which were baked and later assembled as pottery moulds for casting bronze articles.

Larger objects or those more complicated in form were made by the separate casting method even in Shang times. The minor parts of an object were cast beforehand and then placed in a bigger mould for the main body, so that all the various components could be cast into a whole. Sometimes the main body was cast first and its minor parts were fitted onto it by another casting. (This is similar to the method in which an iron cauldron is repaired in present-day China.) The two handles on the *gui* of the middle Shang unearthed at Panlongcheng in Huangpi, Hubei Province, were pre-cast and attached to the rest of the vessel by separate casting. The famous Ram *zun* (Pl. 86) unearthed in Ningxiang, Hunan Province, is decorated with a ram's head projecting from each of the four corners of the square vessel. The rams' spiral horns are too complicated to have been cast in one pouring. After careful study, scholars concluded that they had been individually cast beforehand. The vessel marked the pinnacle of the Shang Dynasty's casting technique.

The different proportions of copper, tin and other elements in bronze determine the properties of the alloy. The Shang craftsmen were aware of this and made conscious use of this fact. The handle and the vessel of the Ge *you* discovered in Ningxiang, Hunan Province, have verdigris of different colours on them, as they were made of dissimilar bronze alloys (Pl. 7).

Pottery moulds with fine decorative designs have been found in large numbers in the ruins of an early Western Zhou foundry site at Beiyao in Luoyang, Henan Province, and in the ruins of a foundry in Houma, Shanxi Province, which produced between the Spring and Autumn and Warring States periods. Both are of immense value to the study of casting technique. Many of the moulds found at Houma have relief designs, and several more for separate casting were also discovered. They probably represent the highest level of casting with moulds in ancient times.

The question as to whether any casting technique other than that using sectional moulds was used in ancient China has long remained unanswered. With the large amount of work that has been carried out in the study of pottery moulds unearthed in the Yin ruins and Houma in recent years, some still maintain that ancient Chinese bronzes, at least those made prior to the Qin Dynasty, were all cast in sectional moulds. This view is totally unconvincing.

The *pan zun* (Pl. 87) discovered in a large tomb at Leigudun in Suixian, Hubei Province, is a single integrat-

ed piece consisting of a wine container and bowl. Both receptacles are embellished with openwork and entwined dragons finely executed in high relief. It is self-evident that such an article with its exquisite and minute decorations could not have been cast in sectional moulds. Repeated examinations by specialists have confirmed that it was made by the *cire-perdue*, or lost wax, method, which was a more advanced technique than that using sectional moulds. The *zun* as a wine container had become rare in the Central Plain by the middle Zhou period, but *zun* wine vessels of the Eastern Zhou have been found recently in the south at Yancheng in Wujin County, Jiangsu Province, in Qingchangdi, Suzhou City, Fenghuangshan in Songjiang County, Hengshan in Hunan Province, and at Yangjia in Gongcheng County, Guangxi Zhuang Autonomous Region, although they might have served different purposes from the earlier *zun*.

The *pan zun* of Suixian is an important discovery, for it irrefutably proves that the lost wax method was adopted in China. It was owned by Marquis Yi of the State of Zeng, who shared the same surname as the Zhou kings. The State of Zeng was the State of Sui alluded to in historical documents, a princedom situated in the Hanshui River valley, quite near the heartland of China. The fact that the lost wax technique attained such a high degree of perfection in the *pan zun* indicates that it must have previously undergone a long period of evolution. Researchers following this line of thought have indeed found from a Chu tomb at Xiasi in Xichuan County, Henan Province, bronze articles made in this way traceable to the Spring and Autumn Period. It can be expected that still earlier samples may be discovered in time.

The technique of embellishing bronzes with inlays was developed in China at a very early date. Turquoise was the first stone used specifically for this purpose (Pl. 88). Turquoise-inlaid bronzes of the Erlitou Culture show that this technique had already reached a fairly advanced stage by then, as evidenced by the exquisite plaques with a *taotie* motif (similar plaques have been found among collectors abroad) (Pl. 89). During the late Shang, turquoise inlays became more popular. These semi-precious stones were not only inlaid for pure ornamentation, but were also arranged in such a way as to form characters on the bronzes. A kind of adhesive was probably used to secure the small bits of turquoise on the metal surface; some greyish-white matter is still visible in places where the inlays have come off. Certain Shang bronzes were entirely covered with turquoise inlays, as exemplified by the splendid ogre-mask *lei* now kept in the Museum of

Chinese History.

Jade was also used as a decorative element on certain bronze objects. A bronze *ge* or *yue* might be furnished with a jade blade, and a spear, a jade point (Pl. 90). This was done by inserting the jade in the mould before pouring the molten metal into it. Such precious objects often had turquoise inlays on the bronze part of their body too. All traceable bronze weapons with jade fittings —and there are still many whose sources are not yet known—come from the Yin ruins, and were probably carried by the guards of honour of the Shang kings.

Bronze weapons with iron blades were made in the same method. A *yue* and a *ge* belonging to the early Zhou period, or perhaps a little earlier, were discovered in 1931 at Xincun in Junxian, Henan Province. The blades of both the *yue* and *ge* have been identified as having been made of meteoritic iron.[1] Two more Shang bronze *yue* with iron blades were discovered in recent years, one in Taixi in Gaocheng County, Hebei Province (Pl. 91), and another in Liujiahe in Pinggu County, Beijing. Scientific investigation has revealed that the blade of the *yue* unearthed in Taixi was made of meteoritic iron too. Another similar *yue* is known to have existed, whose original iron blade was removed by an antique dealer and substituted by one of the jade.

It is worth noting that, with the Xincun *ge*, the iron section which joins the blade to the hilt was made in the shape of the Greek letter Ω, and in the case of the *yue*, the connecting part has a series of indentations. These enabled the iron blades to fit tightly in the bronze and not loosen with changes in temperature. From this we can deduce that bronzes with iron fittings must have already experienced a long period of development for craftsmen to have learnt how to design such ingenious joints.

An X-ray examination of a Shang *qi* battle-axe with a jade blade housed in the Lushun Museum revealed that there were two tiny round holes in the connecting part which were used to enable the molten copper therein to fix the blade tightly in the bronze.[2] This technique is similar to that used for the above-mentioned *ge* and *yue*. Shang weapons inlaid with gold or copper have not been found in archaeological excavations, the ones presently on hand being obtained from other sources than excavations. The only gold-inlaid weapon known to the public is a *ge* with a triangular blade now preserved in the Jinan City Museum.[3]

Also found at Xincun was another more unusual *ge* with two perforations, which is inlaid with shells set in a pattern. The novelty of its appearance led some scholars to discount it as a fake. This author saw the

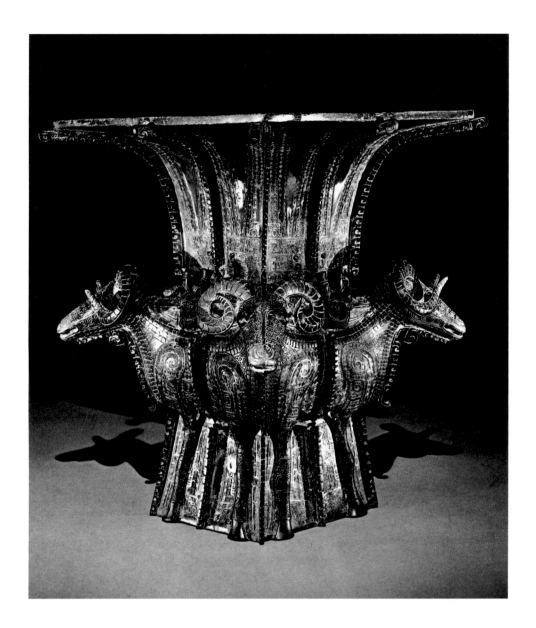

86.
Rectangular four-ram *zun*, wine vessel, late Shang Dynasty, unearthed at
Yueshanpu, Ningxiang, Hunan, height 58.3 cm.

87.
Zun pan (zun inside *pan)* of the Marquis of Zeng, wine vessel, early Warring States Period, unearthed at Leigudun, Suizhou, Hubei, height of *zun,* 33.1 cm, height of *pan,* 24 cm.

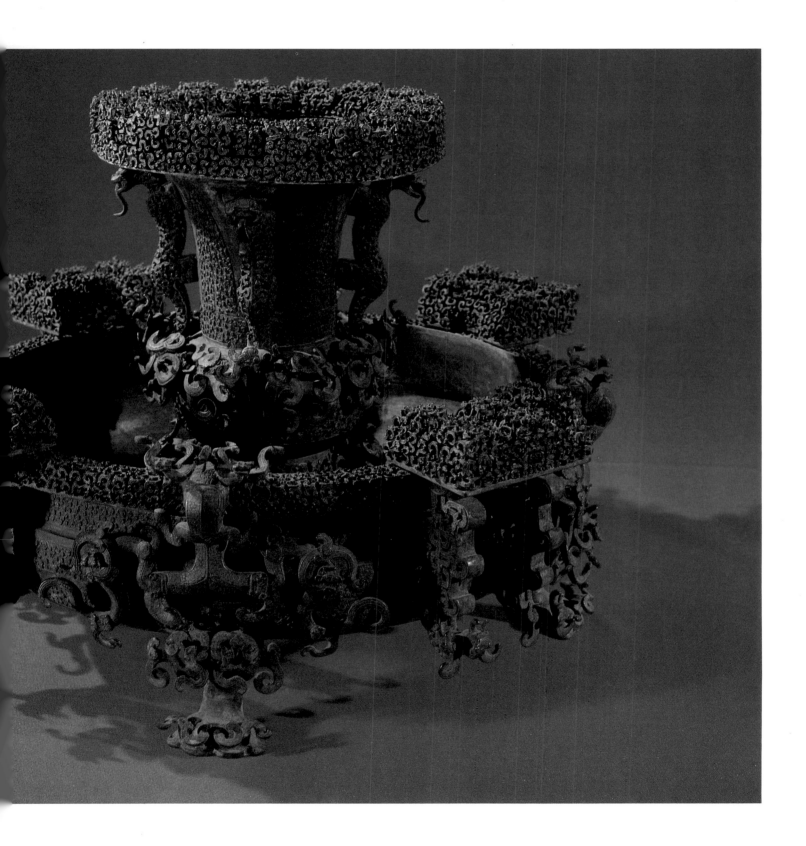

88.
Yue with turquoise inlay and cross design, weapon, Shang Dynasty, height 35.6 cm.

89.
Pendant with ogre-mask motif, Erlitou Culture, unearthed at Erlitou, Yanshi, Henan, length 16.5 cm.

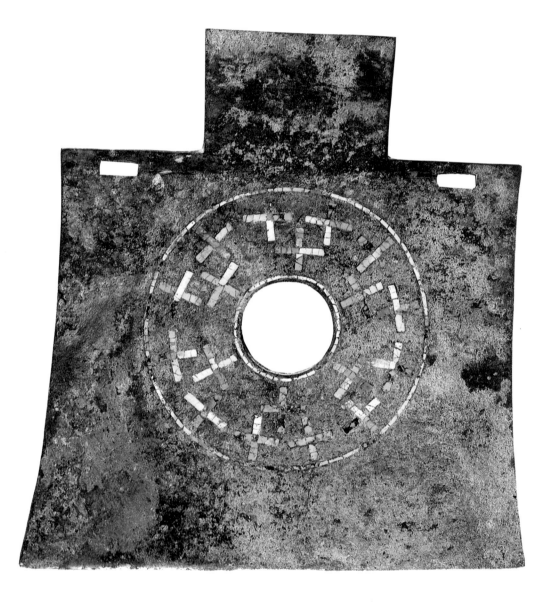

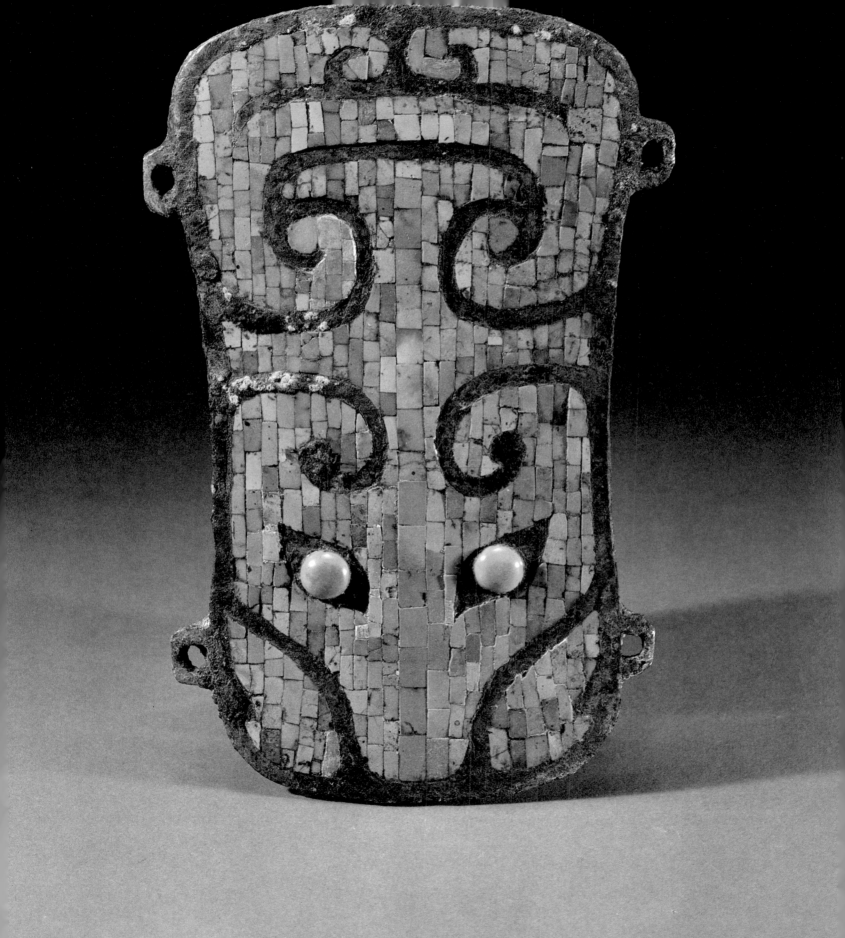

92.
Ti Lian *hu* with copper inlay, wine vessel, early Warring States Period, unearthed at Pingdingshan, Henan, height 43 cm.

90.
Bronze *mao* spear with a jade blade, late Shang Dynasty, length 18.4 cm.

91.
Iron-bladed *yue* (incomplete) with nipple design, weapon, late Shang Dynasty, unearthed at Taixi, Gaocheng, Hebei, length 11.1 cm.

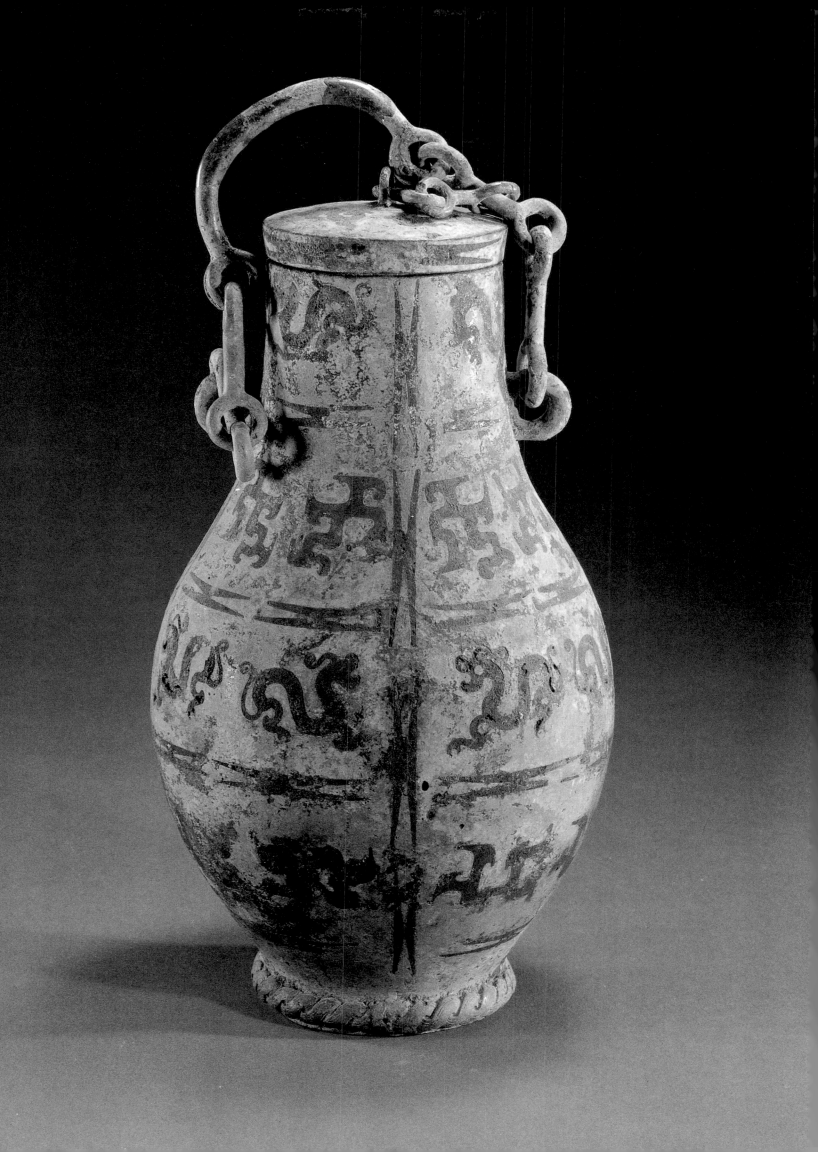

original object in the Freer Gallery of Art in Washington D.C., and found no reason to suspect its genuineness. Whereas the jade parts of the first *ge* were inserted into the mould before the bronze section of the weapon was cast, in the instance of the perforated one, the reverse method was used, where the shells, after being carefully polished, were inlaid with the greatest precision in grooves in a previously cast piece of bronze. Had the shells been placed in the mould prior to casting, they might have cracked with the heat.

Bronze ware with copper inlay grew in number in the middle Spring and Autumn Period, the earliest one being a group of vessels belonging to a man named Feng Shu unearthed in Tengxian, Shandong Province. An ewer in the collection, known as the Feng Shu *yi* and kept in the Shanghai Museum, has on its wall copper-inlaid animal designs visible on both the interior as well as exterior of the receptacle. The effect was created by placing pre-cast copper designs in the mould before the bronze was cast. This method was applied to diverse vessels, using copper as well as other metals for the inlay (Pl. 92), as exemplified by vessels with complicated pictorial patterns. Another proof of the use of such a method has been furnished by the pottery mould for making the metal inlay with a mulberry-gathering motif found in Shanxi's Houma County.

Very few forged objects of the Shang and Western Zhou periods have been found. The late Spring and Autumn Period produced some forged thin-walled vessels of which the *zhou* (oval-mouthed tray) unearthed in Huangchuan in Henan Province is an example. Its body was first forged, and then its two handles, which had been previously cast, were riveted on the body. Another example is a *fou* (wine container) of a metal very similar to copper discovered at Beixinbao in Huailai County, Hebei Province. Its decorative pattern, carved with a sharp instrument, is of the *zhen ke wen* (needle carved design) type. Designs of this kind are often found on forged copper vessels, probably owing to the fact that this metal is softer and easier to carve than most.

Metallurgical and casting technique continued to improve during the Eastern Zhou (Pl. 93). The bronze casting technique of this period is summarized in the article "A Manual of Crafts" in *Zhou Li* (*The Rites of Zhou*), which lists in detail the different proportions of copper and tin in the bronze used for making bells, food containers, axes, knives, halberds and mirrors. As a result of continuous years of war, the casting of weapons developed with great rapidity. Swords made in the states of Wu and Yue were renowned throughout the land for their sharpness. A number of artisans, among them Gan

Jiang and Ou Ye, made names for themselves in sword-making. Many of the Wu, Yue and Chu swords discovered over the last few years boast exquisite craftsmanship and the keenest edges, corroborating all that has been written about them in historical books. Even though they have been buried underground for more than 20 centuries, some of them can still cut through whole stacks of paper. Precious swords like the one used by Gou Jian, prince of the State of Yue (Pl. 19), were treated with certain chemicals, which gave them a rust-proof coating with brilliant lozenge-shaped, fish-scale and flame-like patterns. Many of the bronze swords (Pl. 94) and arrowheads recently unearthed from the tomb of the First Emperor of the Qin Dynasty (Qin Shi Huang) at Lishan, Shaanxi Province, were likewise treated, and their resplendence has endured to this very day.

The technique of embellishing bronzes with gold and silver became increasingly popular in the late middle Spring and Autumn Period. Gold and silver ornamentation of the Warring States Period was usually very thin. The chime of bells, or *bian zhong*, unearthed from the large tomb at Leigudun in Suixian, for example, have 2,800 characters inscribed on them, most of which are covered with a thin layer of gold. This could have been done either with inlay or by applying gold mercuride in the grooved characters and driving off the mercury with heat (a method similar to gilding). But whether the latter method was employed or not has yet to be proved by further study and experiment. Inlaying with gold wire, done by hammering a length of the wire into grooved designs on the bronze which was subsequently polished, was not an uncommon practice. The joints of the wires are discernible on such objects. Bronze objects of later periods were sometimes inlaid with gold or silver chips. In Yunmeng, Hubei Province, a lacquer vessel with a bronze rim was found whose gold and silver cloud patterns have partly peeled off, exposing the original thickness of the chips. Tin-plated bronze vessels of the Qin period have also been found in Yunmeng. The date of invention of the tinning technique remains a subject of research. Some of the copper armours found in Tomb 1004 at Xibeigang in Houjiazhuang in the Yin ruins are believed to be plated with tin, but this is yet to be verified.

Objects were sometimes cast in two different metals during the Warring States Period, the most popular combination being bronze and iron. The giant *ding* discovered in the tomb of Prince Zhongshan at Pingshan has three cast-iron feet. During the Qin Dynasty, the weight of a balance was often inlaid with a bronze plate, so that the imperial decree dictating the unification

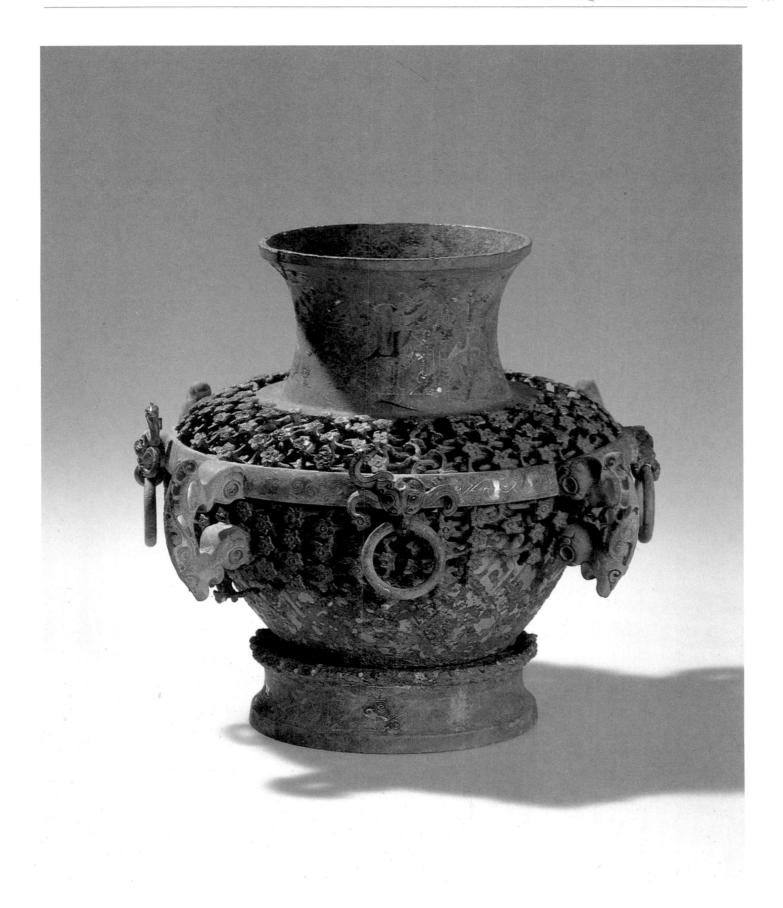

93.
Chen Zhang round *hu*, wine vessel, middle Warring States Period,
unearthed at Nanyao, Xuyi, Jiangsu, height 24 cm.

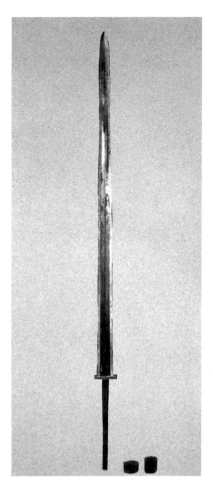

94.
Bian Jing long *jian* sword, Qin Dynasty, unearthed from the Tomb of Qin Shi Huang, Lintong, Shaanxi, length 91 cm.

of weights and measures could be carved on it. A few bronze swords from the State of Chu were reinforced with an iron rod in the centre which was covered with a strip of bronze, so that unless the sword were broken, the secret of this technique would not be revealed.

Bronze vessels inlaid with jade or glaze (Pl. 95) appeared in the Warring States Period, lending added beauty to them. A number of rare objects of this kind, for example, have been discovered in Jincun, Luoyang.

Inscriptions and decorations on Western Zhou bronzes were occasionally filled with lacquer, and by the time of

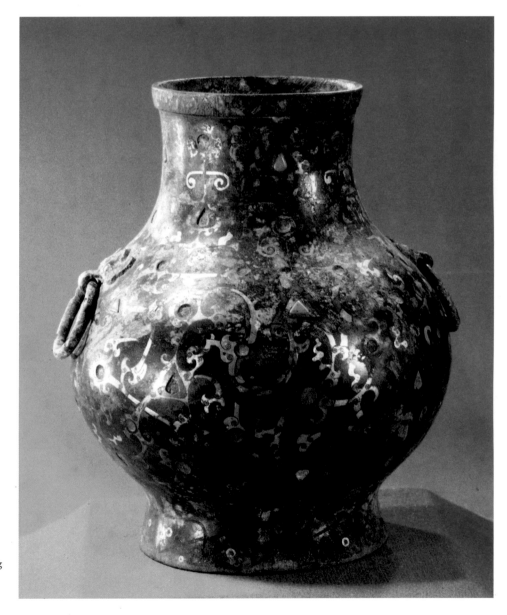

95.
Hu with cloud design, middle or late Warring States Period, unearthed at Baoji, Shaanxi, height 19.3 cm.

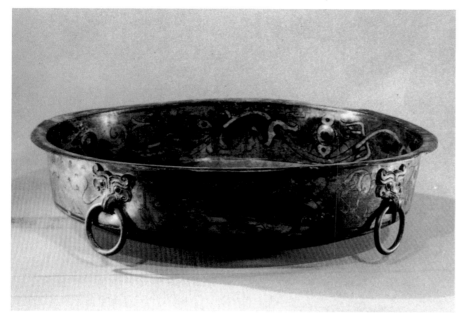

96.
Pot with coloured tableaux, Western Han Dynasty, unearthed at Luobowan, Guixian, Guangxi, diameter 44 cm.

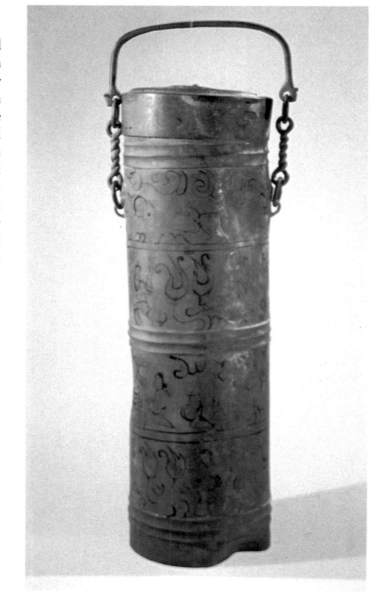

the Warring States, bronzes with colourfully painted designs had made their appearance. Copper human figures were found standing beneath the *bian zhong* (chime of bells) frame discovered in Tomb 1 at Leigudun in Suixian County, Hubei Province. A bronze lamp in the shape of a human figure dressed in splendidly painted array was unearthed in Sanmenxia, Henan Province. In the Han Dynasty, more bronze objects were decorated both on the interior and the exterior with colour designs. Among the early Han bronzes unearthed at Luobowan in Guixian County, Guangxi, was a pot (Pl. 96) with four groups of coloured tableaux on the exterior of the wall depicting galloping horses, warriors, and scenes of battles between men and struggles between men and beasts, while the interior is decorated with a dragon and fish design. There was also a bamboo-shaped bronze tube (Pl. 97) in the same tomb painted with birds, animals, human figures and cloud designs. Both are outstanding works of painted bronze.

[1] See also R. J. Gettens, R. S. Clarke, Jr., W. T. Chase: "Two Early Chinese Bronze Weapons with Meteoritic Iron Blades."

[2] See Wang Lin, "The Combined Casting Technique of Metals and Nonmetals of the Shang Dynasty as Seen from Several Jade-Bladed Bronze Weapons," *Archaeology*, No. 4, 1987.

[3] Yu Zhonghan, "Selections of Shang and Zhou Bronzes from the Jinan City Museum," *Haidai Archaeology*, Vol. I.

97.
Painted bamboo-shaped bronze tube, Western Han Dynasty, unearthed at Luobowan, Guixian, Guangxi, height 42 cm.

Characteristics of Fine Arts

ON a snowy afternoon a few years ago, this author accompanied a professor from University of Pittsburgh, U.S.A., and his wife to the Imperial Palace in Beijing to visit an exhibition of unearthed artifacts from the tomb of the Prince of Zhongshan in Pingshan, Hebei Province. The exhibits were mainly bronzes. I introduced the bronze objects to them, one by one, and explained their archaeological significance. When we were walking out of the exhibition hall after the visit, the professor's wife suddenly asked me:

"Why do you call it an archaeological exhibition?"

"Because these cultural relics are the results of scientific excavations and the achievements of archaeological work."

"But I think it is a good exhibition of fine arts. All exhibits here are art works of high value."

Her view is correct. The bronze objects from the tomb of the Prince of Zhongshan, as well as most bronzes of ancient China, are indeed works of art. Bronzes are an important category in the history of Chinese fine arts.

Bronzes were created by ancient artisans. Many ancient books record the names of some famous artisans. For instance, in the late Spring and Autumn Period, Gan Jiang of the State of Wù, and Ou Ye of the State of Yue, excelled at making swords. *Lost History of the State of Yue* records that Ou Ye made five swords with tin from a mountain in Chijin and copper from a stream in Ruoye. He named the first sword, Zhanlu; the second, Chunjun; the third, Shengxie; the fourth, Yuchang, and the fifth, Juque. In the pre-Qin period, there was a great number of artisans as skilful as Gan Jiang and Ou Ye, but their names were unknown. We can only appreciate their works now.

In ancient China, the most capable and skilled artisans gathered at the capitals of the dynasty and the princely states. Masters taught their apprentices techniques and handed down skills, generation by generation. Like other artists, bronze artisans fell into different schools. From the pre-Qin period to the Han Dynasty, bronzes made both by the court artisans and those by local artisans had their own unique attainments. For instance, meticulously decorated bronzes of the Chu Culture represent a special style of art school.

Chinese history shows that bronzes were cast in different places. Metropolitan cities and remote places alike had their own bronze handicraft industries. Therefore, in each period, several styles of bronze objects coexisted, with both common and different techniques. Take the bronze objects of the Shang Dynasty, for instance. Those excavated from the Yin ruins are quite different from those unearthed in Shanxi and Shaanxi provinces; and those from Hubei and Hunan show their own characteristics. Many vessels of the same category have similar designs, but display a different type of beauty. The vigour and dignity of the bronze vessels of north China contrasted strikingly with the freshness and elegance characteristic of those of south China, as manifested in Shang bronzes. The Ersibiqi *you* jar, and the Sisibiqi *you* (Pls. 98-99), unearthed from the Yin ruins, were made at the end of the Shang Dynasty. The Ersibiqi *you* is short and thick, without animal heads on both ends of the loop handle, and with a high-edge cover topped by a rhombus knob. The Sisibiqi *you* is higher, with animal heads on both ends of the loop handle and a low-edge cover topped by a knob. The Ersibiqi *you* carries a *kui*-dragon design; and the Sisibiqi *you* has a *taotie* ogre-mask motif, providing a feeling of simplicity and solemnity. The basic structure of the Ge *you* unearthed in Ningxiang, Hunan Province, is similar to the Ersibiqi *you*. It has four discontinuous flanges from cover to circular legs, protruding angles on the sides of the cover and long and short birds, *kui*-dragon, cicada and perpendicular patterns, with meticulously made cloud-and-thunder pattern as the background, making it much more gorgeous than the two Biqi *you*.

Ancient bronzes and the creation of fine arts are closely related as to techniques. As described earlier, the method of composite mould was commonly adopted to cast bronzes. The pottery moulds were usually destroyed after a bronze object was cast. Thus, casting a bronze means a creative effort involving the entire process from mould-making to casting. Although some bronzes look alike, slight differences can be found by careful observation. Judging from the development of Chinese bronzes, casting bronze objects is full of creativity. Great changes took place in the bronze industry once every fifty years.

Each period brought forth masterpieces of high artistic value, the results of eminent artisans' painstaking efforts.

The following is a brief account of artistic characteristics of ancient Chinese bronzes:

Harmony in shape, arrangement of decorative patterns, colour contrast, etc., are a prominent principle much emphasized in designing Chinese bronzes.

Even in very early periods, artisans had directed their attention to the harmony of all parts of a vessel. As mentioned before, the *jue* discovered at Erlitou and other places in Yanshi County, Henan Province, are the earliest bronze containers ever found. The shape of *jue* is very complicated: The front part has a spout with a pillar; the rear has a tail on whose side is a knob; and its flat bottom is supported by three thin legs. The shapes of the bronze *jue* discovered at Erlitou and other places are quite different from each other, thanks to different proportions of all parts. Worthy of particular mention is

that the *jue* with nipple design (Pl. 100) unearthed at Erlitou in 1975 has a very long, narrow spout and an elongated tail, so that its upper portion looks fairly large. To avoid creating imbalance, the designer shaped it with a slender waist, and three long, thin legs, resulting in a very elegant and beautiful piece.

As described earlier, one of the two square *ding* with nipple and ogre-mask motifs unearthed from Zhangzhaiqian Street in Zhengzhou, Henan Province, is the largest bronze vessel of the early Shang Dynasty. It is 100 cm high, has a deep belly and wide folded edges on which are arch-shaped upright ears. On the upper part of its belly is an ogre-mask motif, and both sides of the belly and its lower part are decorated with a nipple design, forming a U-shaped frame. The four legs, thick above and thin below, show ogre-mask and bow-string patterns. With a big belly and short legs, this *ding* cooking vessel looks slightly imbalanced. However, arti-

98.
Er Si Bi Qi *you*, wine container, late Shang Dynasty, reportedly unearthed at Anyang, Henan, height 38.4 cm.

99.
Si Si Bi Qi *you*. wine container, late Shang Dynasty, reportedly unearthed at Anyang, Henan, height 34.5 cm.

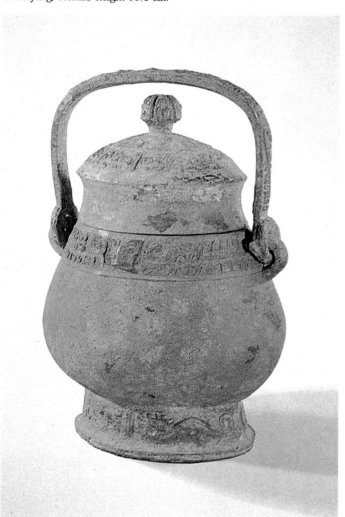

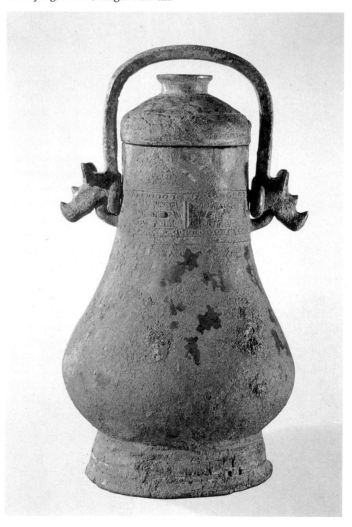

sans moved the ogre-mask motif that should have been under the edges downward to the upper middle part of the belly, thus to a certain degree making up for the imbalance.

In the early Shang Dynasty, most patterns on bronzes were strip-like, so the need of harmony was not very obvious. In the later Shang Dynasty, as bronzes were fully decorated, harmony of the patterns on all parts of a vessel became an important subject. Bronzes with complicated patterns made in the later Shang and early Zhou show a great success in harmonizing various designs. For instance, the three-sheep zun with an ogre-mask motif excavated at Huarong, Hunan, in 1966, is 73.2 cm high; such a heavy bronze zun is rarely seen. This zun has a wide flared mouth with folded shoulders and high circular legs. On its neck are two bow-string patterns; on the shoulders, a kui-dragon design, three sheep heads with rolled horns alternating with three reclined birds holding their heads high. The belly is decorated with a taotie motif and three flanges. The taotie on the belly and leg surface clearly echo the bow-string pattern on the neck and legs; and the belly and the legs are connected by flanges. The bronze as a whole is decorated with various patterns in excellent harmony.

Harmony in colour was also stressed. A newly cast bronze, unlike those that were coated with rust when brought to light, is usually golden, flesh red or silver white depending on the alloy elements it contains. Yellow, the main colour for most bronzes, will be pleasing to the eye if dark green is added to it. Starting from the time of the Erlitou Culture, artisans chose turquoise from a wide variety of precious stones as a decorative element for certain bronze objects. Later there were more and more ways to decorate bronzes with a wide variety of colours. Some bronzes of the Shang Dynasty were inlaid with yellowish white or greenish white jade, or silver white meteoric iron, with fine aesthetic effects. Artisans of the Eastern Zhou Dynasty excelled at embellishing bronzes with gold or silver filigrees and foils. Other bronzes are inlaid with red copper to create appealing patterns. The bronzes decorated with jade and glaze of the Warring States Period are very colourful. One kettle is inlaid with gold, silver and coloured glaze.

Decorative motifs, another characteristic of Chinese bronzes, emerged with the birth of bronzes.

The triangle and nipple designs are among the earliest decorations on ancient bronzes. Both the broken knife handle and the seven-pointed star mirror of the Qijia Culture mentioned earlier are decorated with triangle designs. On the back of the mirror is a triangle between two bow-strings, forming a seven-pointed star design with a background of oblique lines. The triangle and nipple patterns are commonly seen on the bronze objects of the Erlitou Culture and the first half of the Shang Dynasty.

Taotie motif, the most common of the bronze decorations, as described earlier, is a design of mythical meaning. From a fine arts viewpoint, the taotie motif has complicated connotations. Some look like real or mythical animals, such as the dragon, tiger, cattle, sheep and deer; some are a combined pattern—half of the taotie pattern is a kui-dragon, and the other half consists of kui-dragon on the horns and brows of the taotie, and small inverted kui-dragons on both sides of the taotie. In this case, therefore, a taotie is a combination of several animal designs.

Another characteristic of Chinese bronzes is that no portraits have been found up to now on bronze objects. However, many bronze objects adopt the human mask as decoration, such as the human-mask square ding tripod and the human-mask yue axe, but these masks represent no particular person. More objects show the whole human image, such as the human-shaped lantern or stand, or use the whole human image as a part of an object. For instance, a clock stand consists of a human being who wears a sword, supporting a horizontal beam. A bronze plate has several human-shaped legs. These humans wear the attire of a male or female attendant but they are not portraits of any particular attendant. In a foreign country in 1982, I saw a stand for a bronze object in the shape of a woman. She wore a meticulously made costume and hair, and had a very pretty face. While it is a real work of art, I am not able to tell which historical figure she represents.

As art works, bronze objects are somewhat different from paintings and other works of fine arts. Chinese painters began to use their works to represent concrete human figures long ago. Two silk paintings of the Warring States Period unearthed, respectively, at Chenjiadashan and Zidanku in Changsha, Hunan Province, are the oldest silk paintings found. One painting shows a woman with wide sleeves and a thin waist; the other, a man wearing a hat, robe and sword. Both are sacrificial objects, representing the people in the tombs. The Western Han silk paintings discovered at Mawangdui, Changsha and other places also represent portraits of the tomb occupants. However, no portraits of any particular person have been found on bronze objects up to now. Though some bronzes carry colourful figurines, such as the bronze mirrors unearthed at Xi'an, Shaanxi, which are decorated with colourful human figures and chariots, they are not portraits.

100.
Jue with nipple design, wine vessel, Erlitou Culture, unearthed at Erlitou,
Yanshi, Henan, height 22.5 cm.

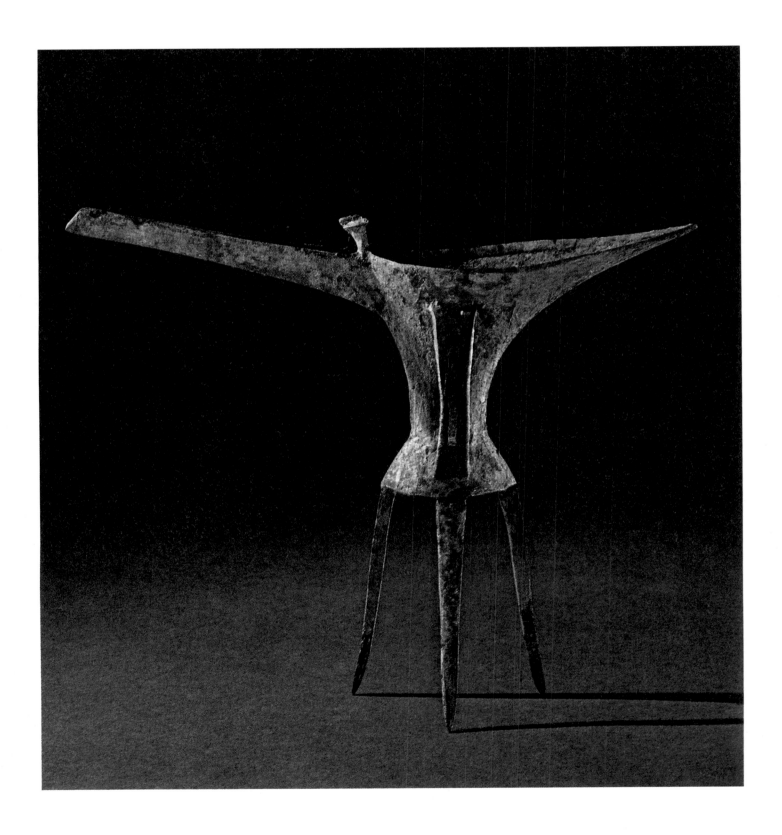

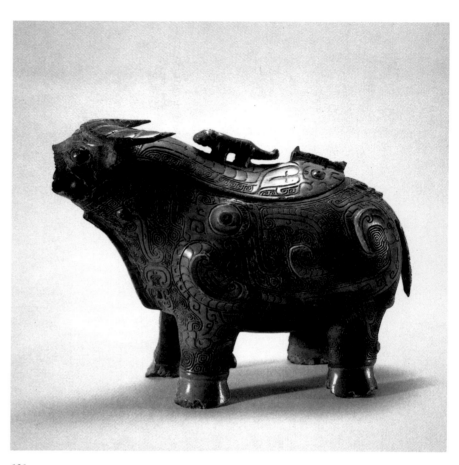

101.
Ox-shaped *zun* (incomplete), late Shang Dynasty, unearthed on the outskirts of Hengyang, Hunan, length 19 cm.

Most animal designs on bronze objects are mythical creatures rather than the recreations of true animals. For instance, a *zun* cup in the shape of a buffalo excavated at Hengyang, Hunan, in 1977 (Pl. 101), has many other decorations: Its cover has a dragon design on which is a standing tiger; the part below the buffalo's neck is a *kui*-dragon; its belly is a *taotie* ogre-mask with a flange; and both sides of the body are decorated with big birds. It is obvious that instead of a commonly seen buffalo, the buffalo on the *zun* is a mythical beast, a combination of various weird animals. A *gong* wine vessel with a bird-and-animal design is preserved in the Freer Gallery of Art in the U.S.A. The front tip of the cover is an animal's head with teeth exposed and turned-up horns; on the cover's back is a reclining dragon. The end of the cover represents a cattle's head, and on both sides are a *kui*-dragon, elephant and weird animal with scales. The owl-shaped front part of the *gong* has a serpent design; the rear is decorated with *taotie*, and its hind leg is decorated with a dragon with a human mask. Its knob is a standing bird topped with an animal head. This vessel represents various kinds of precious birds and strange animals.

All of the above-mentioned characteristics show that ancient Chinese bronzes differ from those bronzes cast in other ancient countries, and have, indeed, become a category with a special position in the history of fine arts. It is no wonder that Chinese bronze objects occupy an important position in both Chinese and foreign museums and art galleries. These institutions treasure not only large bronze articles, such as sacrificial objects and musical instruments, but also small objects, such as bronze mirrors and belt hooks. An account of small bronze objects will be given in the next chapter.

Bronze Mirrors, Belt Hooks, Seals and Coins

MIRRORS, belt hooks, seals and coins do not normally feature in the realm of bronzes, as they are objects of specialist collectors and are therefore dealt with individually and thematically. Moreover, they are not confined merely to bronze, but are often made of other materials too. Mirrors have been fashioned of iron, and belt hooks of iron, jade and other substances. Seals cover an even greater range of materials, such as jade, stone, agate, rock crystal, glass and so on. Apart from bronze coins, cowrie shells and gold coins were also circulated as legal tender. However, as these four items have all been traditionally included in records of ancient bronzes, we shall give them a brief mention here.

Let us first look at mirrors.

Many scholars once thought that bronze mirrors

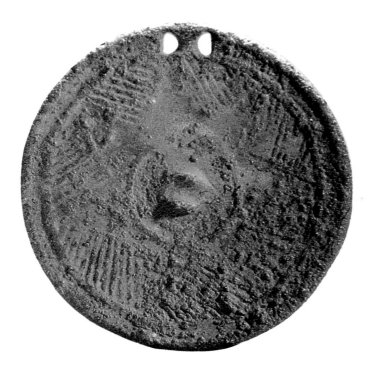

102.
Seven-pointed star mirror, Qijia Culture, unearthed at Gamatai, Guinan, Qinghai, diameter 8.9 cm.

appeared initially at the time of the Warring States, but this has been disproved by recent archaeological findings. The earliest bronze mirror known so far is of the Qijia Culture. There are two such mirrors dating back to that period. One, 9 cm in diameter and its back adorned with seven-pointed stars, was unearthed at Gamatai in Guinan County (Pl. 102), Qinghai Province, as more than once mentioned before. The other, 6 cm in diameter devoid of ornamentation and fitted with a bridge-shaped boss, was found at Qiajiaping in Guanghe County, Gansu Province. There is yet another, which was discovered in Linxia, Gansu, and is now kept in the Museum of History. This one, 14.3 cm in diameter, has two rings of star patterns on its back.[1]

Mirrors of the Shang period have also been found. In the 1930s, a bronze article was discovered in the Yin ruins,[2] which one scholar declared was a mirror, but because it was a solitary find it was not generally accepted as such. Then, in 1976, in the tomb of Fu Hao (Tomb 5) at Xiaotun, also part of the Yin ruins, four bronze mirrors were recovered, establishing once and for all that such mirrors had been in use as far back as the Shang Dynasty. All four were round, with a small central boss on the back encircled by geometric patterns. At Baifu, Changping, on the outskirts of Beijing, and at Baoji and Fengxiang, both in Shaanxi Province, Western Zhou bronze mirrors have been found, and some dating from the Spring and Autumn Period have been retrieved in Shangcunling, Sanmenxia, Henan Province. These discoveries have provided us with a broad outline of the evolution of ancient Chinese bronze mirrors. The style of the motifs of the Shang mirrors is different from those of the other bronze vessels of the same period; they are in the same strain as bronze mirrors of the Qijia Culture. The back of the bronze mirror of the Spring and Autumn Period unearthed in Shangcunling bears animal and bird motifs whose shapes bespeak influence of the northern ethnic groups. All this suggests that bronze mirrors followed an independent line of development within a considerable length of time and were probably not products of the same craftsmen.

The making of bronze mirrors became a full-fledged craft in the Warring States Period. In form, the mirrors of this period were of two types, namely, square and round, with a small boss rising from a panel or a ring of bronze. Unlike those of other countries, ancient Chinese bronze mirrors had no handles to them. It was only after the Tang Dynasty that mirrors with handles emerged.

Most mirrors of the Warring States Period had beautiful and lavishly rendered designs. The background was generally very fine. Most had staggered *shan* (山) motifs on them, or the *kui*-dragon, phoenix or other animal motifs, scenes of fighting beasts, and so on, often interspersed with floral patterns. In addition to these, there were the various ogre-mask and coiled dragon motif mirrors.

The staggered *shan* motif, derived from the geometric patterns of the Shang, usually consists of three to six such characters (Pl. 103). *Shan* mirrors were most fre-

103.
Six-*shan* mirror, Warring States Period,
diameter 14.3 cm.

Fig. 39 Mirror with staggered *shan*-character design restored by means of a pottery mould, unearthed from the ruins of the second capital of the State of Yan.

Fig. 40 Mirror, Qin Dynasty, from Shuihudi, Yunmeng, Hubei Province.

quently encountered in the Warring States Period, and the majority of them had only four such characters arranged around the four sides of the panel beneath the boss. In the ruins of the second capital of the State of Yan, moulds for mirrors with the four characters positioned on the four corners of the panel (Fig. 39) have been found.

Legend has it that there was a style of Qin mirror which could reflect one's viscera like X-rays. Of course, this was pure myth, but it was this very subject that earned Qin mirrors their reputation. Scholars had debated at length over the nature of Qin mirrors until recently, when a number of them (Fig. 40) came to light at Shuihudi, Yunmeng, in Hubei Province, with reliable dates.

It was discovered that Qin mirrors of this area were actually an elegant continuation of those of the Warring States. What had been previously considered as Warring States mirrors in actual fact included mirrors made in the period from the Qin to the early Western Han dynasties. In early Western Han tombs dating as far back as the reign of Emperor Wen Di, mirrors were found still with the *shan* and coiled dragon motif and others of the Warring States, as was the case of the mirror with the intertwining dragon motif found at Tomb 1 in Mawangdui, Changsha, Hunan Province, and the six-*shan* mirror found at the King of Nanyue's tomb in Xianggang, Guangzhou. Of the mirrors found prior to this in the Huai River basin and at Changsha many actually belonged to the period from the Qin to the early Han.

The erroneous belief of certain scholars that mirrors of the Warring States could have inscriptions,[3] as did those discovered in the Huai basin, was dispelled when, on closer examination, the engraved scripts were identified as being early Han. Several of the inscriptions begin with "*xiu xiang si*," where the character "*xiu*" has been substituted for "*chang*" ("*chang xiang si*" meaning "eternal love") to avoid vilifying the name of Liu Chang—the second character being exactly the same as that mentioned above —who was prince of the southern Huai region during the Han Dynasty.[4]

Mirrors produced during the reign of Emperor Wu Di of the Han Dynasty and afterwards underwent marked changes. The former small boss on the back grew into a solid semi-spheroid.

There are also mirrors with painted designs, made mostly in the early period of the Western Han Dynasty. The bronze mirror found in 1963 at Hongmiaocun in Xi'an (Pl. 30) carries representations of chariots and human figures, which are realistically rendered and even more finely executed than those in silk pictures of that

time. In the Fogg Museum of Art, Cambridge, Mass., is a mirror of the same type[5] and probably of the same period. Bronze mirrors with painted designs of the Warring States Period have also been unearthed in Hunan Province.

Late Eastern Han Dynasty mirrors reveal a Buddhist influence as evident on the designs of mirrors found recently at Echeng in Hubei Province.

Most Eastern Han mirrors bear long inscriptions, some even with dates, a practice which was continued into the Wei and Jin dynasties. Certain mirrors are engraved with poems of seven-character lines and many show signs of mystical influence. An Eastern Han mirror inscribed with the *Shuo Ren*, an ode to beautiful women, from the *Shi Jing* (*Book of Songs*) is a very precious find. In the Sui and Tang dynasties, mirrors with such verses became quite popular.

Hooked belt clasps, apart from being utilitarian objects, were also articles of adornment for garments. Records indicate that they were already worn back in the Spring and Autumn Period. In 685 B.C., in the State of Qi, there was a fight for the succession to the throne. The chief ministers of Qi, Gao and Guo summoned a prince Xiao. Bai from the State of Ju, while the State of Lu sent an army to install another prince by the name of Jiu on the throne, simultaneously despatching Guan Zhong with troops to intercept Xiao Bai. When Guan Zhong and Xiao Bai met, the former took a shot at Xiao Bai but his arrow only struck the clasp of Xiao Bai's garment. The latter, taking advantage of the situation, feigned death, and by means of this stratagem, was the first to reach the capital of the State of Qi where he was proclaimed the ruling prince and subsequently became the well-known Prince Huan of Qi.

It must be pointed out that belt hooks were originally a part of the dress of China's northern tribes, a characteristic which distinguished these people from the rest of the country. It was not till the middle of the Warring States Period that they had spread to the south.

Many clasps are inlaid with gold and silver, or inset with jade, glass, and turquoise (Pl. 104); some are also gilded. They come in various shapes—cudgels, serpents, *pipa* (an oval stringed instrument) and so on—and are objects of superb craftsmanship. The knobs of certain clasps of the Warring States and the Qin and Han dynasties are shaped like seals, such as that of Zhao Chongguo of the Han Dynasty. In the Song Dynasty work, *Inscriptions on Bronzes of Various Dynasties*, there is mention of a gold-inlaid clasp with a lengthy admonition written in "bird script."

The *xi* (seals) used in ancient China were different from those of posterity, which are first inked so that the ink is transferred onto paper. In the old days, seals were used to seal letters and stamped in clay on the envelope as sealing wax or other impressible substances were used in Europe not very long ago. Two bronze *xi* have been found in the Yin ruins, one of which is in the shape of the character *ya* (亞) enclosing the character *luo*. This resembles certain bronze inscriptions of the same period[6] and it is possible that this had in fact been used to stamp bronze vessel moulds. The other seal bears several characters which have not yet been deciphered.

Seals could also be large in form and be engraved with sizable characters. Specimens have been found mostly in Shandong Province. They are mostly flat and their designs are fairly simple. The structure of the characters they bear indicates that this type of large seal is probably of the Spring and Autumn-Warring States periods, but as very few have been found, some scholars still have reservations on their dating. Pottery vessels have been found stamped with such characters, so they are clearly not spurious. In a shaft at Jinzhuang Mine of the Kailuan Colliery in Tangshan, Hebei Province, a large bronze seal was unearthed in 1962 which is now in the Museum of Chinese History (Fig. 41). The seal bears four characters, *hui qi shi xi*, of which the first two were the name of the region in former times which embraced present-day Kailuan where the *xi* was found (another seal bearing the characters *hui qi* had been found earlier[7]).

During the Warring States Period, each state had a seal with its own peculiar form. In the State of Yan, the seal was narrow and had a long, thin handle. The Dan You Du *xi* found at Xiguan in Yixian County during the late Qing Dynasty was of this shape. "Dan You Du" was the

104.
Belt hook (incomplete) inlaid with gold and inset with turquoise, middle or late Warring States Period, unearthed at Liejiangpo, Xinzheng, Henan, length 25.5 cm.

name of a place in the State of Yan (*du* meaning "burg" or "city"). An earthenware well enclosure discovered in the capital of Yan in what is now a district of Beijing, and the pottery vessels excavated from the ruins of Yan's second capital at Yixian County, bear traces of impressions made by these long, narrow seals. Apart from these, Yan possessed square seals too.

At this time there were also special seals such as the large Ri Geng Du Cui Che Ma seal found in Shandong Province, which was hollow and probably used for branding horses. The seal was heated and the mark seared on the skin. Excavations in Changsha, Hunan Province, brought to light an unusual seal composed of three parts. Each segment was kept by a different person, so that all three segments had to be brought together before an entire seal could be stamped. Other seals were used, including private ones, which were generally small, and those engraved with auspicious verses or maxims for sealing letters.

After the Qin Dynasty had unified the country, the populace in general was forbidden to call their seals *xi*. They had to be referred to as *yin*, since *xi* was now the term reserved for imperial seals.

Bronze seals of the Western Han were extremely thin and exquisitely made, and the tail of the righthand section of the character 印 (*yin*, meaning "seal") inscribed on them was short. In contrast, those of the Eastern Han were cruder and heavier and the tail of the character *yin* did not droop.

In earliest times in China, cowrie shells were widely used as money. Metal coins did not appear until the Spring and Autumn Period. In 524 B.C., King Jing of Zhou minted a large coin,[8] which was of much larger denomination than the coins already in use. It can be seen from this that copper coins had been in use for quite some time. The copper coins of the Spring and Autumn Period were called *bu*, which took the shape of a small spade with a hollow handle (Fig. 42). The shoulders and the cutting edge were parallel and the whole was described as a *ping jian kong shou bu*, that is, "flat-shouldered, hollow-handled *bu*." The shoulders of the *bu* of the Spring and Autumn and Warring States periods found at Houma in Shanxi Province had rising shoulders. Sometimes such coins had a few characters cast on them, which served as identification marks.

During the Warring States Period, each state issued its own currency which was different in shape from that of other states.

Zhou kings issued a type of coin which continued the tradition of the Spring and Autumn Period, similar in form—hollow-handled, with flat shoulders—but whose

Fig. 41 Bronze seal unearthed in 1962 in a shaft at Jinzhuang Mine of the Kailuan Colliery in Tangshan, Hebei Province.

designs were set at a diagonal instead of vertical parallel rows.

Most of the characters were place names, such as "Wang" (Royal City), "Dong Zhou" (Eastern Zhou), etc. Another kind of coin, round in shape with a circular hole in the centre, bore the characters "Dong Zhou" and "Xi Zhou" (Western Zhou). "Dong Zhou" coins have been found at Jincun in Luoyang, Henan Province.

The eastern states of Qi and Yan mainly circulated "knife-coins," thus named because of their shape. Those of the State of Qi were rather thick and heavy and bore the characters "Knife of the State of Qi," "Knife of Ji Mo"[9] and so on. Samples of these coins and their moulds have been found in various places in Shandong Province. The small knife-coins of the State of Yan bore the character "*ming*" and so became known as *ming dao*, or "*ming* knives." Large hoards of these knife-coins have been found in Beijing, Tianjin, and Hebei and Liaoning provinces.

The main currency of the states of Han, Zhao and Wei was the *bu*. The Wei *bu* were spade-like and possessed level shoulders and a solid handle. Towards the end of

首 shou

肩 jian

跨 kua

Fig. 42 *Kong shou bu* (hollow-handled *bu*).

the period, it developed into a square-legged one with a round crotch between the two legs and was issued in three denominations: *ban jin, yi jin* and *er jin,* respectively, half, one and two *jin. Jin* was the unit of the currency. Caches of such coins have been found in Dongzhoucun, Wanquan, Shanxi Province. The State of Wei also used round coins which had a circular hole in the centre, but no raised rim of Zhou coins, and bore place names.

The square-legged *bu* was used chiefly in the State of Han, but also in the states of Zhao and Wei. Some scholars claim that Han also circulated round-crotched *bu* like those of Wei, but this needs to be investigated further.

The State of Zhao had the greatest variety of coins, featuring in the main the *jian zu bu,* which was issued in two grades, the *yuan zu bu,* which generally had "Lin" or "Li Shi," names of places of manufacture, inscribed on them, and the *jian shou dao.* There was also another extremely rare type of *bu* in one *liang* and 12 *zhu* denominations, with three round holes, and bearing the place names Pingtai, Jiumen, Xi, and such like, which are the most precious of pre-Qin coins. At Suanzao, Henan Province, three-holed *bu* bearing the place name "Dong Shang" were found during the Qing Dynasty, and recently in Dingxian County, Hebei Province, three-holed *bu* bearing the place name "Xin Nan" were also discovered. The State of Zhao had a small knife-coin with the place names "Han Dan," "Bai Ren," etc. Circular Zhao coins, similar to Wei ones, had no raised rim.

A pair of bronze dies used for making impressions on gold coins were found in Shouxian County, Anhui Province, and are now in the Museum of Chinese History. The main currency in the State of Chu was the bronze *bei* (shell), the character for which was generally inscribed on the coin, and because of the similarity of the form of this character to the face of a human being, *bei* were popularly known as *gui lian qian,* or "funny-face" coins. Specimens of these have been discovered in every region where the people of Chu made their appearance, ranging from Hubei Province to the western part of Shandong Province. In addition, Chu also used a long narrow *bu* in two denominations.

Qin currency, according to inscribed bamboo slips found at Shuihudi in Yunmeng, was in use right up to the late Warring States. It was a piece of trapezoidal hand-woven linen of a set length (minted coins emerged later). Qin law decreed that 11 *qian* made one *bu.* The *qian* was otherwise known as a *ban liang,* round in shape with a square hole in the centre and had no raised rim. After Emperor Qin Shi Huang unified the country, the *ban liang* became the only fixed bronze legal tender in use. In the early Western Han Dynasty, the *ban liang* coins were still in circulation, but they were lighter and thinner. At this time, the rulers of certain principalities began issuing their own inscribed and diversely shaped currency on a small scale, alongside the official *ban liang,* which caused much confusion. Emperor Wu Di of the Han Dynasty reformed the currency and minted a small quantity of *san zhu,* but it was not until 118 B.C. that *wu zhu* were struck, making the handling of money much more convenient to all. Thus, the *wu zhu* became the fixed currency for both the Western and the Eastern Han dynasties. Pottery and bronze moulds for *wu zhu* coins were equally common.

A word must be said about the subjective and archaistic innovations of the Wang Mang interregnum, and the currency he introduced, namely, the six denominations of the round coin *quan* (meaning literally "source" or "flow," and hence, by analogy, "currency"), and the 10 denominations of *bu.* The addition of two kinds of knife-coins complicated matters and consequently the currency was soon abandoned. A round *huo quan* and a *huo bu* (a form of *bu*) were issued. The coinage of Wang Mang's time was finely made, particularly the knife-coins or *dao bi,* with its two characters *yi dao* (one knife) inlaid in gold.

Coin collectors of olden times never managed to acquire a complete set of the six *quan* or the ten *bu,* and assembling any one of the series was in itself quite a feat. In the catalogues compiled by a collector named Chen Rentao, mention is made of a kind of *guo bao jin kui* coin, a single one of which was worth 10,000 *qian,* and was probably a product of Wang Mang's period, but it is not mentioned in historical records.

[1] Shi Zhilian, "Bronze Mirrors of the Qijia Culture," *Chinese Cultural News,* July 10, 1987.

[2] For photographs, see Chen Mengjia's "Bronzes of the Yin Dynasty," Plate 12, in *Archaeological Gazette,* Vol. 7.

[3] See Liang Shangchun, *Mirrors from Caves.*

[4] See Gao Quxun, On *"A Study of Pre-Han Mirrors"* and the Dating of the *"Huai Style."*

[5] G. L. Winthrop: *Retrospective for a Collector,* 1969, Fig. 56.

[6] Huo Haoxuan, *Excavations in the Yin Ruins,* Pl. 80, Xuexi Shenghuo Publishing House, 1955.

[7] Guo Xi, *Ancient Seals of the Han Wa Yan Zhai Collection,* Vol. II, p. 29.

[8] "Records of Zhou," *Anecdotes of the States.*

[9] Ji Mo was a city in the State of Qi in present-day Shandong Province.

The Spread of Culture and Cultural Exchange

THE culture of the Chinese Bronze Age spread outwards from its focal point in the Central Plain. The development of ancient civilization was obviously uneven as each region began its bronze age at a separate time, and so the division of periods of bronze culture was also different. Generally speaking, the culture of the Central Plain exerted considerable influence on the remote border regions of China, but was in turn affected to a certain degree by the varied cultures of these distant areas.

Geographical distribution of places where Shang and Western Zhou bronzes were unearthed was extensive. For instance, bronzes of the Erligang period in the Shang Dynasty were mainly concentrated in Henan Province, but some were also discovered over vast areas in the surrounding provinces of Shandong, Shaanxi and Hubei, and even in the northeastern province of Liaoning. Bronzes of the late Shang (Yin Ruins Period) were unearthed over still larger areas north of the Yin ruins, including northern Hebei, northern Shanxi and the southern regions of Inner Mongolia and Liaoning. At the northernmost point, in Tianbaotong of Keshiketeng Banner on the banks of the Xilamulun River in Inner Mongolia, a bronze *yan* (cooking vessel) was found, whose shape and decoration were very much like those seen on objects recovered from the Yin ruins. Still further north, an inscribed Western Zhou bronze was recently excavated together with other artifacts which clearly possessed the national characteristics of the people of the north. It had in all probability been carried there by nomadic tribes, thus prompting the northward movement of Shang-Zhou culture.

Similar instances of this cultural influence can be found in history. In A.D. 89, that is, the first year of the Yongyuan reign of Emperor He Di of the Han Dynasty, the Southern Chanyu chief of the Xiongnu tribe presented to a minister named Dou Xian a bronze Zhong Shan Fu *ding*[1] of the late Western Zhou. A book of the Qing Dynasty mentions a Shi Wang *ding*, a bronze vessel of the middle Western Zhou, said to have been obtained

from Xinjiang. These bronzes had possibly been taken north in ancient times.

Xinjiang has also reported discoveries of bronzes, some of which bear notable influence of the Central Plain culture. For example, a bronze mirror datable to the Western Zhou or Spring and Autumn Period unearthed in an ancient tomb at the mouth of Chawuhu Gully in Hejing County, Xinjiang, is decorated with coiled dragon motifs similar to those of the Central Plain.

Late Shang bronzes have cropped up frequently south of the Yangtze. The bronze *yan* unearthed in Duchang, Jiangxi, is of the same type as the one from Keshiketeng Banner in the north, as well as that from the Yin ruins in the Central Plain. The largest number of bronzes of this period was found in Hunan in the counties around Lake Dongting and the distant counties of Changning and Liling, and even in the remote region of Fenghuang in western Hunan. The shape, decorations and workmanship of the late Shang bronzes found in Hunan can be compared with those of the Central Plain (Pl. 105). The magnificent *nao* (musical instrument) and the superb four-ram *zun* (wine container) from Ningxiang are rare pieces of art, even among the bronzes of the Yin ruins. In Yuhang and Hangzhou in Zhejiang, big *nao* similar to those found in Hunan were also discovered. In 1963, a bronze *you* (wine container) was retrieved from a river at Tanheli in Ningxiang. It contained over 1,000 jade pearls and jade pipes. In 1970, in Huangcai Village, again in Ningxiang, a Ge *you* was found containing more than 300 jade articles. Other instances of jade treasures stored in Shang bronze *you* were discovered in Wenzhou, Zhejiang Province.

The Hunan-Jiangxi-Zhejiang line by no means formed the southern limit of locations of unearthed Shang bronzes. Traces have been found in the south of China in the Guangxi Zhuang Autonomous Region of the existence of such bronzes. In 1974, a storage pit was discovered in Mianling, Wuming County, Guangxi, containing a *ge* (dagger-axe) and a *you*. The shape and inscription of the *you* indicate that it dated from the late

105.
Bu with ogre-mask motif, wine vessel, late Shang Dynasty, unearthed at
Zhaizishan, Ningxiang, Hunan, height 42.5 cm.

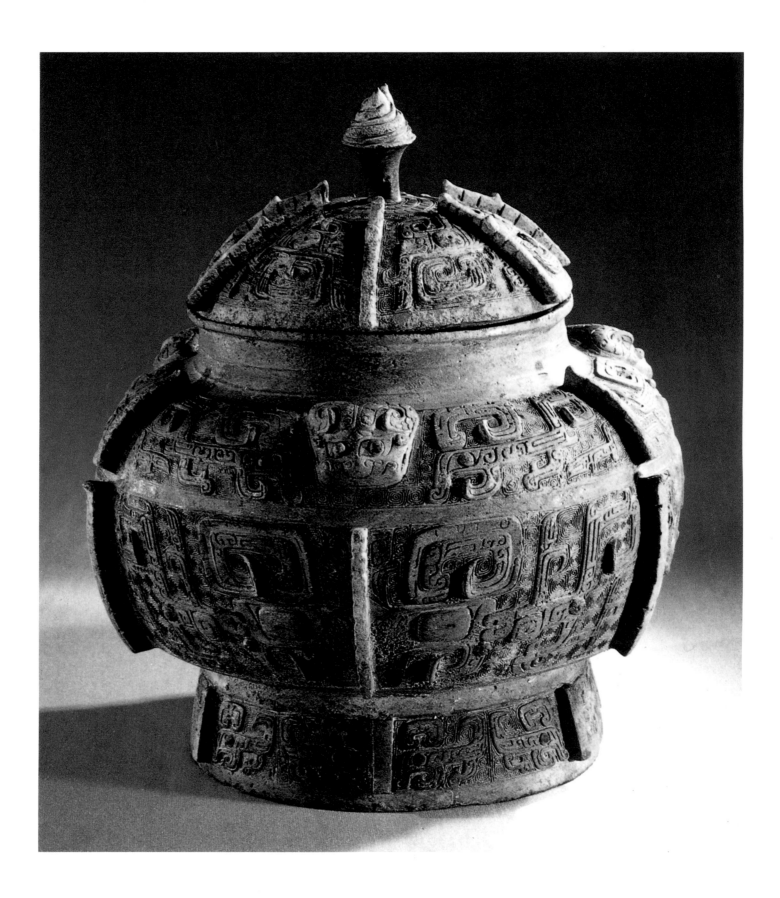

Shang. The *ge* with its blade tilted slightly upward is typical of the *ge* between the Shang and the Zhou. In 1976, a *you* of the late Shang with an ogre-mask motif and an inscription of three characters was recovered in Xing'an, Guangxi. These locations, especially Wuming near Nanning, were far removed from the centre of the Shang culture.

It is worth noting that the unearthed Shang-Zhou bronzes had common features, while artifacts of other materials found alongside them had more local characteristics. This fact suggests that ancient Chinese bronzes had a common origin.

Here, we can quote the example of the bronzes of Qingjiang County, Jiangxi Province. A *jia* (wine vessel) unearthed in Wucheng and two *ding* in Chushicao are typical of late Shang bronzes. Shang weapons found in the same place have a shape similar to that seen in the Central Plain, but their designs, such as the cloud and lozenge designs, bear close resemblance to those found on the local pottery. Contemporary earthenware had more distinctive features than the bronzes and their quality and shape were quite unlike those of the Central Plain.

The same is true of Zhou bronzes excavated in Dantu County, Jiangsu Province, and Tunxi, Anhui Province. The inscription on the food container *gui* of Marquis Ce of Yi (Pl. 106) unearthed at Yandunshan, Dantu County, reads that the marquis was enfeoffed at a place in the east by order of the King of Zhou. Other bronzes unearthed together with the *gui* possessed special designs closely resembling those on the local pottery, but their shapes were not so characteristic. The bronzes unearthed at Yiqi, Tunxi (Pl. 107), also have some of their own peculiar designs, such as a *gui* with a weaving pattern (Pl. 108) commonly seen on bamboo-woven articles of south China, but rarely encountered in the Central Plain. All this testifies to the spread of the Central Plain's bronze culture to other places, where it blended in with the local

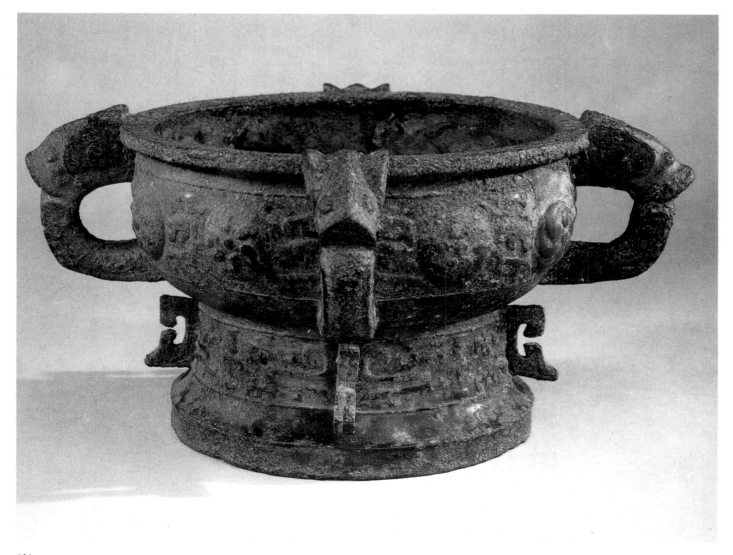

106.
Gui of Marquis Shi of Yi, food container, early Western Zhou Dynasty, unearthed at Yandunshan, Dantu, Jiangsu, height 15.7 cm.

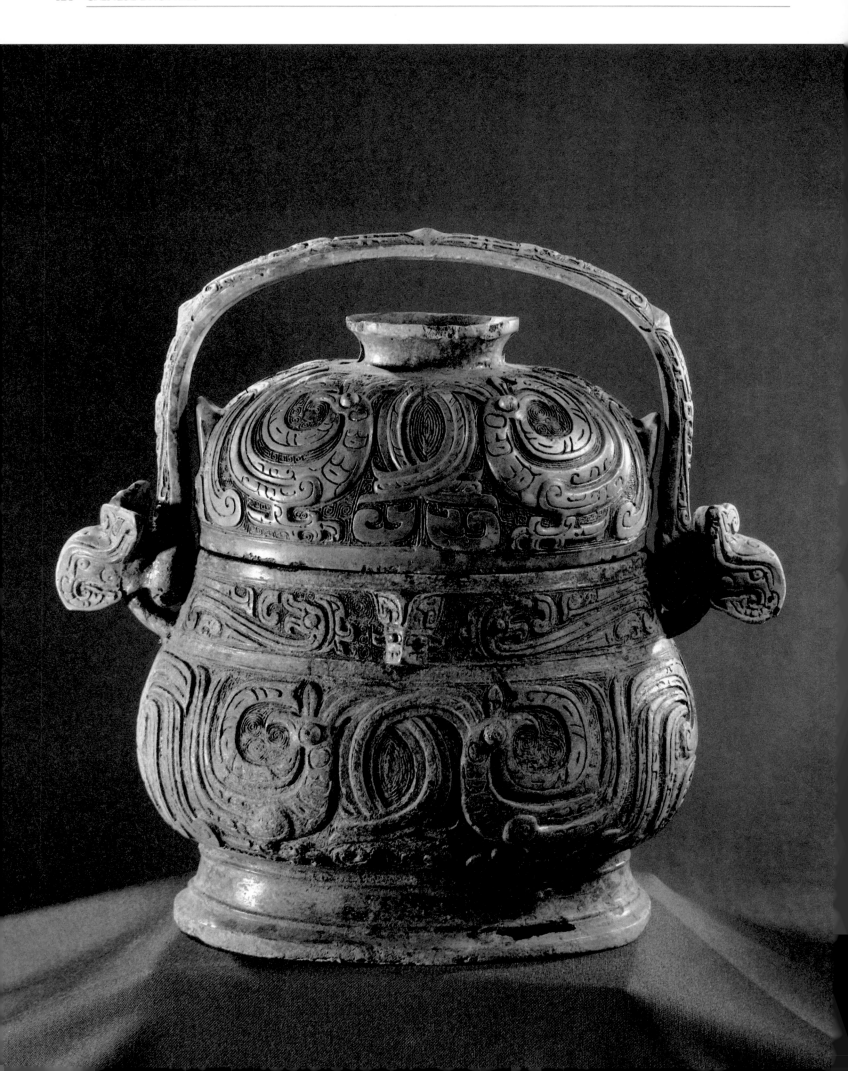

107.
Gong *you*, wine vessel, early Western Zhou Dynasty, unearthed at Yiqi,
Tunxi, Anhui, height 23.5 cm.

108.
Gui with weave pattern, food container, early Western Zhou Dynasty,
unearthed at Yiqi, Tunxi, Anhui, height 19.7 cm.

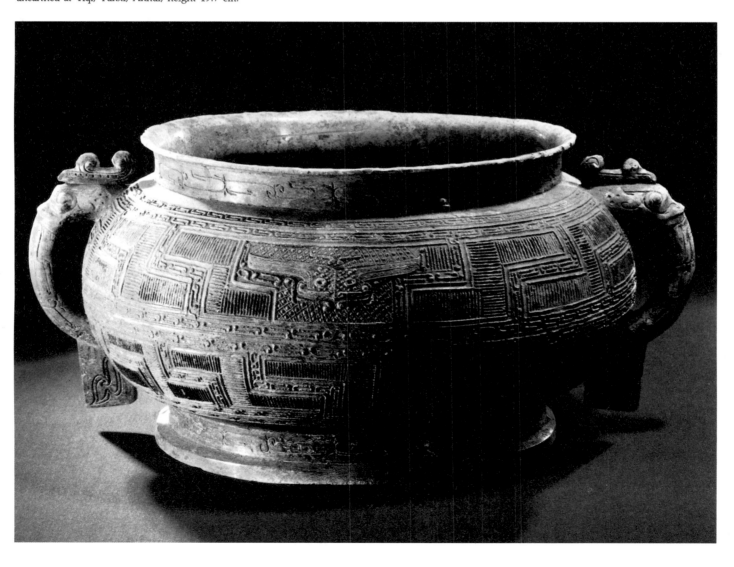

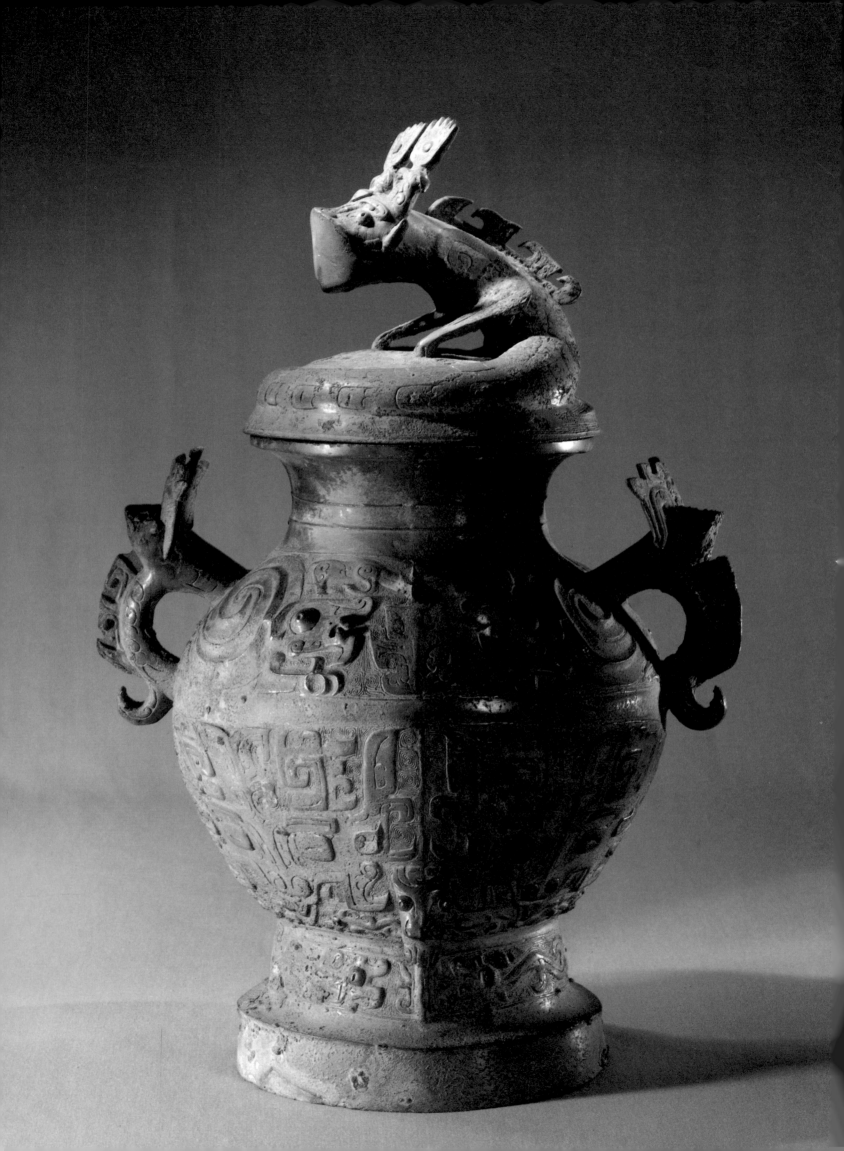

110.
Frog and snake-shaped horse pendants, early Warring States Period, unearthed at Sanguandianzi, Lingyuan, Liaoning, length 20 cm, width 4.5 cm.

national culture.

Nevertheless, the major and most essential factor is still the common feature of the bronzes. This incidence is best brought out in the example of the two *lei* (water or wine containers), one found in Kazuo, Liaoning Province (Pl. 109), and the other in Pengxian, Sichuan Province, both almost identical in shape, dating from the early Western Zhou. But how two such similar bronzes could be found in locations so far apart, one in the northeast and the other in the southwest, is quite remarkable.

China's ancient minority peoples developed their own bronze technology with its peculiar traits, but which also showed signs of influence from the culture of the Central Plain.

In the northeast, the Donghu and other minority peoples produced in the main bronze short swords of various kinds (Pl. 110). Some manufactured multiple-

109.
Lei with coiled dragon-shaped lid, wine vessel, early Western Zhou Dynasty, unearthed at Kazuobeidong, Liaoning, height 44.5 cm.

knobbed bronze mirrors of the Zhou-Han period. The northern tribes made bronze animal-shaped pendants, knives with handles in the form of animal heads, and keen-edged weapons with perforated handles. While the Shang Dynasty was influential in the north, certain elements of the bronze technology of the northern minorities also influenced that of the Shang, as was the case of the perforated bronze axe and bronze dagger and scraper with animal-head handles found in the Yin ruins.

Little is known of the bronzes of the minorities in the southeast. Artifacts of the Huai Yi, Shu, Wu and Yue people in Anhui and Jiangxi provinces and the greater part of Jiangsu and Zhejiang, basically followed the forms dominant in the Central Plain. Excavations in Fujian Province brought to light bronzes of the type from the Central Plain, and others like those found in Zhejiang, but the weapons discovered in Caiying Village, Nan'an County, were of a more distinct local colour (Fig. 43), such as the *ge* without a *hu*. According to the *ge*'s development in the Central Plain, this weapon ought to belong to the Shang period, but if taken within the context of its locality, it should be attributed a much later date. With regard to weaponry, the *ge*, *qi* and *jian* were still the principal ones, clearly a result of the influence of the Central Plain. The same applies to those of Guangdong and Guangxi.

Weapons of the Qin Dynasty have been unearthed in Guangzhou and Guilin, where they had been left during the Qin's military expedition to the south. According to *Records of the Historian*, in 214 B.C., Qin Shi Huang, the first emperor of the Qin Dynasty, after having annexed the south, set up three prefectures—Guilin, Xiangjun and Nanhai. The Can Ling *mao* (spear) of the Qin discovered recently in Yinshanling, Pingle County, Guangxi, must be one of the weapons carried into Guangxi by the Qin

Fig. 43 Bronze weapons discovered at Caiying Village, Nan'an County, Fujian Province.

army in its southward drive. Several of the bronzes found in 1976 in a large tomb at Luobowan, Guixian County, Guangxi, were originally made in the Central Plain, which proves that the bronze culture of the Central Plain had a protracted effect on the Guangdong-Guangxi region.

In Sichuan, the bronzes of the Ba-Shu culture were products of a minority people culture heavily influenced by the Central Plain. Ba and Shu had once been independent principalities (the latter having a much longer history than the former), subsequently annexed to Qin territory in the late Warring States Period. Ba-Shu bronzes were decorated with special designs. Particularly characteristic of this culture was a pair of short swords in a single sheath, in all probability the "flying swords" alluded to in ancient documents, which were used to hurl at their enemies.

One of the most surprising discoveries was that of thousands of bronzes of ancient minority peoples in the remote province of Yunnan; most of them belonged to the people of Dian. Yunnan's bronzework used the lost wax method, which produced articles of the finest quality. Some were inlaid with turquoise or agate, some gilt with gold, others tin-plated. Around the area of Dianchi Lake, the most colourful bronzes unearthed were from Lijiashan in Jiangchuan County and Shizhaishan in Jinning County (Pls. 111-113), dating probably from the Spring and Autumn-Warring States periods at the earliest to the early Eastern Han at the latest.

Ancient Chinese bronze culture and the cultures of the peoples of neighbouring countries and regions are interrelated and interacted on each other, forming a brilliant chapter in the history of friendship between China and other countries.

Some examples are given below:

From the Shang Dynasty to the Western Zhou, the bronze objects produced in north China (including the northwestern Loess Plateau, the Yellow River Valley at the juncture of Shaanxi and Shanxi provinces, Ordos in Inner Mongolia and the vast areas to the north and south of the Yanshan Mountains) fall into several categories, but have common characteristics (Pls. 114-115). These include such items as the dagger-shaped sword with a crank, an axe with a tube-like socket, a bronze helmet (Pl. 116), a knife with an animal-head handle, and a knife with a knobbed ring handle. Analysis proves that the bronze objects of north China exerted great influence on the Kalasuk culture in Minusinsk Basin, South Siberia, in the former Soviet Union in 12-11th centuries B.C.,[2] where similar bronzes were discovered and the vestiges of Shang culture of China can be seen. Arc-shaped

111.
Bronze peacock, Western Han Dynasty, unearthed at Shizhaishan, Jinning, Yunnan, height 13.9 cm.

bronze objects unearthed there were very popular in China from the later Shang Dynasty to the early Zhou.

In later periods, many short bronze swords were produced in north and northeast China. Archaeologists call them north China bronze swords and northeast China bronze swords. Archaeologists also maintain that the earlier ones were used by the Xiongnu, Wuwan, Xianbei and other minorities (collectively known as the Northern Tribes in ancient times), and the later ones, by Gaojuli, Fuyu and other minorities (collectively known as the Eastern Tribes in ancient times). A sword, which was excavated from Jiongbaeori at Pyongyang in South Pyongan Province, Korea, in 1958, was closely related to the northeast China bronze swords. Also, a silver seal inscribed with the characters, "Lord Fuzu Hui," was also found.[3]

Usually excavated together with northeast China

bronze swords are bronze mirrors, most of which have two or three knobs on their backs carrying a thick broken line, leaf vein or triangle designs. These mirrors are closely related to the "multi-knob mirrors" unearthed in Korea and Japan. Some scholars hold that northeast China bronze mirrors were introduced to the Korean Peninsula and Japan between the end of the Western Zhou and the late Warring States Period.[4]

Chinese bronze mirrors have been discovered in Japan and Caucasia. The oldest mirror unearthed in Japan was cast in the mid-Western Han Dynasty, and Chinese bronze mirrors excavated in Siberia and other places in the former Soviet Union were made in the Warring States and Western Han periods. Large numbers of Chinese-style bronze mirrors have been found in Japan. Studies of some scholars prove that bronze objects have also been found in Europe with shapes bearing Chinese influence. The Chinese bronze casting techniques were probably also introduced to Europe in ancient times.

Some varieties of bronzes cast in south China have also been found in parts of Southeast Asia, such as bronze drums and boot-shape hatchets with unsymmetrical

112.
Button pendant with dancers, Western Han Dynasty, unearthed at Lijia-shan, Jiangchuan, Yunnan, diameter 7.1 cm.

113.
Curved pipe *sheng*, wind instrument, Western Han Dynasty, unearthed at Lijiashan, Jiangchuan, Yunnan, height 28.2 cm.

blades.

Many kinds of boot-shape hatchets and bronze drums were discovered in Hunan, Guangdong, Guangxi and Yunnan, as well as the Indo-China Peninsula and Indonesia. Moreover, early bronze drums were distributed widely to south Sichuan and northwest Guizhou.[5] According to studies, bronze drums unearthed in Xiangyun and Chuxiong in west Yunnan are the most primitive, and this part of Yunnan should be the birthplace of bronze drums.[6]

[1] See "Records of Emperor Zhang Di," *History of the Latter Han Dynasty*, and "Auspicious Signs," *History of the Song*.

[2] See Wu En, "The Bronze Objects of North China from the Yin to the Early Zhou," *Archaeology Journal*, No. 2, 1985.

[3] See Lin Yun, "A Preliminary Study of the Northeast China Bronze Swords," *Archaeology Journal*, No. 2, 1980.

[4] See Zhang Xiying, "On the Bronze Mirrors of the Pre-Qin Period in Northeast China," *Archaeology*, No. 2, 1986.

[5] See Wang Ningsheng, "On Unsymmetrical Boot-Shape Hatchets," *Archaeology*, No. 5, 1985.

[6] See Jiang Tingyu, *History of Bronze Drums*, Cultural Relics Publishing House, p. 56-67.

114.
Three-hole *yue* axe, weapon, late Shang Dynasty, reportedly unearthed at Yulin, Shaanxi, length 18 cm.

116.
Bronze *zhou* helmet, early Spring and Autumn Period, unearthed at Nanshangen, Ningcheng, Inner Mongolia, height 23.8 cm.

115.
Seven-hole *yue* axe, weapon, late Shang Dynasty, unearthed at Panjialiang, Huangzhong, Qinghai, length 16 cm.

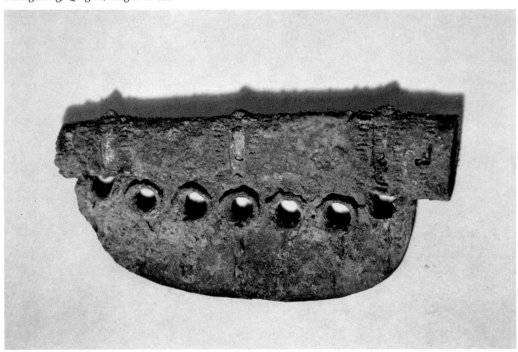

Endless New Discoveries

ROM the 1980s to the current time is a period attracting wide attention in the history of Chinese archaeology. During these years, China has made much progress in field work. The features of ancient culture have been further exposed, many blanks have been filled in and many advances have been achieved in the discovery and study of bronzes.

China has also achieved remarkable results in the study of the origin of Chinese bronzes. In 1984, two important events occurred.

The first was the discovery of a piece of bronze fragment at an ash pit of the later period of the Longshan Culture at Wangchenggang, Dengfeng County, Henan Province. It is 5 cm long, 5.5 cm wide, containing 7 percent tin. Radiocarbon age dating determined that charcoal from the pit was produced around 1900 B.C.[1] Significant is that the piece of bronze is obviously a fragment of a fairly large container, probably the belly bottom of a bronze *gui*, which is probably related to the *gui* in the *Xi Qing Collection of Ancient Bronzes*, as mentioned in the first chapter.

More recently (in January 1984), a bronze bell, 2.65 cm high and 6.3 cm wide, was unearthed from a tomb of the later period of the Longshan Culture at the Taosi ruins, Xiangfen County, Shanxi Province. It was determined to be highly pure copper. C_{14} tests showed that the bell was made around 2100 B.C.[2] This well- preserved bronze bell was cast in a mould.

These two discoveries prove that in the later period of the Longshan Culture (about 2000 B.C.) China was already able to make large and complicated bronze objects. As a matter of fact, at a coal hill in Linru not far away from Dengfeng, Henan, fragments of a crucible for casting copper were found, in addition to other related discoveries.

Another discovery was reported not long ago that "several small square pottery moulds were found at a site of the Hongshan Culture in Xitai, in 1987. After having been burnt, some gaps in the shape of a fishhook were seen inside the moulds."[3] The Hongshan Culture is scattered over the areas bordering on Inner Mongolia, Liaoning and Hebei and is dated approximately the same as the Yangshao Culture. The news of the discovery, if confirmed, would provide an important clue to the origin of bronzes.

Some scholars have suggested that China's Yangshao Culture Age started from the late Neolithic Age and ended at the early Chalcolithic Age, and that the Longshan Culture belonged to the late Chalcolithic Age.[4] Yan's view remains to be further proved, but it is probably correct.

More and more bronze objects of the Erlitou Culture have been found, including more varieties than those described in the first chapter. Containers include *ding*, and more than a dozen *jue*. Also discovered: *jiao*, *jia* (three), *gu* and *he*. Other Erlitou findings: *ge* dagger-axe, *qi* battle-axe, arrow-heads, *zao* (chisel), *ben* (adze), *zhui* (awl), *zuan* (drill), *dao* (knife), *ke dao* (carving knife), *jue* (pick-axe), and *yu gou* (fishhook). Also, decorative plaques inlaid with turquoise have been discovered from time to time, including those not found in archaeological excavations, each decorated with complicated designs.[5] Moreover, between fine veins on some knives, vestiges of gold-plating can be seen. The estimate we made concerning bronze objects of that period is probably still low.

In 1974-76, a group of bronze objects were discovered at Wangjialou, Xinzheng, east of the Erlitou site in Yanshi, Henan Province, including *ding*, *li*, *jue*, *jia*, *gu* and *ge* with jade-laid blade.[6] The bronze objects have *taotie*, *kui*-dragon, cloud, linked pearl and rhombus designs similar in style to the early Shang bronzes unearthed in Zhengzhou and other places, except for the *jue* which are same as those excavated from Erlitou. There is every reason, therefore, to believe that these bronze objects were cast at the beginning of the Shang Dynasty in the area between Erlitou and Zhengzhou. To a certain extent, this discovery has filled the information breach about the development of bronzes in this period.

A sketch map in Chapter XI shows that bronze objects of the early Shang Dynasty are distributed in Henan, Liaoning, Shandong, Shaanxi and Hubei, with Henan as the centre. To our great surprise, bronzes of the early Shang were found at Chenggulongtou Town, Hanzhong Prefecture, south Shaanxi Province, in 1980 and 1981, respectively. These objects fall into many categories, such as *yan*, *gui*, *zun*, *lei*, *you*, *hu*, *jue*, *gu*, *pan*, *ge*, a willow

leaf-shaped *mao* characteristic of the Ba-Shu Culture, and a round-bladed *yue*. All these have not only enriched our understanding of the distribution of early Shang bronzes, but also provided us with evidence of the influence of early Shang bronzes on the Ba-Shu area.

It is not surprising that the bronze objects of the late Shang Dynasty (the period of the Yin ruins) should have appeared in the Ba-Shu hinterland. An especially important example was the discovery at the Sanxingdui site in Guanghan County, to the north of Chengdu, about which a detailed account will be provided later. Bronze objects of the late Shang Dynasty were also excavated on many occasions in Hanzhong, Shaanxi (Pl. 117). For instance, a meticulously made ritual *zun* with *kui*-dragon design unearthed in Yangxian County, Shaanxi, in 1983 is identical with the one preserved by Arthur M. Sackler of the United States.[7]

The years after 1986 witnessed the discovery of a large Shang site at Laoniupo, Xi'an, where many bronze objects were excavated from the tombs. Laoniupo is the most important archaeological site of this period in Shaanxi Province. It probably was in the domain of the State of Chong which was later conquered by King Wen of Zhou. Though most bronze objects found here are similar to those from the Central Plain, vestiges of the cultural influence of some minority peoples can still be seen, including the influence of the bronze culture of the area where Shanxi and Shaanxi meet.

The Shanxi-Shaanxi border region starts from Baode and Yulin in the north, and ends at Shilou, Yonghe and Xixian in the south. Bronze objects with distinctive local flavour have been found there again and again in past years. Some scholars believe these areas belonged to the States of Fangguo, Guifang and Tufang mentioned in the oracle bone inscriptions of the Shang Dynasty. Not long ago, similar bronzes were discovered in Chunhua County to the north of Xi'an. Not until then was it recognized that the culture of the Shanxi-Shaanxi border region had extended as far south as Chunhua. Bronzes of the late Shang Dynasty were also found in the remote Youyudachuan at the foot of the Great Wall at the northern rim of Shanxi Province.

The year 1979 saw the discovery of a cellar holding five bronze objects of the Shang Dynasty at Huaerlou, Yixian County, Liaoning. One of them is a rarely seen *zu* (chopping block), under which is a small bell (Pl. 118). Huaerlou at the western foot of Yuwulu Mountain is one of the farthest northeastern spots where Shang bronzes were found. Information on the discovery was issued in 1981.

In 1986, the *Cultural Relics* monthly published pictures of the bronze objects (some of them with inscriptions) of the late Shang Dynasty discovered at Zhoujiawan, Anji County, Zhejiang Province. Anji County is also an out-of-the-way place in the southeast. Among the excavated objects are a unique set of table legs with *kui*-dragon design and in the shape of animal feet.

Especially astonishing was the excavation in 1989 of a large Shang tomb at Dayangzhou, Xingan County, Jiangxi Province. The coffin chamber of the tomb is 8.22 metres long, from which 484 bronze objects were brought out. The tomb belongs to Wucheng Culture of the second period, corresponding to the beginning of the later Shang period. Among items found: a big square *ding*, 97 cm high (Pl. 119), showing the style of the Erligang period, and a big, magnificent *yan* 114 cm high (Pl. 120). Many objects are decorated with reclining tigers, standing deer and local special designs as well.

The bronze objects from Dayangzhou clearly show the influences of both the Central Plain and the home locality. Some of them are meticulously made; for instance, a square *you* wine vessel (Pl. 121) has crossed tubes on the belly for warming wine with boiling water; a square *ding* has two doors at the bottom for placing charcoal inside. Both show outstanding workmanship.

In addition, many farm tools, such as ploughs, spades, ploughshares and sickles, were found from the Shang tomb at Dayangzhou (Pls. 122-128); these are of great importance to the study of China's ancient agriculture.

All these discoveries strengthen our conviction that Shang bronzes are distributed much more widely than many people expect.

If the new discoveries of the Shang bronzes have brought home to people their wide distribution, the new discoveries of the bronzes of the Western Zhou have helped us further understand the height the culture of that period had attained.

In the past, the bronzes excavated from the sites of the capital cities—Fengjing and Gaojing in Chang'an County, Shaanxi Province (the heartland of the Western Zhou Dynasty), could not match those from the Zhouyuan site between Fufeng and Qishan counties, in both quality and quantity. As the archaeological work progressed, however, a number of bronze objects of great importance were found there, one after another.

In 1954, a significant number of bronze objects were excavated from only one tomb at Pudu Village, Gaojing (capital of the Western Zhou Dynasty), on the eastern bank of the Fenghe River, Chang'an County. In 1980-81, several Western Zhou tombs were excavated there, resulting in a great number of bronze objects, some of which carry fairly long inscriptions. Those from Tombs

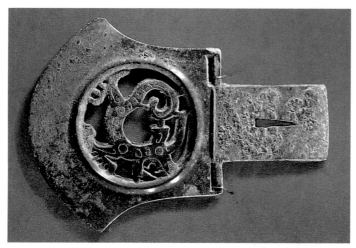

117.
Yue axe with dragon design, late Shang Dynasty, unearthed at Wulang-miao, Chenggu, Shaanxi, length 17 cm.

120.
Big *yan* with ogre-mask motif, cooking vessel, late Shang Dynasty, unearthed at Dayangzhou, Xingan, Jiangxi, height 114 cm.

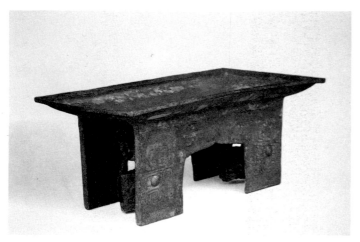

118.
Zu chopping block with ogre-mask design, late Shang Dynasty, unearthed at Huaerlou, Yixian, Liaoning, length 33.6 cm.

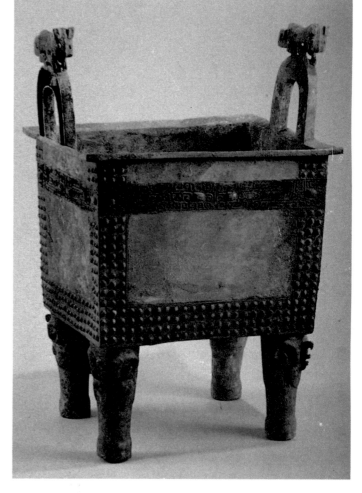

119.
Rectangular *ding* with ogre-mask and nipple pattern, cooking vessel, late Shang Dynasty, unearthed at Dayangzhou, Xingan, Jiangxi, height 97 cm.

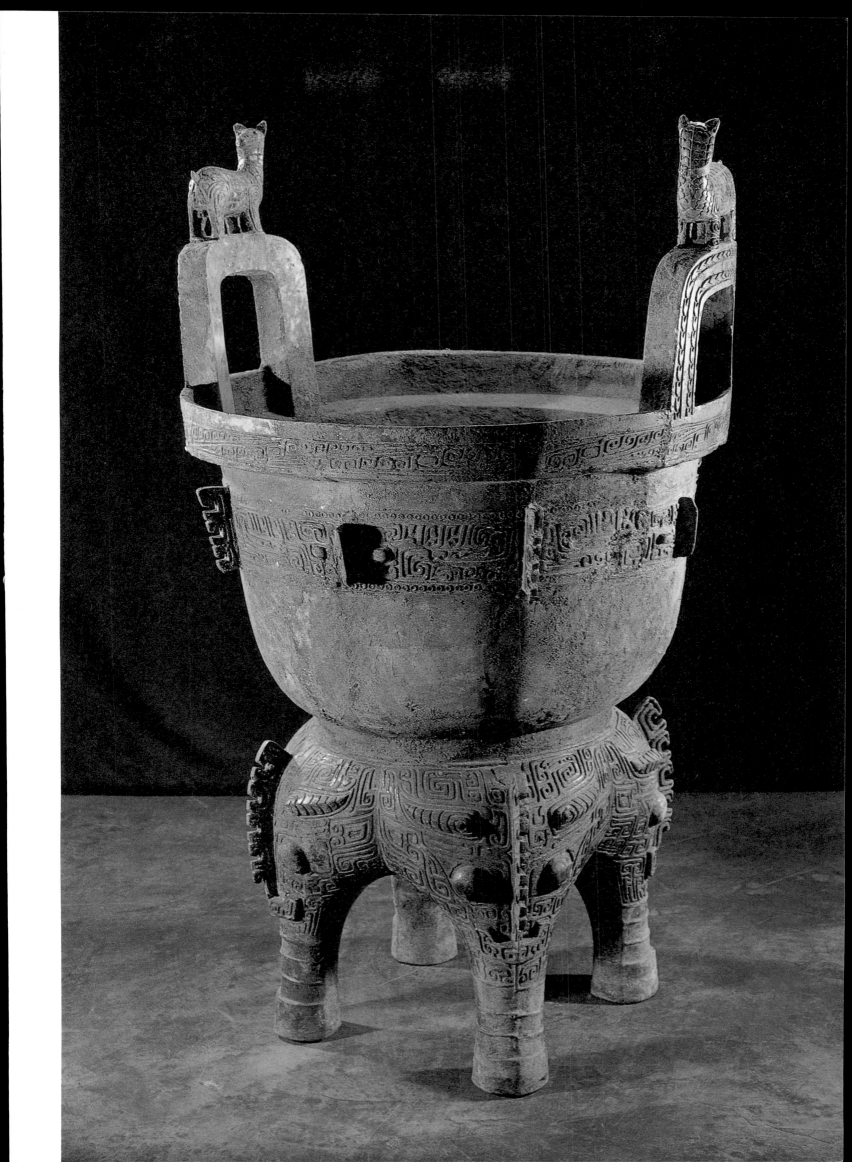

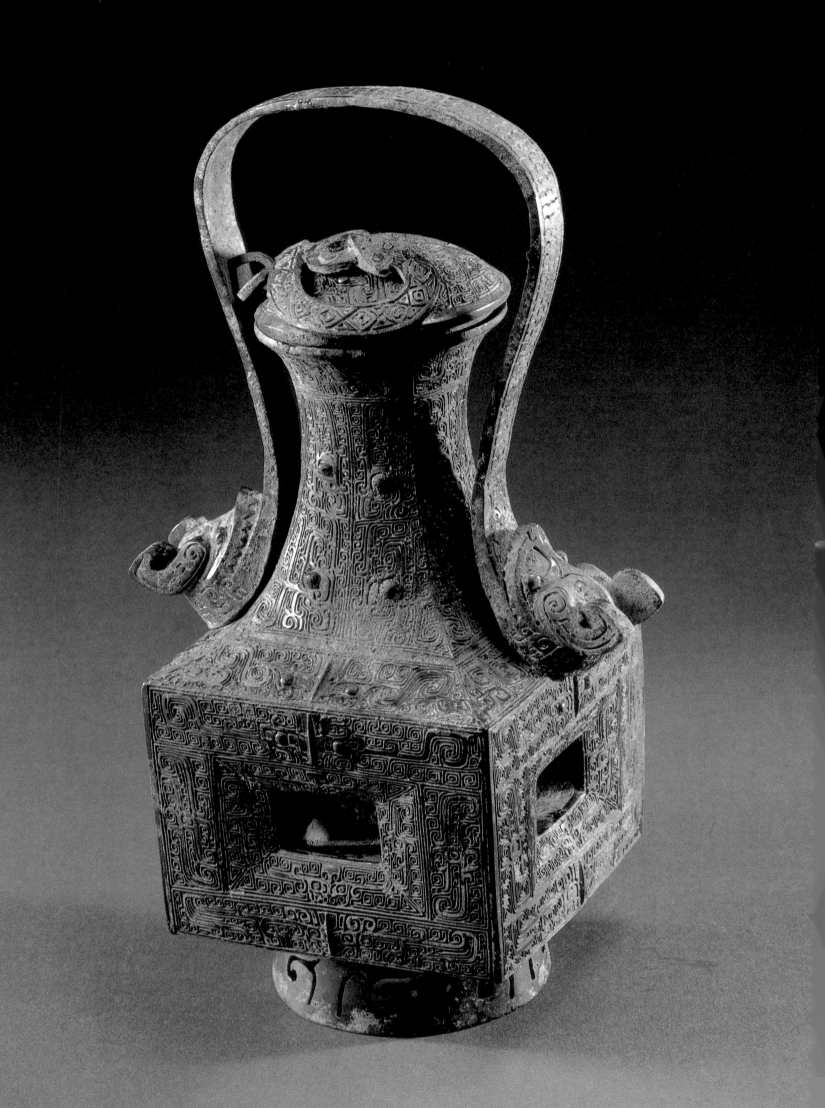

121.
Rectangular *you* with cruciform opening, wine vessel, late Shang Dynasty, unearthed at Dayangzhou, Xingan, Jiangxi, height 27.8 cm.

124.
Bronze *cha* spade, late Shang Dynasty, unearthed at Dayangzhou, Xingan, Jiangxi, length 11.5 cm.

122.
Bronze *si* ploughshare and bronze *li* plough, late Shang Dynasty, unearthed at Dayangzhou, Xingan, Jiangxi, *si* length 11.5 cm, *li* length 9.7 cm.

125.
Rectangular-holed *chan* shovel, late Shang Dynasty, unearthed at Dayangzhou, Xingan, Jiangxi.

123.
Bronze *lei* plough and bronze *jue* pick-axe, late Shang Dynasty, unearthed at Dayangzhou, Xingan, Jiangxi, *lei* length 12.7 cm, *jue* length 14.8 cm.

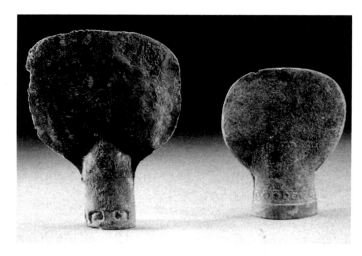

126.
Chan shovel with two-eyed design and *chan* shovel with interlinking beads, late Shang Dynasty, unearthed at Dayangzhou, Xingan, Jiangxi, length of *chan* with two-eyed design 17.8 cm.

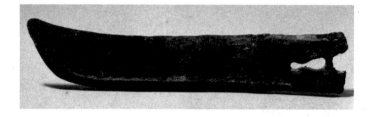

127.
Bronze *lian* sickle, late Shang Dynasty, unearthed at Dayangzhou, Xingan, Jiangxi, length 20.5 cm.

128.
Bronze *zhi* (short sickle), late Shang Dynasty, unearthed at Dayangzhou, Xingan, Jiangxi, length 20.5 cm.

15 and 17 at Huayuan Village, cast in the periods of King Zhao and King Mu, are very beautiful. A *gui* food container from Tomb 17 has a bird design on its belly, a supporting stand and two bird-shaped loops, which had never been seen before on vessels not obtained from excavations. From the same tomb, a four-legged *he* wine vessel was unearthed. Its cover is designed with a big bird with its head held high. This work shows ingenious conception and is of great artistic value.

On the western bank of the Fenghe River was Fengyi (Fengjing) of the Western Zhou Dynasty, from where some important bronze objects have been found in the past few years (Pl. 129). For instance, in 1984 a Dengzhong animal-shaped *zun* was excavated from Tomb 163 at Zhangjiapo.[8] The weird animal, decorated all over with *taotie* and *kui*-dragon designs, has horns on the head, four legs with paws, a standing tiger on its neck, reclining dragons on the chest and tail, and a standing bird on its back. The Yaci animal-shaped *zun* mentioned in some old records[9] is similar to this one, but its design is not complicated and splendid.

Bronze objects were found time and again in Baoji, Shaanxi Province, especially the discoveries at Doujitai and Daijiawan in 1901 and 1926 respectively, which have been described earlier. Since 1974, a large number of important bronze objects have been dug out at Rujiazhuang, Zhuyuangou (Pls. 130-131) and Zhifangtou (Pls. 132-133). Information on these discoveries has been published recently.[10] For instance, a big *ding* from Tomb 1 at Zhifangtou has a flat cover which can be placed upside down, and a two-looped *gui* in the same tomb has especially high circular legs. Two *you* from Tomb 7 at Zhuyuangou has carved animal heads on the loop handle and on its two sides. Each of the *zun* and *you* from Tomb 4 has four legs and the *zun* also has a single ear. Each of the large and small bird-shaped *zun* from Tomb 1 at Rujiazhuang has three legs. All of them are rarely seen.

A *fang yi* (rectangular casket-shaped vessel with a knob on the cover) is similar to the bronzes discovered at Baoji, and was found in 1987 at Tangjiadun, Zongyang County, south Anhui. It has a bird design, and flanges and small bells inside the circular legs. It shows that the cultural influence of the early Zhou Dynasty had gone deep into as far south as Anhui.[11]

The year 1982 witnessed the discovery of bronze objects of the Marquis of Teng in the early Western Zhou period from a tomb at Zhuanglixi Village, Teng-

129.
Jing Shu *zhong* bell, late Western Zhou Dynasty, unearthed at Zhangjiapo, Chang'an, Shaanxi, height 37.5 cm.

126.
Chan shovel with two-eyed design and chan shovel with interlinking beads, late Shang Dynasty, unearthed at Dayangzhou, Xin'gan, Jiangxi, length of chan with two-eyed design 17.8 cm.

127.
Bronze lian sickle, late Shang Dynasty, unearthed at Dayangzhou, Xingan, Jiangxi, length 20.5 cm.

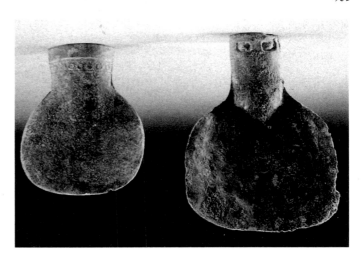

128.
Bronze zhi (short sickle), late Shang Dynasty, unearthed at Dayangzhou, Xingan, Jiangxi, length 20.5 cm.

129.
Jing Shu zhong bell, late Western Zhou Dynasty, unearthed at Zhangjiapo, Chang'an, Shaanxi, height 37.5 cm.

15 and 17 at Huayuan Village, cast in the periods of King Zhao and King Mu, are very beautiful. A *gui* food container from Tomb 17 has a bird design on its belly, a supporting stand and two bird-shaped loops, which had never been seen before on vessels not obtained from excavations. From the same tomb, a four-legged *he* wine vessel was unearthed. Its cover is designed with a big bird with its head held high. This work shows ingenious conception and is of great artistic value.

On the western bank of the Fenghe River was Fengyi (Fengjing) of the Western Zhou Dynasty, from where some important bronze objects have been found in the past few years. For instance, in 1984 a Deng-zhong animal-shaped *zun* was excavated from Tomb 163 at Zhangjiapo.[8] The weird animal, decorated all over with *taotie* and *kui*-dragon designs, has horns on the head, four legs with paws, a standing tiger on its neck, reclining dragons on the chest and tail, and a standing bird on its back. The Yaci animal-shaped *zun* mentioned in some old records[9] is similar to this one, but its design is not complicated and splendid.

Bronze objects were found time and again in Baoji, Shaanxi Province, especially the discoveries at Doujitai and Daijiawan in 1901 and 1926 respectively, which have been described earlier. Since 1974, a large number of important bronze objects have been dug out at Rujia-zhuang, Zhuyuangou (Pls. 130-131) and Zhifangtou (Pls. 132-133). Information on these discoveries has been published recently.[10] For instance, a big *ding* from Tomb 1 at Zhifangtou has a flat cover which can be placed upside down, and a two-looped *gui* in the same tomb has especially high circular legs. Two *you* from Tomb 7 at Zhuyuangou has carved animal heads on the loop handle and on its two sides. Each of the *zun* and *you* from Tomb 4 has four legs and the *zun* also has a single ear. Each of the large and small bird-shaped *zun* from Tomb 1 at Rujiazhuang has three legs. All of them are rarely seen. A *fang yi* (rectangular casket-shaped vessel with a knob on the cover) is similar to the bronzes discovered at Baoji, and was found in 1987 at Tangjiadun, Zongyang County, south Anhui. It has a bird design, and flanges and small bells inside the circular legs. It shows that the cultural influence of the early Zhou Dynasty had gone deep into as far south as Anhui.[11]

The year 1982 witnessed the discovery of bronze objects of the Marquis of Teng in the early Western Zhou period from a tomb at Zhuangbaixi Village, Teng-

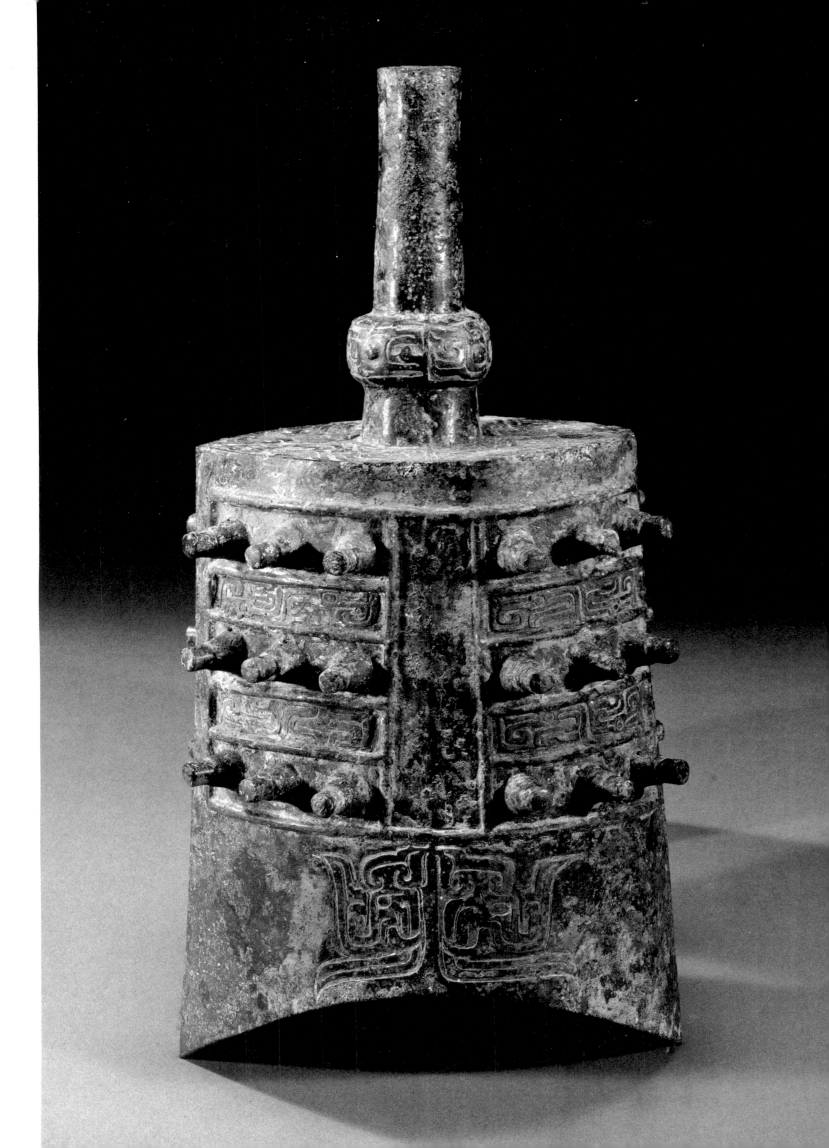

xian County, Shandong Province. Meanwhile, bronze objects of the State of Yan were frequently found at Liulihe, Beijing, of which the most important ones are the Ke *he* (Pl. 134) and Ke *lei* wine vessels found from Tomb 1193 in 1986.[12] Their inscriptions describe the history of granting title to the State of Yan in the early Zhou Dynasty. The discoveries from these two sites prove that the State of Teng was located in present-day Tengxian County, and the State of Yan, in today's Beijing, agreeing with the records in ancient books.

Other important information on the history of the Western Zhou follows:

In 1980, a Duoyou *ding* was discovered at Xiaquan Village, Chang'an County, Shaanxi. This deep-belly *ding* with bow-string pattern was cast in the late Western Zhou Dynasty and inscribed with 22 lines, totalling 278 characters, which relate a story: During the reign of King Li, Xianyun, a national minority in northwest China, made an incursion. With the king's edict, Lord Wu ordered Duoyou to lead chariots to chase after the Xianyuns and take back the property they seized. During the battle, Duoyou captured 127 of Xianyun's chariots, which tells us that Xianyun was not a mere nomadic tribe as people had previously believed, but an ethnic group with capability for large-scale chariot wars.

The Shitong *ding* excavated from Xiawuzi in Fufeng County, Shaanxi, in 1981, contains seven lines of an inscription, totalling 54 characters, which is the last half of the inscription. The first half should be on another *ding* that has not been found. The Shitong *ding* was cast probably in the reign of King Yi. The inscription describes the battle against the Rong people, in which the spoils of war totalled 120, including chariots, carts, sheep and bronze objects, such as helmets, *ding* and swords. It is important evidence showing that some of the national minorities in the northwest at that time were not primitive as people believed.

In 1986, a Shimi *gui* excavated from Wangjiaba in Ankang County, Shaanxi Province was made in the mid-Western Zhou. It has a nine-line inscription, totalling 93 characters, describing the battles against the minority peoples in the southern border areas. The inscription also tells how the king of Zhou sent generals to lead troops of the states of Qi, Lai, Biyang and Yi to fight against enemies invading the eastern part of Zhou territory. This inscription not only records the historical facts of that period, and makes up for information that ancient books fail to contain, but it is also of great importance to the study of the military system of the Western Zhou.

The most important discovery of the mid- and late-Western Zhou bronzes was in the cemetery of the State of Jin at Beizhao Village, Quwoqucun Town, Shanxi. This cemetery was repeatedly robbed in 1991, and many bronze objects were carried away from the country. In 1992, archaeologists began to excavate the cemetery. Consequently, they surveyed the cemetery and obtained many rare cultural relics (Pls. 135-136). Among the bronze objects found the rabbit-shaped *zun* (Pl. 137) was a treasure never seen before.

Many of the bronze objects from this cemetery have inscriptions. Especially attractive are the bronze vessels used by several rulers of the State of Jin. Preliminary studies reveal that some bronze objects are inscribed with the names and titles of Marquises Li, Jing, Li (the same pronunciation as the first marquis, but a different Chinese character), Xian and Mu; these are identical with the records in "The Pedigree of Jin," *Records of the Historian*. The Jin Marquis Su *bian zhong* chime of bells from Tomb 8 with a long inscription on the bells is of great value.[13] In the past we thought that inscribing characters on bronze objects started in the mid-Spring and Autumn Period, but now we know that Chinese artisans began to inscribe characters on bronzes dating back to the late Western Zhou. It also reminds us of a big *ding* unearthed from Renjia Village, Fufeng County, Shaanxi Province, which also carried an inscription "similar to the writing of the late Western Zhou."[14] It thus serves as a supporting evidence to the chimes of bells.

As more and more bronze inscriptions are found, many parts of Western Zhou history should be rewritten.

Discoveries of a greater variety of bronze objects of the Eastern Zhou have given us a deeper understanding of the colourful bronzes cast in all the states of the Eastern Zhou period.

In 1956-57, a great number of tombs and chariot-and-horse pits of the early Eastern Zhou (including the tomb of Crown Prince Yuan of the State of Guo) were unearthed at Shangcunling, Sanmenxia City, Henan Province, from which a large number of bronzes were found (Pls. 138-139). It was a significant discovery. In 1989, another group of tombs and chariot-and-horse pits were disclosed, from which more valuable bronze vessels were brought out. The promulgated information says that Tomb 2001 belongs to the ruler of the State of Guo,[15] and that in the tomb are beautiful bronze objects. Among them is an iron sword with a jade-covered bronze handle. Tests prove that the iron was artificially smelt; this is is very important.

130.
Bo Ge *zun*, wine vessel, early Western Zhou Dynasty, unearthed at Zhuyuangou, Baoji, Shaanxi, height 25.8 cm.

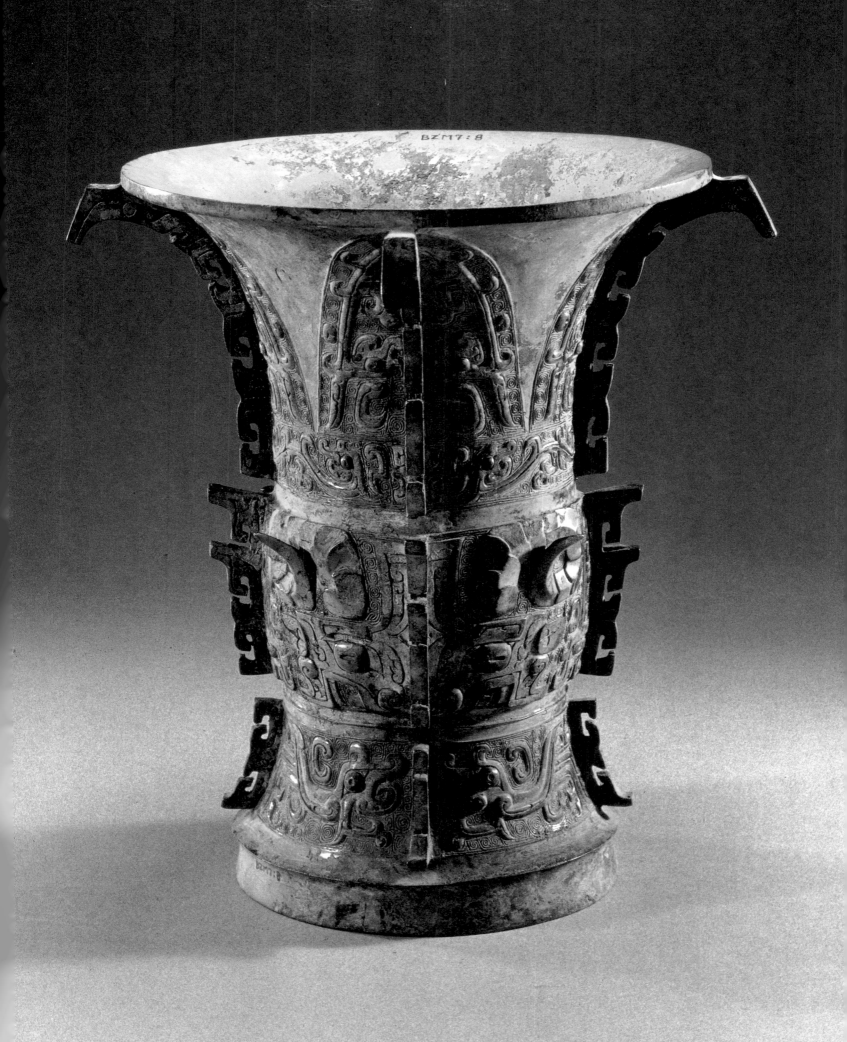

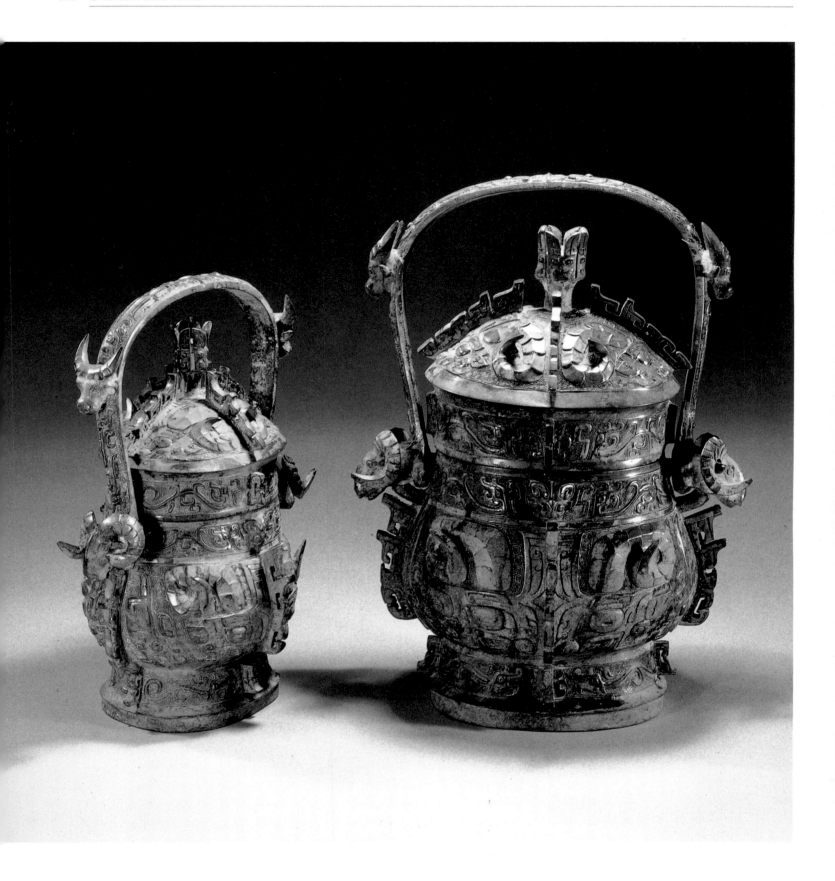

131.
Bo Ge *you*, wine vessel, early Western Zhou Dynasty, unearthed at
Zhuyuangou, Baoji, Shaanxi, height 33.6 cm (larger one), 27.5 cm (smaller
one).

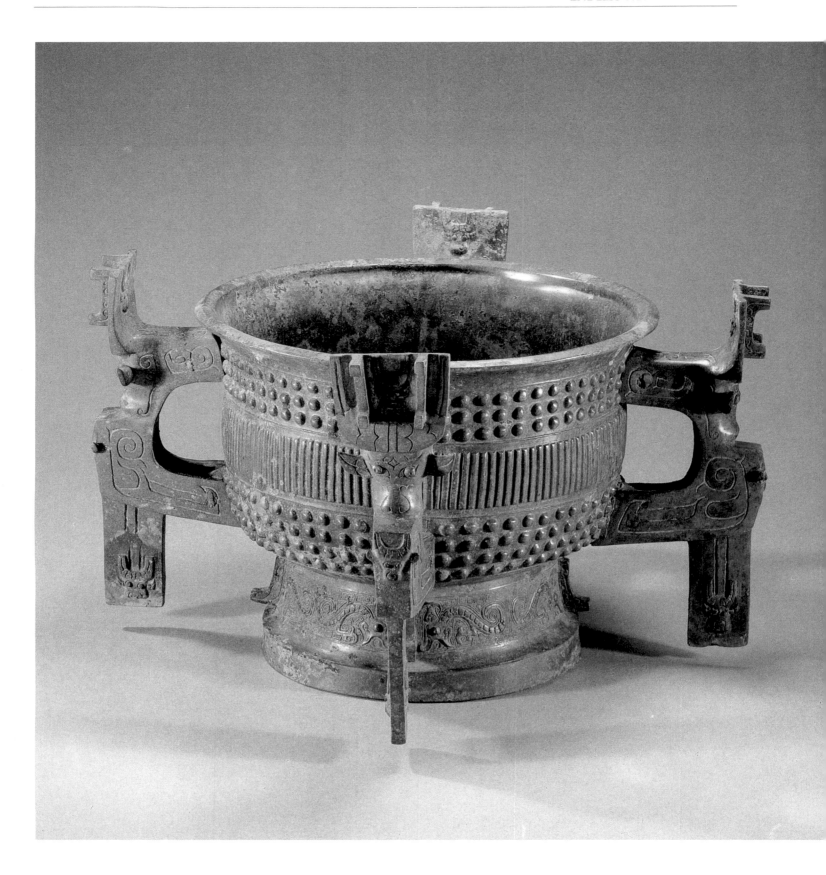

132.
Gui with perpendicular and nipple pattern, food container, early Western
Zhou Dynasty, unearthed at Zhifangtou, Baoji, Shaanxi, height 23.8 cm.

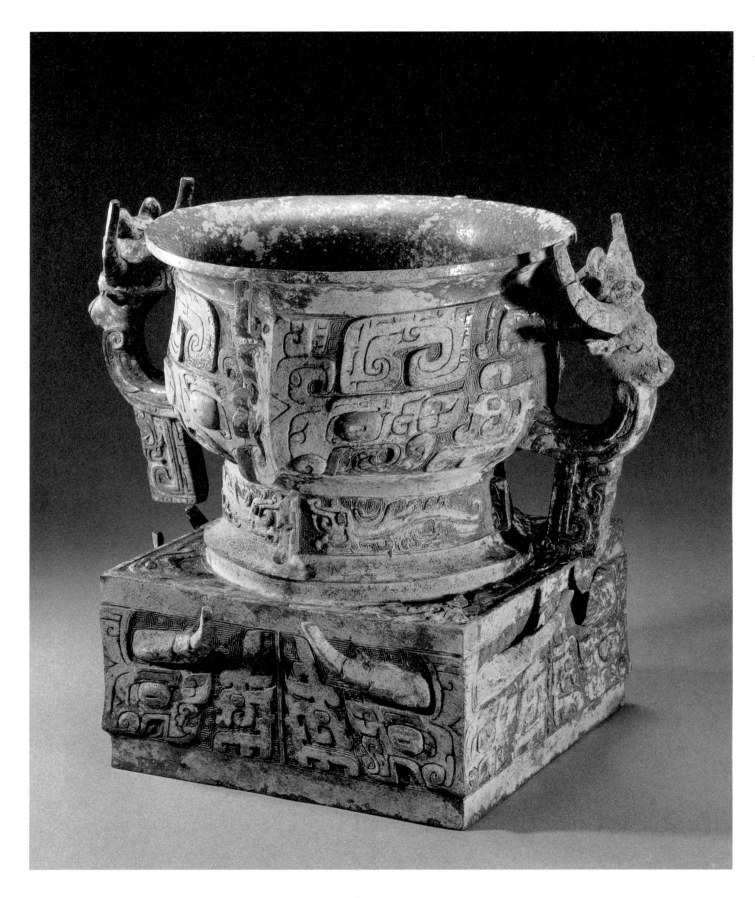

133.
Yu Bo *gui*, food container, early Western Zhou Dynasty, unearthed at
Zhifangtou, Baoji, Shaanxi, height 31 cm.

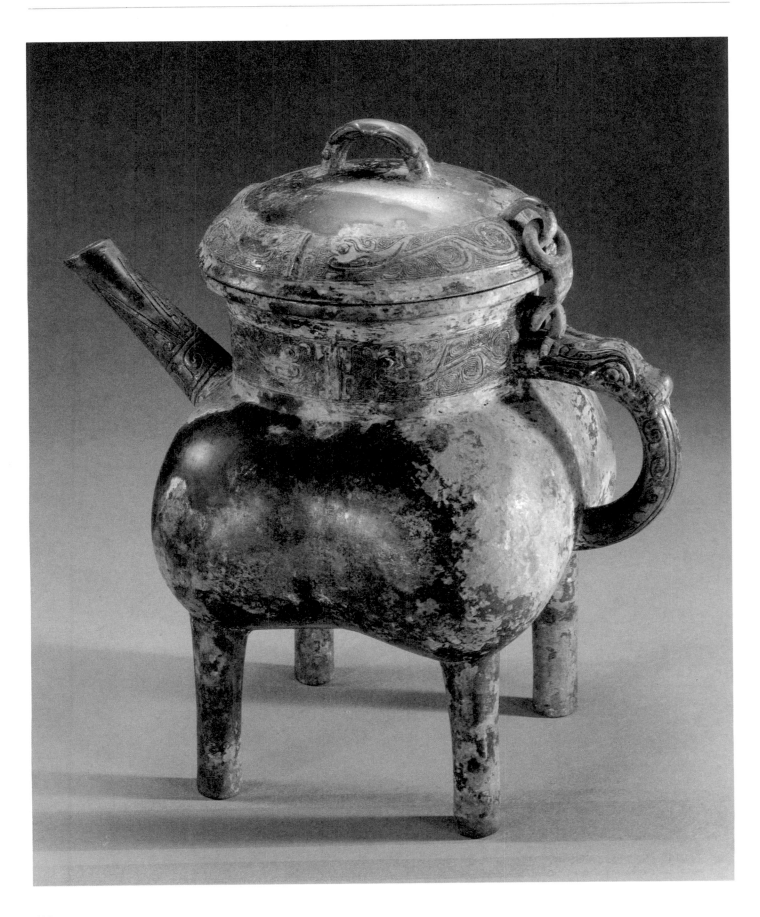

134.
Ke *he*, wine vessel, early Western Zhou Dynasty, unearthed at Liulihe,
Fangshan, Beijing, height 26.8 cm.

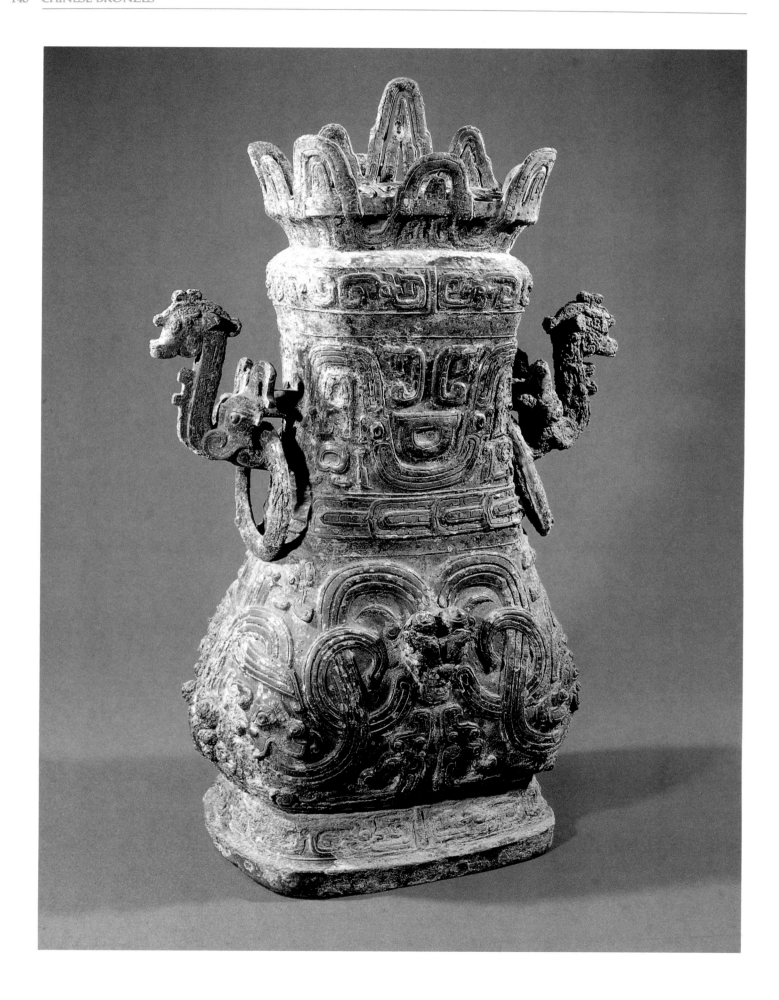

135.
Rectangular *hu* of the Marquis of Jin, wine vessel, late Western Zhou
Dynasty, unearthed at Beizhao, Quwo, Shanxi, height 68.8 cm.

136.
He with coiled dragon design, wine vessel, late Western Zhou Dynasty,
unearthed at Beizhao, Quwo, Shanxi, height 34.6 cm.

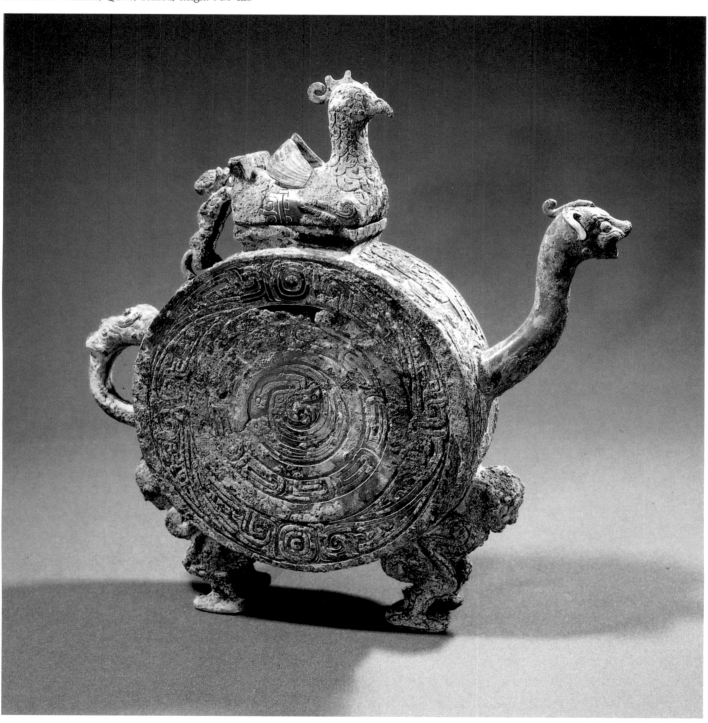

137.
Rabbit-shaped *zun*, wine vessel, late Western Zhou Dynasty, unearthed at Beizhao, Quwo, Shanxi, height 31.8 cm.

138.
Guo Ji *bian zhong* chime of bells, early Spring and Autumn Period, unearthed at Shangcunling, Sanmenxia, Henan, height 56 cm.

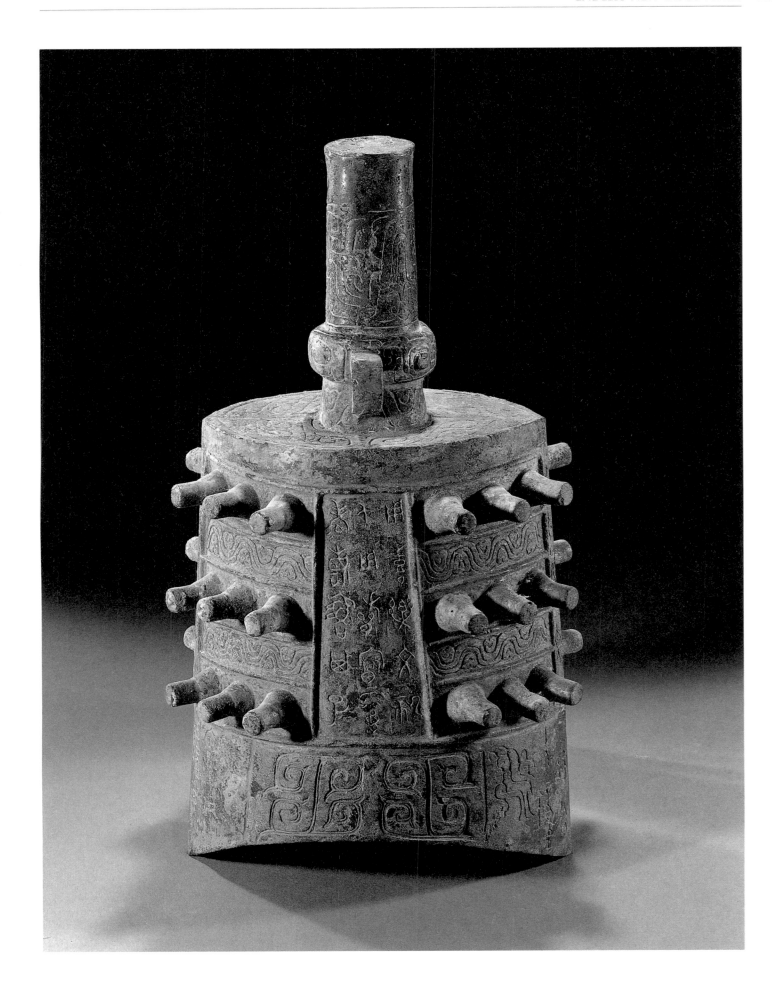

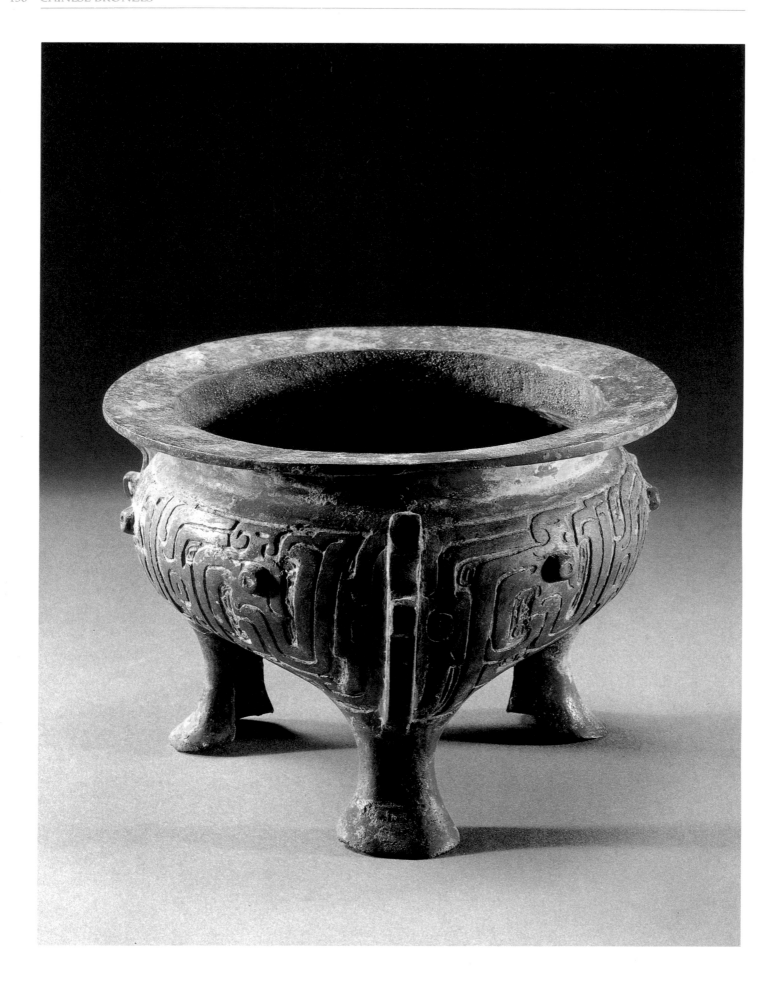

139.
Guo Ji *li*, cooking vessel, early Spring and Autumn Period, unearthed at
Shangcunling, Sanmenxia, Henan, height 12.7 cm.

140.
You Liu *ding* with perpendicular fish scale design, cooking vessel, middle
Spring and Autumn Period, unearthed at Shangmacun, Houma, Shanxi,
height 6.5 cm.

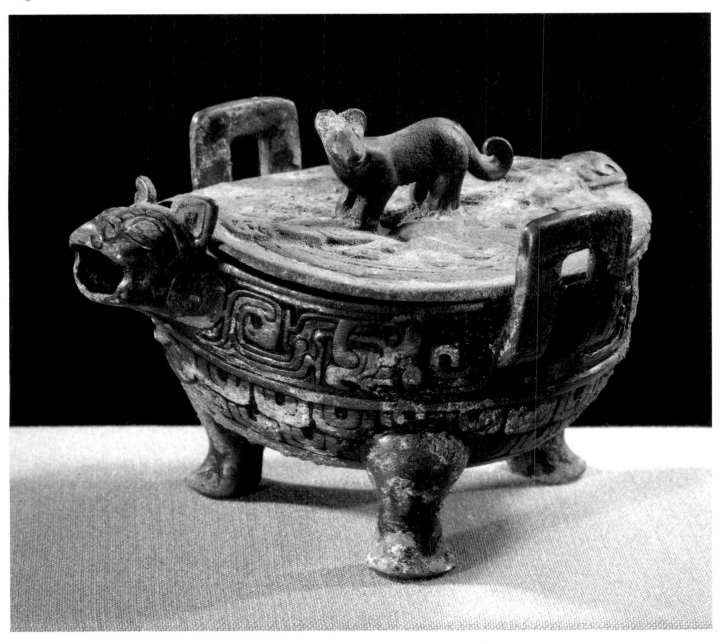

141.
Six-wheel bronze chariot, late Western Zhou Dynasty, unearthed at Shang-
guocun, Wenxi, Shanxi, length 13.7 cm.

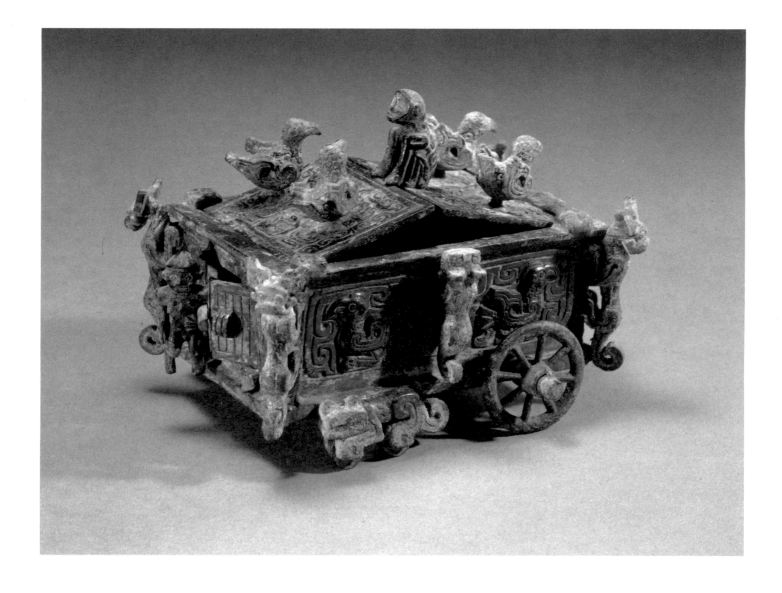

The bronze objects of the Spring and Autumn Period were also found in north China, such as Shangguo Village in Wenxi County, Shangma Village in Houma County (Pl. 140) and Jinsheng Village in Taiyuan, all in Shanxi Province. They were all located in the State of Jin during the Spring and Autumn Period.

Wenxi's old name is Quwo, which once served as the capital of Jin in the early Spring and Autumn Period. The excavation of the tombs at Shangguo Village started in 1974 and found many valuable bronzes. In 1989, a very special bronze was discovered here (Pl. 141). It is a rectangular case, 9.1 cm high, 13.7 cm long and 11.3 cm wide. At the bottom is a pair of big wheels and a pair of reclining animals; under their feet are four small wheels. With its six wheels, the case can move freely. On its top is a two-leaf cover on which are four movable birds; in its centre is a knob in the shape of a monkey. The sides of the case are decorated with a bird motif and six reclining beasts. A two-leaf door is in the front of the case, guarded by a man with severed legs.[16] This case might have been used to hold jewellery.

Houma was where the Jin capital Xintian was located in the late Spring and Autumn Period. Like the Shangguo Village cemetery in Wenxi, the excavation of the tombs at Shangma Village in Houma lasted a long time. From 1959 to the end of 1986, more than 1,300 tombs of the Zhou Dynasty were excavated, yielding a large number of bronzes.

Tomb 251 at Jinsheng Village, Taiyuan, which contained artifacts from the time between the Spring and Autumn and the Warring States periods, was excavated in 1988.[17] The excavated big *ding*, 100 cm high, is the largest of that period we have found. Most of the bronze objects from the tomb are very beautiful; most interesting is a bird-shaped *zun* (Pl. 142), similar to the *zun* preserved in the Freer Gallery of Art, U.S.A., which also originated from Taiyuan.

Bronze objects of the State of Qin were also unearthed. The excavation of the large No. 1 Nanzhihui Tomb in Fengxiang County, Shaanxi Province, was finally completed after a few years' work. All evidence proves that it is the tomb of Duke Jing of Qin, who died in 537 B.C. Unfortunately many of his funeral objects were stolen. A bronze mirror with interlaced hydra design is an unprecedented find.

In 1982, many *bian zhong* and *bian bo* chimes of bells, ritual vessels and weapons were discovered in a large tomb at Fenghuangling, Linyi County, Shandong Province.[18] The tomb was built in the late Spring and Autumn Period, but some of the bronze objects might have been cast earlier. Probably, these objects belonged

to a small princely state called Yu, but the spears with a rhombus design, interesting enough, were obviously imported from the State of Wu.

A great number of bronze objects cast by small states between the Huaishui and Hanshui rivers in south Henan and north Hubei, have also been discovered. For instance, in 1983, a tomb of the ruler of the State of Huang in the early mid-Spring and Autumn Period was excavated at Baoxiang Temple in Guangshan, Henan, and a large number of bronze objects discovered. The inscriptions on the surface of the bronzes have rarely been seen before.

In 1980, a big tomb at Jiulidun in Shucheng County, Anhui Province, which had been robbed, was unearthed, and more than 170 bronze objects were dug out. Among them is a drum stand decorated with a dragon-and-tiger design and inscribed with 150 characters. The tomb, constructed between the Spring and Autumn and the Warring States periods, probably belonged to Qunshu (Pl. 143), a local ethnic group.

As described earlier, a group of tombs of the State of Chu were unearthed at Xiasi in Xichuan County, Henan, in the late 1970s.[19] A bronze *jin* (rectangular stand which supports a wine vessel) and several other vessels discovered at Xiasi were made by adopting the lost-wax method, a great contribution to the study of bronze objects. But archaeologists have different opinions on the date of the tombs. In 1986, an Anshen *zhan* (small cup) of the King Gong of the State of Chu (who died in 560 B.C.) appeared in New York. Its shape is identical with the *zhan* unearthed from Tomb 1 at Xiasi and the hollowed-out handle on its lid was cast by the lost-wax method. It proves that the Chu tombs at Xiasi yielded objects of a not very later period, and at that time the advanced lost-wax method was already in use.

Later, new progress was made in excavating the Chu tombs. In 1990-91, groups of Chu tombs were discovered at Heshangling and Xujialing, Xichuan. Many bronze objects were discovered there, some of them with inscriptions. All were made between the late Spring and Autumn and the early Warring States periods. A pair of *ding* with side ears unearthed from Tomb 1 of Heshangling (Pl. 144) is decorated with a cloud design filled in with lacquer and very beautiful.

Other Chu tombs that have been excavated include Tomb 2 at Leigudun, Suixian County, Hubei, discovered in 1981, and Tomb 2 at Baoshan, Jingmen, Hubei Province, unearthed in 1986-87. Bronzes were found in all these Chu tombs. A human-shaped bronze lantern was discovered at Baoshan.[20] On the square base stands a vivid bronze figurine, with left hand on his chest and

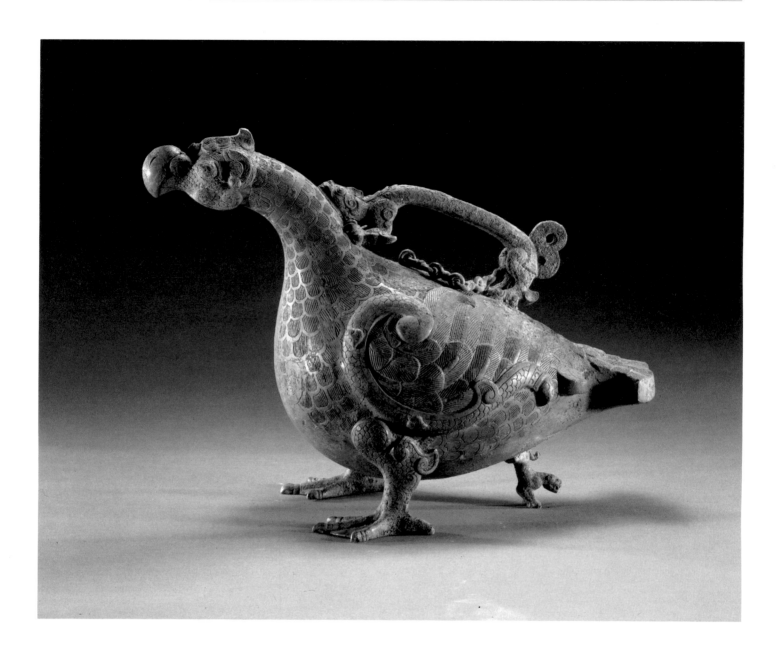

142.
Bird-shaped *zun*, wine vessel, late Spring and Autumn Period, unearthed at
Jinshengcun, Taiyuan, Shanxi, height 25.3 cm.

144.
Bi Zi Shou *bo*, musical instrument, middle Spring and Autumn Period,
unearthed at Heshangling, Xichuan, Henan, height 39 cm.

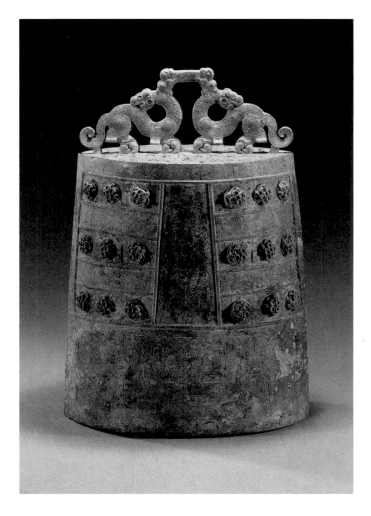

143.
Ding with the head of a *xi* (a beast of a uniform colour for sacrifice),
cooking vessel, late Spring and Autumn Period, unearthed at Shucheng,
Anhui, height 27.5 cm.

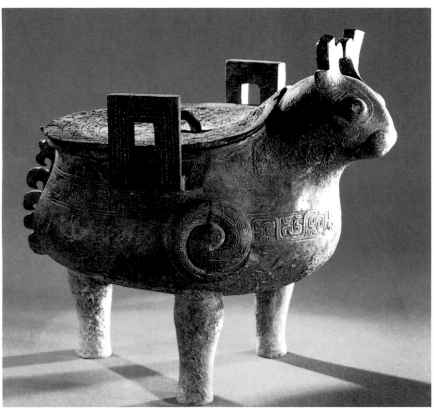

right hand holding the lantern—a marvellous work of art.

Generally speaking, the bronzes of south China in the Warring States Period are gorgeous and elegant, such as the bronze objects cast by the states of Chu, Wu and Yue, as well as those by some minority peoples.

The past ten years have witnessed quick progress in understanding the bronzes of the states of Wu and Yue. Now we know that as early as in the Shang Dynasty, the bronze culture of the Central Plain started to influence the states of Wu and Yue. More important is that after Taibo and Zhongyong (sons of King Tai of Zhou) entered the State of Wu, the culture of the Central Plain was combined with the cultures of the local ethnic communities. Bronze objects of the State of Wu also reflect this combination. There were three kinds of bronze objects in the State of Wu: the first kind was introduced from the Central Plain; the second modelled on those of the Central Plain, and the third showed local characteristics.[21] More often than not the three kinds of bronzes were found in one and the same tomb. The tomb of the Western Zhou at Muzidun, Dantu County, Jiangsu Province (Pl. 145), excavated in 1982, is a typical example. From the tomb, a *gui* food container was found, supported by a square stand with two bird-shaped ears. It looks very much like the *gui* discovered at Huayuan Village, Chang'an, and mentioned earlier. However, the *you* jars from the same tomb have bird-shaped cover knobs and are decorated with linked pearl and linked dot designs, rarely seen in the Central Plain. The *mao* spear's lower part is in the shape of a fish tail, showing local characteristics. All these prove that the State of Wu in the early Zhou Dynasty served as an important bridge between the culture of the Zhou Dynasty and that of the areas south of the Yangtze River. In the late Spring and Autumn Period, local characteristics of the Wu bronzes became insignificant, proved by more than 400 bronzes excavated from the tomb at Beishanding, Dantu, in 1983.

We do not know as much about the bronze objects of the State of Yue as we do about those made by the State of Wu. In 1982, a tomb of the early Warring States Period was excavated at Lion Hill, Shaoxing, Zhejiang Province. A group of unique bronze objects were found (Pl. 146), of which the most precious is a bronze house (Pl. 147), 17 cm high and 13 cm wide.[22] The house has a four-sided conical roof with a pillar at the top, on which is a reclining bird. The front part of this three-bay house is open with two pillars. The walls on the two sides are rectangular checks, and there is a window on the back wall. Inside the house are six people sitting, one

beating a drum, one playing a *qin* guitar, one blowing a *sheng* reedpipe, etc.

Yue bronzes were also discovered at other places. In 1986, a large *you*, 35.5 cm high, was unearthed at Jinqi Village, Xiangtan County, Hunan Province.[23] On the belly of the *you* is a boot-shaped axe design; the other parts are decorated with the motifs of frog, snake and other reptiles similar to the *zun* unearthed in Xialiu City, Hengshan, Hunan Province. Boot-shaped axes typical of Yue cultural relics were once found in the areas from Hengshan to Xiangtan. Though these *zun* and *you* are similar to those cast in the Western Zhou Dynasty, they were made in a much later period. This discovery indicates that some elements of the Central Plain bronzes had been preserved for quite a long time in the bronze objects of the minority peoples in remote areas.

Another example is the bronze *lei* jars discovered at Lipu, Binyang, and Luchuan counties in Guangxi Zhuang Autonomous Region. All have wide shoulders and long ring feet, similar to the Central Plain *lei* of the Western Zhou Dynasty. They are decorated with *kui*-dragon, double-ring, wave and hanging-leaf designs, like those on Western Zhou bronzes. However, these bronzes have two animal-shaped loops, which were separately cast and welded on later, showing a much later date. Japan's Tenri Reference Hall also has such a *lei*. Though these bronze objects were modelled on early Central Plain bronzes, they show slight differences in shape, design and technology.

In 1986, two pits at Sanxingdui, Guanghan County, Sichuan, were dug up, bringing forth many bronze objects of the State of Shu. It was a very important discovery. Discovery of the ancient site dated back to 1929 (or 1931). In 1933, the West China University Museum made excavations. Since the 1960s, excavations have been made time and again, bringing to light many ancient objects, mostly jade. According to C_{14} data, the bronzes from the two pits were cast in the late Shang Dynasty, one equivalent to the early period of the Yin ruins; the other, the late period of the Yin ruins.[24]

A *zun* from the No. 1 Pit, known as the dragon-and-tiger *zun*, is similar to those excavated from Zhuzhai in Funan, Anhui Province, in 1957. The four-ox *zun* and the three-sheep *zun* unearthed from the No. 2 Pit look like those discovered in Zaoyang, Hubei Province, Huarong, Hunan Province, and Chenggu, Shaanxi Province; and the four-sheep *lei* from the same pit is very close to those discovered at Shashi in Hubei and Yueyang in Hunan. All of them show the indirect Shang cultural influence from the Central Plain. In addition, many bronze objects with distinctive local characteristics were unearthed from

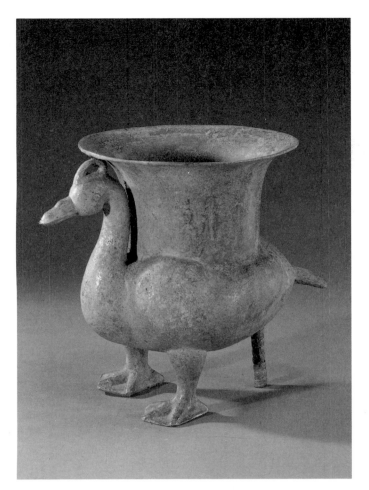

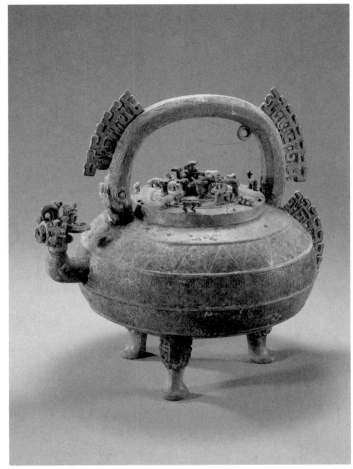

145.
Mandarin duck-shaped *zun*, wine vessel, early Western Zhou Dynasty. unearthed at Muzidun, Dantu, Jiangsu, height 22.2 cm.

146.
Loop-handle *he*, wine vessel, late Spring and Autumn Period, unearthed at Potang, Shaoxing, Zhejiang, height 29 cm.

147.
Copper house with cloud design, early Warring States Period, unearthed at
Shizishan, Shaoxing, Zhejiang, height 17 cm.

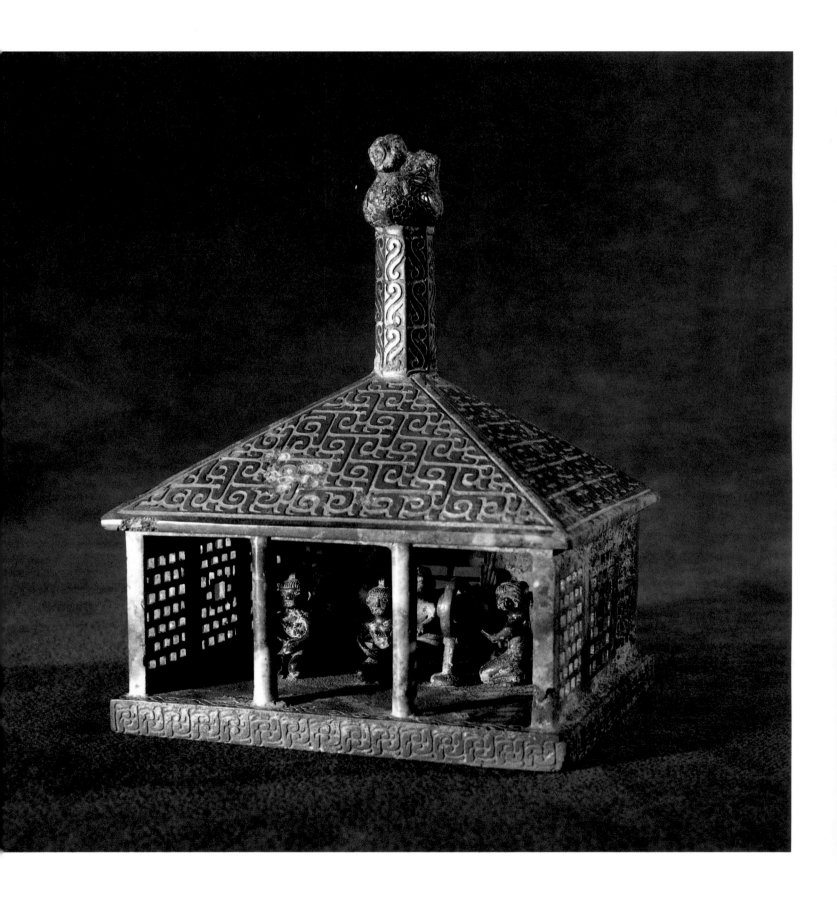

148.
Bronze human mask, late Shang Dynasty, unearthed at Sanxingdui, Guang-han, Sichuan, height 37.5 cm.

149.
Small bronze human mask, late Shang Dynasty, unearthed at Sanxingdui, Guanghan, Sichuan, height 6.5 cm.

the two pits, including many bronze figurines and human masks (Pls. 148-149), which are the most attractive. The largest bronze figurine is 2.6 metres high, including a bronze base (Pl. 150) on which are four dragon-type flattened feet supporting a figurine. A barefoot man wears a hat and a long robe; his two hands seem to hold something. The design of the bronze object shows characteristics of the Shang culture. The largest human mask (Pl. 151) is 64.5 cm high and 1.38 cm wide, with long ears, protruding eyes, a high nose and a wide mouth.

At least three bronze trees were also found in the Sanxingdui pits, the highest 3.9 metres tall, in which are huge dragons, animals, birds, flowers and fruits. Under another tree are three figurines kneeling on the ground and facing outwards.[25] The bronze mythical tree has taken the place of Houmuwu square *ding* as the largest ancient bronze object hitherto found.

The discovery at Sanxingdui made us realize for the first time the astonishing aspects of the bronzes of the early Shu.

In 1980, a large Shu tomb was found at Jiuliandun in Xindu to the south of Guanghan County. Under the coffin chamber is a wooden pit holding 188 bronze ritual vessels, weapons and tools. They are all in sets, each with two or five pieces. Most surprising is that many objects looked brand new when excavated. The tomb was built in the early mid-Warring States Period. The shapes of some of the bronze objects, such as the three-blade *ge*, still show the characteristics of the Central Plain bronzes in the early Western Zhou. It proves that from remote antiquity to the Warring States Period, the bronzes of the State of Shu had their own developing "arteries and veins."

Bronzes of the minority peoples were also found in Yunnan Province. The discoveries at Tianzi Temple in Chenggong County and Dabona in Xiangyun County have helped people further understand the bronze culture of this area.

The most attractive bronzes of the Qin and Han dynasties are the two horses-and-chariots excavated from the mausoleum of Emperor Qin Shi Huang at Lintong, Shaanxi Province, at the end of 1980.[26] The two bronze horses-and-chariots were discovered from an attendant tomb to the west of the mound of the Qin Shi Huang Mausoleum. The structures of the two chariots are different: the first chariot, driven by four horses, has a canopy with a figurine standing under it (Pl. 153); the

150.
Bronze figurine-shaped stand, late Shang Dynasty, unearthed at Sanxingdui, Guanghan, Sichuan, height 261 cm.

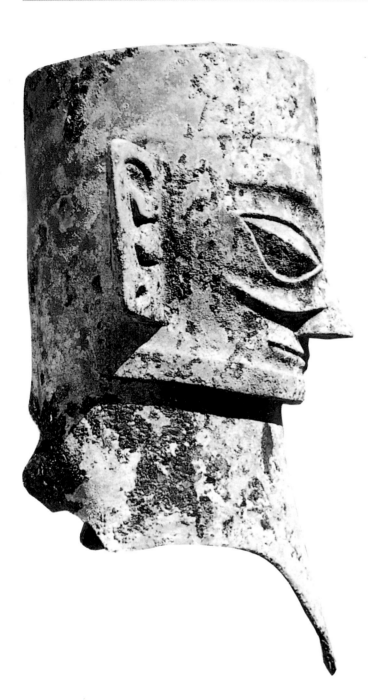

148.
Bronze human mask, late Shang Dynasty, unearthed at Sanxingdui, Guanghan, Sichuan, height 37.5 cm.

149.
Small bronze human mask, late Shang Dynasty, unearthed at Sanxingdui, Guanghan, Sichuan, height 6.5 cm.

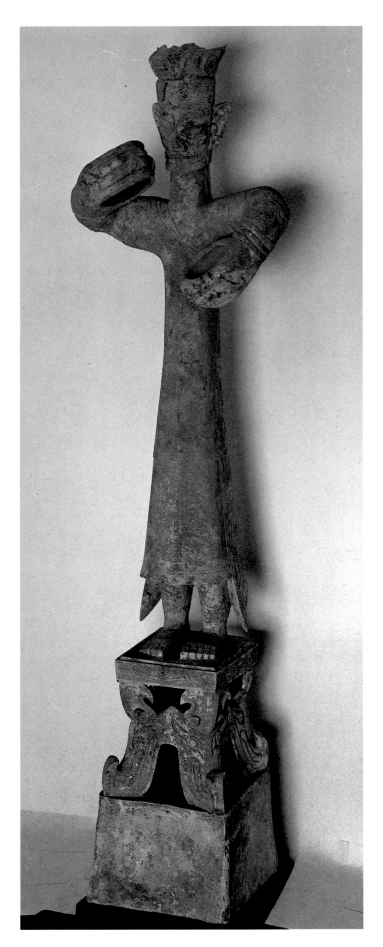

the two pits, including many bronze figurines and hu-
man masks (Pls. 148-149), which are the most attractive.
The largest bronze figurine is 2.6 metres high, including
a bronze base (Pl. 150) on which are four dragon-type
flattened feet supporting a figurine. A barefoot man
wears a hat and a long robe; his two hands seem to hold
something. The design of the bronze object shows char-
acteristics of the Shang culture. The largest human mask
(Pl. 151) is 64.5 cm high and 1.38 cm wide, with long
ears, protruding eyes, a high nose and a wide mouth.

At least three bronze trees were also found in the
Sanxingdui pits, the highest 3.9 metres tall, in which are
huge dragons, animals, birds, flowers and fruits. Under
another tree are three figurines kneeling on the ground
and facing outwards.[25] The bronze mythical tree has
taken the place of Houmuwu square *ding* as the largest
ancient bronze object hitherto found.

The discovery at Sanxingdui made us realize for the
first time the astonishing aspects of the bronzes of the
early Shu.

In 1980, a large Shu tomb was found at Jiuliandun in
Xindu to the south of Guanghan County. Under the
coffin chamber is a wooden pit holding 188 bronze ritual
vessels, weapons and tools. They are all in sets, each with
two or five pieces. Most surprising is that many objects
looked brand new when excavated. The tomb was built
in the early mid-Warring States Period. The shapes of
some of the bronze objects, such as the three-blade *ge*,
still show the characteristics of the Central Plain bronzes
in the early Western Zhou. It proves that from remote
antiquity to the Warring States Period, the bronzes of
the State of Shu had their own developing "arteries and
veins."

Bronzes of the minority peoples were also found in
Yunnan Province. The discoveries at Tianzi Temple in
Chenggong County and Dabona in Xiangyun County
have helped people further understand the bronze cul-
ture of this area.

The most attractive bronzes of the Qin and Han
dynasties are the two horses-and-chariots excavated from
the mausoleum of Emperor Qin Shi Huang at Lintong,
Shaanxi Province, at the end of 1980.[26] The two bronze
horses-and-chariots were discovered from an attendant
tomb to the west of the mound of the Qin Shi Huang
Mausoleum. The structures of the two chariots are
different: the first chariot, driven by four horses, has a
canopy with a figurine standing under it (Pl. 153); the

150.
Bronze figurine-shaped stand, late Shang Dynasty, unearthed at Sanxing-
dui, Guanghan, Sichuan, height 261 cm.

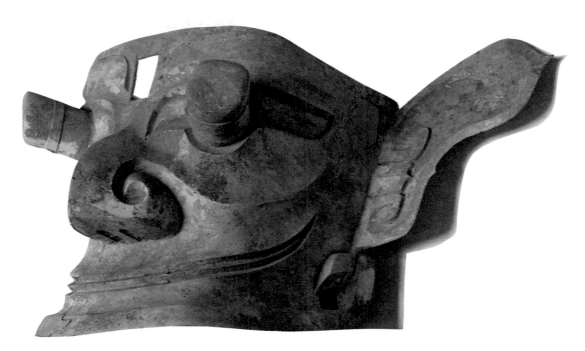

151.
Large bronze human mask, late Shang Dynasty, unearthed at Sanxingdui,
Guanghan, Sichuan, height 64.5 cm.

second chariot, also driven by four horses, has an awning with the driver sitting in the chariot (Pl. 152). The meticulously cast bronze horses and chariots, the size of which conforms with the proportions of real horses and chariots, are decorated with gold and silver ornaments and painted with various colours. The second chariot, which was renovated earlier, is 3.17 metres long and 1.062 metres high, is the largest in size and the most complicated in structure of any bronze object so far found in China. The two chariots must be the models of the imperial vehicles for Emperor Qin Shi Huang and certainly represent the highest techniques of that era.

Another typical example is the bronzes from the No. 1 Attendant Pit of the No. 1 Nameless Tomb at Maoling Mausoleum, Xingping County, Shaanxi Province, in 1981. Maoling Mausoleum is the tomb of Emperor Wu Di of the Han Dynasty. Most bronzes from the pit are inscribed with the characters, "Yangxin Family," referring to Emperor Wu Di's elder sister Princess Yangxin. In addition there were some imperial vessels cast by the Office of Royal Household Affairs. The most outstanding bronze objects include a gilded standing horse (Pl. 154), 62 cm high and 76 cm long, and an incense burner with a peak-shaped hollowed cover. The burner (Pl. 155), supported by three dragons, has a long handle under which is a gold- and silver-plated coiled dragon, 58 cm high. Both of these are rare treasures.

The most celebrated bronze object of the Eastern Han Dynasty is a big bronze horse.[27] The horse, now in London, is 127 cm high and 100 cm long, with four legs stretched as if running. The steed consists of several parts, which were cast separately. The remaining red, white and green colours on its body and within its ears indicate that the horse was originally painted. A bigger bronze horse was excavated from Hejia Mountain, Mianyang, Sichuan, in 1990.[28] The horse, 134 cm high and 115 cm long, is also composed of several separately cast parts. Moreover, a groom for this bronze horse was also unearthed.

It is necessary incidentally to mention some new discoveries of raw materials for casting bronze objects. Examination results of the bronze objects of the Shang and Zhou dynasties with lead isotope ratio show that the raw materials for some Central Plain bronzes in the period between the Shang and the Western Zhou might have come from Yunnan.[29] It is very interesting information. The ancient copper mines which we discovered in the 1960-70s are mainly located in Tonglu Mountain in Daye, Hubei Province. The archaeological site is fairly large: two kilometres long and one kilometre wide. Several hundred shafts and nearly a thousand drifts were found, in addition to some vertical furnaces for smelting copper. It has been proved that they were built in the Spring and Autumn Period or even earlier. Archaeological work is continuing there. Ancient copper mines of the Warring States Period were also found in Mayang County, Hunan Province, in 1982. Some of those from the

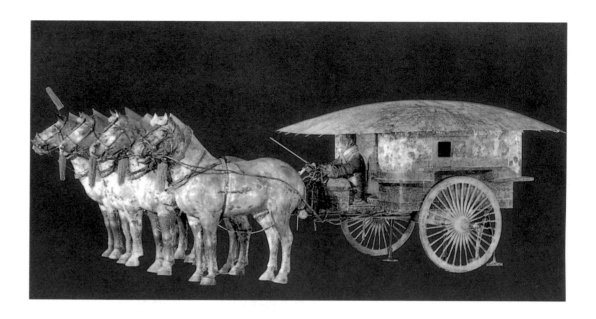

152.
(1) Bronze horses with chariot, Qin Dynasty, unearthed from the tomb of
Qin Shi Huang, Lintong, Shaanxi, length 317 cm. (2) Charioteer. (3) Head
of one of the horses.

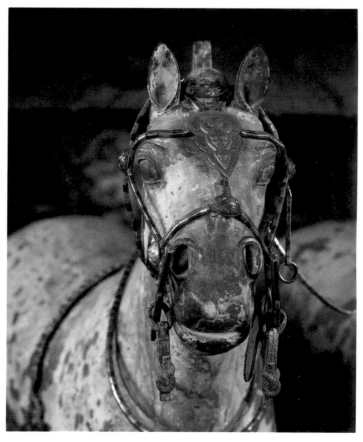

153.
Bronze charioteer, Qin Dynasty, unearthed from the tomb of Qin Shi Huang, Lintong, Shaanxi, height 92 cm.

Western Han Dynasty were discovered in Tongling, Anhui Province, in 1987, and some from the mid-Shang Dynasty, at Tongling in Ruichang County, Jiangxi Province, in 1989.

We have provided a brief review of the new discoveries of bronzes after the 1980s. However, the discovery of bronzes is endless. It is impossible to introduce each discovery in a short chapter. Even when I stop writing, archaeologists will probably have made new discoveries.

[1] See Li Xiandeng, "The Bronze Fragments and Things Unearthed from the Wangchenggang Ruins," *Cultural Relics*, No. 11, 1984.

[2] See Shanxi Work Team of the Institute of Archaeology of the Chinese Academy of Social Sciences, & the Linfen Prefectural Cultural Bureau, "The First Discovery of Bronze Objects at the Taosi Ruins, Xiangfen, Shanxi Province," *Archaeology*, No. 12, 1984.

[3] See "Summary of the Forum on the Origin of Chinese Civilization," *Archaeology*, No. 12, 1989.

[4] See Yan Wenming, "On China's Chalcolithic Age," *Pre-historic Studies*, No. 1, 1984.

[5] See Li Xueqin, "The *Taotie* Motif on Bronzes of the Erlitou Culture," *Chinese Cultural Relics Journal*, October 20, 1991.

[6] See *Bronze Objects of the Shang and Zhou Unearthed in Henan*, Vol. I, Cultural Relics Publishing House, 1981.

[7] Robert W. Bagley, *Shang Ritual Bronzes in the Arthur M. Sackler Collections*, 1987, No. 74.

[8] See Fengxi Excavation Team of the Institute of Archaeology of the Chinese Academy of Social Sciences, "A Brief Report on the Excavation of the Tomb of Jingshu of the Western Zhou Dynasty at Zhangjiapo, Chang'an," *Archaeology*, No. 1, 1986.

[9] See Hayashi Kinao, *Study of the Bronzes of the Yin and Zhou Periods*, Vol. 1, Yoshikawa Kobunkan, 1984, No. 17 Bird-and-Animal *zun*.

[10] See Lu Liancheng and Hu Zhisheng, *The Tombs in the State of Yu in Baoji*, Cultural Relics Publishing House, 1988.

[11] See Fang Guoxiang, "A Bronze *Fang Yi* Excavated in Zongyang, Anhui," *Cultural Relics*, No. 6, 1991.

[12] See "Summary of the Forum on the Discovery of the Western Zhou Bronzes with Inscriptions in Liulihe, Beijing," *Archaeology*, No. 10, 1989.

[13] See Zou Heng, "On the Capital of the State of Jin in the Early Period," *Cultural Relics*, No. 1, 1994.

[14] See Shaanxi Provincial Museum & Shaanxi Provincial Cultural Relics Administrative Committee, *Illustrated Annotations on Bronzes*, Fig. 71, Cultural Relics Publishing House, 1960.

[15] See Li Xueqin, "New Discoveries from the Guo Tombs in Sanmenxia and the History of the State of Guo," *Chinese Cultural Relics Journal*, February 3, 1991.

[16] See Zhang Chongning, "A Six-Wheel Cart Guarded by a Man with Severed Legs," *Cultural Relics Quarterly*, No. 2, 1989.

[17] See Shanxi Provincial Institute of Archaeology & Taiyuan Cultural Relics Administrative Committee, "A Brief Report on the Excavation of Tomb 251 and the Chariot-Horse Pits of the Spring and Autumn Period at Jinsheng Village, Taiyuan," *Cultural Relics*, No. 9, 1989.

[18] See Shandong Yanshi Railway Archaeological Work Team, *The Eastern Zhou Tomb at Fenghuangling, Linyi*, Qilu Book Company, 1987.

[19] See Henan Provincial Cultural Relics Institute, Henan Denjiang

154.
Gilded standing horse, Western Han Dynasty, unearthed at Maoling,
Xingping, Shaanxi, height 62 cm.

Reservoir Area Archaeological Team & Xichuan County Museum, *The Chu Tombs of the Spring and Autumn Period at Xiasi in Xichuan*, Cultural Relics Publishing House, 1991.

[20] See Hubei Jingsha Railway Archaeological Team, *The Chu Tombs at Baoshan*, Pl. 57, Cultural Relics Publishing House, 1991.

[21] See Xiao Menglong, "The Bronzes of the Shang and Zhou Dynasties Preserved at Zhenjiang Museum," *Southeast Culture*, No. 5, 1988.

[22] See Zhejiang Provincial Cultural Relics Administrative Committee, Zhejiang Provincial Cultural Relics and Archaeology Institute, Shaoxing Prefectural Cultural Bureau, & Shaoxing City Cultural Administrative Committee, "A Brief Report of the Excavation of the No. 306 Tomb of the Warring States Period at Shaoxing," *Cultural Relics*, No. 1, 1984.

[23] See Xiong Jianhua, "The Bronze *You* with a Loop Handle of the Zhou Dynasty Excavated in Xiangtan County," *Hunan Archaeology*, Vol. I.

[24] Sichuan Guanghan Cultural Bureau, "Selected Data on the Sanxingdui Site in Guanghan," No. 1, 1988.

[25] See Zhao Dianzeng, *Study of the Cultural Relics from the Sacrificial Pits at Sanxingdui* and *Sanxingdui and the Ba-Shu Culture*, Bashu Book Company, 1993.

[26] See Shaanxi Provincial Qin Terracotta Figurines Archaeological Team & Qin Shi Huang Terracotta Warriors and Horses Museum, "The No. 2 Bronze Horses and Chariots from the Qin Shi Huang Mausoleum," *Archaeology and Cultural Relics*, No. 1.

[27] See Ai Lan and Lu Liancheng, "The Big Bronze Horse of the Eastern Han Found in London," *Chinese Cultural Relics Journal*, February 21, 1993.

[28] See *Chinese Cultural Relics Journal*, March 28, 1993.

[29] See Li Xiaocen, "Restudy of the Sources of the Minerals for the Central Plain Bronzes in the Shang and Zhou Dynasties," *Study of the History of Natural Sciences*, No. 3, Vol. 12.

155.
Gilded incense burner, Western Han Dynasty, unearthed at Maoling, Xingping, Shaanxi, height 58 cm.

Appendixes

Chronology of Chinese Dynasties

Xia	c. 21st century-16th century B.C.	Western Wei	535-557
		Northern Qi	550-577
Shang	c. 16th century-11th century B.C.	Northern Zhou	557-581
		Sui	581-618
Western Zhou	c. 11th century-770 B.C.	Tang	618-907
Eastern Zhou		Five Dynasties and Ten Kingdoms	907-979
Spring and Autumn Period	770-476 B.C.		
Warring States Period	475-221 B.C.	Song	960-1279
Qin	221-207 B.C.	Northern Song	960-1127
Western Han	206 B.C.-A.D. 24	Southern Song	1127-1279
Eastern Han	25-220	Liao	916-1125
Three Kingdoms	220-280	Western Xia	1038-1227
Wei	220-265	Kin	1115-1234
Shu	221-263	Yuan	1271-1368
Wu	222-280	Ming	1368-1644
Western Jin	265-316	Qing	1644-1911
Eastern Jin	317-420		
Southern and Northern Dynasties	420-589		
Southern Dynasties	420-589		
Song	420-479		
Qi	479-502		
Liang	502-557		
Chen	557-589		
Northern Dynasties	386-581		
Northern Wei	386-534		
Eastern Wei	534-550		

Reigning Periods of the Later Shang, Western Zhou and Eastern Zhou Dynasties

Later Shang Dynasty

Pangeng, Xiaoxin and Xiaoyi	c. 1300-1239 B.C.
Wuding	c. 1238-1180 B.C.
Zugeng	c. 1179-1173 B.C.
Zujia	c. 1172-1140 B.C.
Linxin and Kangding	c. 1139-1130 B.C.
Wuyi	c. 1129-1095 B.C.
Wending	c. 1094-1084 B.C.
Diyi	c. 1084-1050 B.C.
Dixin	c. 1060-1027 B.C.

Western Zhou Dynasty

King Wu	c. 1027-1025 B.C.
King Cheng	c. 1024-1005 B.C.
King Kang	c. 1004-967 B.C.
King Zhao	c. 966-948 B.C.
King Mu	c. 947-928 B.C.
King Gong	c. 927-908 B.C.
King Yi	c. 907-898 B.C.
King Xiao	c. 897-888 B.C.
King Yi	c. 887-858 B.C.
King Li	c. 857-842 B.C.
King Gonghe	841-828 B.C.
King Xuan	827-782 B.C.
King You	781-771 B.C.

Eastern Zhou Dynasty

King Ping	770-720 B.C.
King Huan	719-697 B.C.
King Zhuang	696-682 B.C.
King Li	681-677 B.C.
King Hui	676-652 B.C.
King Xiang	651-619 B.C.
King Qing	618-613 B.C.
King Kuang	612-607 B.C.
King Ding	606-586 B.C.
King Jian	585-572 B.C.
King Ling	571-545 B.C.
King Jing	544-520 B.C.
King Jing	519-477 B.C.
King Yuan	476-469 B.C.
King Ding (Zhending)	468-441 B.C.
King Kao	440-426 B.C.
King Weilie	425-402 B.C.
King An	401-376 B.C.
King Lie	375-369 B.C.
King Xian	368-321 B.C.
King Shenlian	320-315 B.C.
King Nan	314-256 B.C.

Index

Z

图书在版编目（CIP）数据

中国青铜器概说：英文/李学勤著．—北京：
外文出版社，1995
（文化丛书/外文出版社主编）
ISBN 7－119－01387－4

Ⅰ．中… Ⅱ．李… Ⅲ．青铜器（考古）—中国
—英文 Ⅳ．K876.41

中国版本图书馆 CIP 数据核字（94）第 12843 号

中国青铜器概说

李学勤 著

责任编辑 程钦华

＊

ⓒ外文出版社
外文出版社出版
（中国北京百万庄路 24 号）
邮政编码 100037
精美彩色印刷有限公司印刷
中国国际图书贸易总公司发行
（中国北京车公庄西路 35 号）
北京邮政信箱第 399 号 邮政编码 100044
1995 年（小 8 开）第一版
（英）
ISBN 7－119－01387－4 /J·1079（外）
24800
84－E－752D